KEMCC

R. B. KITAJ

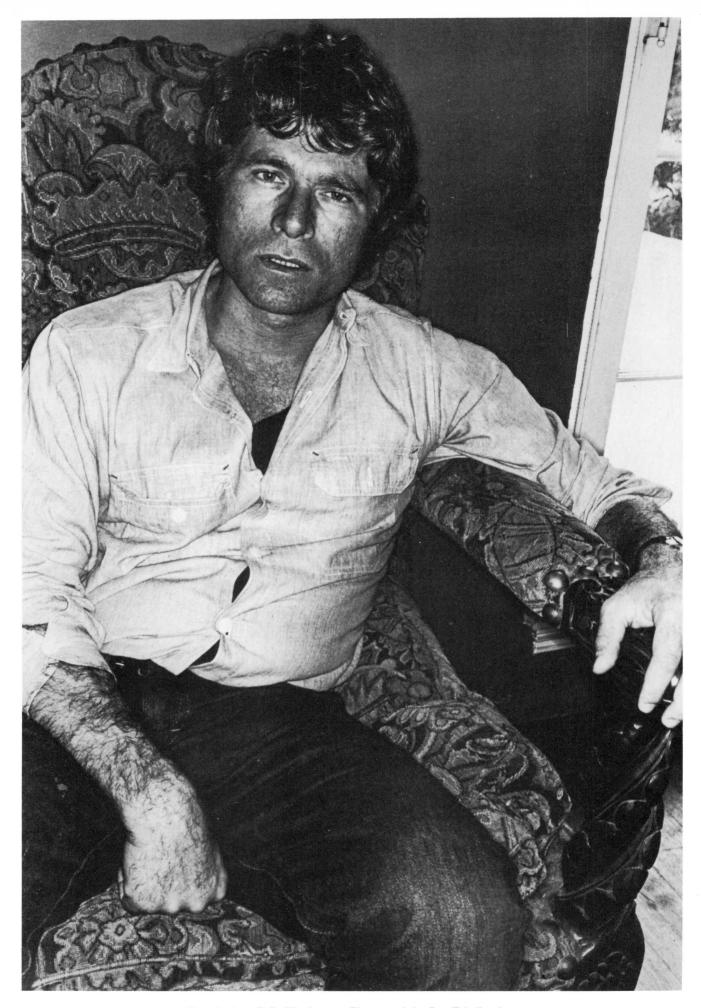

Frontispiece. R.B. Kitaj, 1970. Photograph by Lee Friedlander.

R.B. KITAJ

MARCO LIVINGSTONE

To my parents

The Publishers would like to express their gratitude to Marlborough Fine Art (London) Ltd. for their assistance in the production of this book.

> First published in the United States of America in 1985 by RIZZOLI INTERNATIONAL PUBLICATIONS, INC. 597 Fifth Avenue, New York, NY 10017

Copyright © Phaidon Press Limited, Oxford, 1985

All rights reserved. No part of this publication may be reproduced in any manner whatsoever without permission in writing by Rizzoli International Publications, Inc.

Library of Congress Cataloging in Publication Data

Livingstone, Marco.

R. B. Kitaj

Bibliography: p.

Includes index. 1. Kitaj, R. B.

I. Title.

759.13 [B]

84-26485

N6537.K53L58 1985 ISBN 0-8478-0599-9

Phototypeset by Tradespools Ltd., Frome, Somerset Printed in Great Britain by The Roundwood Press Limited, Kineton, Warwick

CONTENTS

PREFACE		6
INTRODUCTION		7
I.	As a Young Man	8
II.	Certain Forms of Association	11
III.	An American in England	81
IV.	The Age of Mechanical Reproduction	20
V.	Unsettled Years	25
VI.	In Our Time	26
VII.	Towards a Better Life	29
VIII.	The World's Body	32
IX.	A Confessional Art	40
NOTES TO THE TEXT		42
PLATES		47
PREFACES BY R.B. KITAJ		145
BIBLIOGRAPHY		155
LIST OF WORKS		156

PREFACE

It is nearly a decade since I first met R.B. Kitaj, thanks to an introduction from my tutor, John Golding. In the intervening years I have had the good fortune of maintaining contact with the artist, an exchange of ideas and information which has been especially close in the two years since I was commissioned to write this study. The immense and revealing correspondence by which we have conducted a series of interviews on diverse aspects of the painter's work forms, in a real sense, the very core of this book. It is to Kitaj himself, therefore, that I express my first and most profound thanks, for the honesty, frankness and thoughtful care with which he has so patiently answered my many questions and by means of which he has helped unravel both the intimate circumstances of his life and the complex implications of his work.

Marlborough Fine Art, London, have greatly simplified my task in making available their complete photographic documentation of the artist's pictures, as well as their press files and published items which would otherwise have been difficult to trace. My thanks especially to Geoffrey Parton, for giving me early access to the list of paintings and drawings compiled by him for inclusion in this volume, and for showing me works by the artist in store at the gallery. I am grateful, likewise, to the staff of the Tate Gallery Print Department and to other public bodies and individuals who over the years have allowed me to look at works in their collections.

The chapter concerning Kitaj's early work, Certain Forms of Association, is closely based on my article, 'Iconology as Theme in the Early Work of R.B. Kitaj', published in the July 1980 issue of the Burlington Magazine. I am much obliged to Richard Shone and his colleagues at the Burlington for granting me permission to re-use this material.

I might not have taken on this project at all had it not been for the support of David Pears, until recently Chairman of the Museum of Modern Art Oxford, and of David Elliott, its Director, who together with the Museum's Council of Management generously granted me time in which to complete my writing. To them and to all my colleagues at the Museum I should like to express my warm appreciation.

Marco Livingstone Oxford, July 1984

The first half-century of R.B. Kitaj's life has all the makings of a novel, filled with incident and romance, with memorable personal encounters and different cultures. The intricacies of his experiences, together with the artist's constant practice of reinventing himself – dramatizing his changing situation by devising new self-images and by identifying with people he has known, with artists and writers whose work and lives have caught his imagination, and even with figures from the realm of fiction – provide in themselves a worthy subject and one that would go far to explain the context of his work as a painter. The intimate snatches of autobiography that Kitaj has conveyed to me in our constant correspondence over the past two years must, however, remain as fragments within this study of his art.

'As you may guess,' Kitaj wrote as we embarked on our course of written interviews, 'I'm always keen to confound the very widespread idea among our art people that *nothing* matters but the damned *thing* itself and that thing has to "work", as if there could be any real agreement about what "works" and what does not. Even artists I most admire, many dear friends, really shy away from making connections between art and what may be called *the life*, one's life ... Not me." On a separate occasion, however, he warned against taking too much account of what he himself had said in earlier interviews, admitting that 'My pictures had and have secret lives ... and so there were things I did not tell, a lot of stuff I did not say back then which I'm saying now. Also, what I did say was not always well put and was tempered by the secret lives of various pictures. I intend to continue, by the way, allowing forms of secret life to paintings I'm working on right now because it excites me to do that, which excitement can't be all bad, can it?"

Kitaj's contradictory but related impulses towards self-confession on the one hand and, on the other, towards secrecy and ambiguity lie at the root of his art. The work's intimacy and wide range of reference offer points of access, which are, however, often made impenetrable by their frequently private and esoteric nature. Kitaj from the beginning has distrusted the notion, prevalent in our time, that a work of art can be totally self-sufficient and that it can communicate its meaning almost at once without the benefit of additional information; even those forms of painting most rigorously dedicated to questions of perception are modified by the viewer's knowledge of their philosophical standpoint and theoretical intentions and by their place within the history of the avant-garde. Rather than simply accepting that his work, like that of other artists, will be viewed in different ways according to the frame of reference of whoever sees it, Kitaj has sought to incorporate intellectual, emotional and sensual forms of experience into his pictures so that everybody can find the point of entry most pertinent to his or her own personality, knowledge and experience.

Inevitably there will be aspects of certain pictures and perhaps some of Kitaj's general concerns that will remain unclear to those viewers who lack the motivation to make their own investigations. There is a real danger of an artist putting off his prospective audience by making their task as demanding as his own, as I know from my own frustrations in trying to understand the poetry of one of Kitaj's earlier exemplars, Ezra Pound. For their part, Kitaj's pictures, when I first came to know them, seemed threatening in their difficulty and in their constant allusions to historical and political figures and to literature with which I was not always familiar. Even now I must confess

that I am unable – even unwilling – to follow Kitaj in the full diversity of his intellectual and cultural explorations, for they do not all touch me in the same way. My experience and intellectual preoccupations, after all, are not identical to his. But an instance of the power of Kitaj's work – assumed by some of its detractors to appeal primarily to literary minds – is the hold it has had over me, by no means a conventionally 'bookish' person, for more than a decade now. Kitaj's work has long prompted me to extend my knowledge through reading and to reconsider the implications of the art of our time in the context of earlier art. Gradually, and, I must admit, with Kitaj's help as well as by my own investigations, I have experienced the pleasure of deciphering plausible meanings of particular pictures, always keeping in mind the possibility of other, equally convincing, interpretations or contexts in which the works could usefully be viewed.

Kitaj has consistently used all means at his disposal to ensure that the life of his pictures should not be circumscribed by the period of time in which they were made. The pictures generally have a long gestation, formulated by a mixture of impulses which reinforce one another while controlling excesses in any particular direction: the structuring of a picture is as likely to arise from free association from the subconscious, a legacy of Kitaj's grounding in Surrealism, as from a deliberate urge to integrate found images, direct observations from life, personal circumstances and subjects drawn from sources in art, literature and history. The significance of a painting or drawing can change even for the artist because of the complex relationship between conscious intention and subconscious impulse, just as events in one's own life can be reinterpreted through recourse to memory and later experience. It is an issue that interests Kitaj greatly:

Flaubert liked to identify what he called an 'unconscious poetics' which brings work into being. I believe that pictures have many lives and selves and intentions . . . I am a revisionist. The ancient injunction – Remember! – has become a force in my life and pictures and, like other sublimations, has always been there I guess. I try to recover that remembrance of past things. I tend to refuse the notion that pictures should just linger and be left to their autonomous moment. It is never so. They can be taken up again and they always are in history. For one thing, they can be taken up again physically . . . I've tried to reclaim pictures to work on or cut up and sometimes I've been able to do that. I would destroy many of my pictures if I were allowed to. Instead, I content myself with seeking out what interests me or/and what I like about them and also remembering, in the spirit of the great Midrashic traditions (I've only recently discovered) which for thousands of years have sought meanings other than literal ones in spiritual texts long past.

I AS A YOUNG MAN

Kitaj was born Ronald Brooks in Cleveland, Ohio, on 29 October 1932. He never knew his Hungarian father – 'a nice guy, I'm told, a drifter who loved horses and books' – who left when Kitaj was aged about one and died in California a decade later. His mother, Jeanne Brooks, raised him alone, working first as a secretary in a steel mill and later as a schoolteacher; the daughter of Russian Jews, she married for the second time in 1941, taking as her husband a Viennese Jew named Dr Walter Kitaj, whose foreign background, like that of his mother, who came to live with them after the War, 'was a striking infusion and counterpoint in my otherwise rather normal American youth'.

Characteristically, Kitaj cites two novels as indicative of the milieu in which he was raised: *Studs Lonigan*, the first of James T. Farrell's trilogy, which he read in his early 'teens and in which he

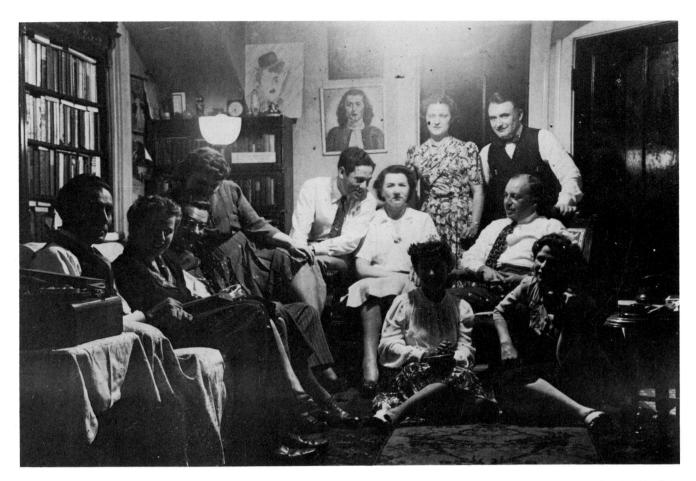

Fig. 1. Photograph of Joe Singer's apartment, Cleveland, Ohio, in the late 1930s. Jeanne Brooks is on the far right, Dr Kitaj in the centre, and Joe Singer is standing.

recognized his own experience of big city life, and Edward Dahlberg's Because I Was Flesh, 'a Portrait of the Artist as a Young Jew', to use Kitaj's description, in which many years later he discovered an even more accurate mirror of his own youth.² The happiest memories of the ten years that Kitaj spent in Cleveland are of the art classes that he attended as a small child in the Cleveland Museum of Art and of the favourite pictures that linger with him to this day: Albert Ryder's Race Track (Death on a Pale Horse), John Singleton Copley's Portrait of Nathaniel Hurd, El Greco's Holy Family, and Jacopo Bassano's Lazarus and the Rich Man, a picture that appeared to him as 'a tantalizing study in humiliation and persecution' and which produced in him one of his earliest sexual frissons. During the War years Kitaj made regular visits back to Cleveland to see his grandparents, encountering Picasso's blue period masterpiece La Vie (1903), which was acquired in 1945 by the Museum and which remains a favourite picture of his.

'Above all there was drawing. I was always a little old kid mad about drawing and although there were times I would have settled for a career in baseball or at sea later on, I never wanted to do anything other than art – and long before Freud's claim that it was really about fame, money and the love of women could take hold of me (I think).' Describing the 'agnostic, left-liberal milieu' in which he was brought up and in which 'political and literary instincts and turmoil colored and overwhelmed more stable or traditional absolutes', Kitaj points to the combination of forces that from the beginning helped shape his ambitions for art: 'Not to labor the point much more, my earliest years knew a confluence of art and books and political life overshadowed by the distant storm in Europe.'

In 1942 Kitaj's stepfather got a job as a research chemist in Troy, a small town in upstate New York, and it was there that Kitaj spent the subsequent six years.

Troy was heavily Irish Catholic and I would huddle with the others to hail Mary before baseball, basketball and boxing. Troy was a lot of sport, pals who endure as close friends to this day, the beautiful Hudson River Valley, refugees, the death of Mr Roosevelt (a big thing), the Truman years and the end of the war (another big thing), more refugees (and by that, I mean – very much in our lives), the McCarthy era and the blooming of an ever newer political soul in me, cruising cars for girls (almost untouchable Catholic girls), the discovery of a modern literature (Whitman, early Joyce, Hemingway, Hart Crane) ... and somehow, beyond the girls and movies and refugees there was always to be art, always drawing, always going to be an artist. I didn't have the Cleveland Museum any more so my focus switched to art books and one of the unsung art-classrooms of America – *Life* Magazine. *Life* was always jam-packed with terrific reproductions in full color. I've always kept these reproductions. I use them every week of my life. They are tattered, treasured survivors pinned to my walls and stuffed into folders.

On leaving high school, his head 'brim full of Thomas Wolfe and Conrad and O'Neill's Long Voyage Home', Kitaj hitch-hiked to New York in the company of his closest friend, Jim Whiton, and with him signed on as a messman on a Norwegian ship called SS Corona, headed for Havana and Mexican ports. This was to be the first of a series of voyages that Kitaj was to make over the following four years, alternating with periods of training at the Cooper Union Institute and at the Academy in Vienna. Kitaj's time as a merchant seaman, often spent on what was referred to as the 'Romance Run' on ships of the Moore-McCormack Line - Santos, Rio de Janeiro, Montevideo and Buenos Aires – had a lasting effect on him. On the one hand it was a period of intense reading, with Kafka and Borges among those whose writings he consumed as part of his daily routine; on the other, it pushed him headlong into maturity while intensifying his taste for romantic adventure. 'Port life', he recalls, 'has marked me in many ways, sexually and otherwise, and themes for an art can be traced there.' The memory of his introduction to brothel life in Havana on his first voyage at the age of seventeen lingers with him still, and it is to this area of experience, which has insinuated itself into his pictures over the years, that he continues to pin one of his ambitions for a type of painting that will synthesize his achievements, as Cézanne did in his late Bathers or Picasso in the Demoiselles d'Avignon.

Kitaj arrived at the Cooper Union in the autumn of 1950, excited at the prospect of living in New York but resistant to the Abstract Expressionist ethos, which then held sway. Though he admired De Kooning and took notice of contemporary developments in painting, his secret ambition – admittedly unfulfilled – was to paint like Hans Memling.

Nevertheless, I would, for better and often for worse, become rather addicted to the surreal—dada—symbolist strain in our modern art which I haven't been able to get off my back yet. There were remarkable teachers there and memorable students. The Cosmopolitanism of the place was, in retrospect, its distinguishing aspect for me and I suppose, come to think of it, it is the Cosmopolitan nature of Modernism which I find most attractive still.

He pays tribute to the teaching of Sydney Delevante, 'a genuine early American modernist of the surreal—symbolist persuasion', but perhaps the most profound part of his education took place outside the school in the bookshops along 4th Avenue. 'I had discovered Pound and Eliot and Joyce and Kafka and an innate bibliomania was rekindled there as it would be, on and off, manic and depressive through my life, feeding and bloating the pictures I would do.'

In the autumn of 1951 Kitaj passed through Paris on his way to Vienna, which he recalls as being very much as shown in Carol Reed's 1949 film *The Third Man*. He registered at the Akademie, where Klimt and Schiele had been students at the turn of the century, and entered the studios of Albert Paris von Gütersloh, who himself had been a friend of Schiele. He drew regularly from the figure and also produced watercolours and drawings of the bombed ruins of the Opera

and of the Danube Canal in the Russian zone; none of these, however, seems to have survived. In the anatomical dissection class that he attended he met an American girl from Cleveland, Elsi Roessler, whom he began courting and whom he married in the following winter after his return to New York.

In 1953 Kitaj and his bride returned to Vienna and then travelled on through North Africa and Spain, spending the winter in what was then the quiet port of San Felíu de Guixols. It was during that first stay in this town, to which he made several return visits during the 'fifties before beginning his regular pilgrimages there in the summer of 1962, that Kitaj met José Vicente Roma, 'an extraordinary man who would become one of my many brothers and a very great influence on my life'.

Having made his last journey to sea, Kitaj was conscripted into the American Army in 1956 and was posted to AFCE headquarters at Fontainebleau, where he drew pictures of the latest Russian tanks and installations for war games. He lived with his wife at Thoméry sur Seine, a town set in the forest near many of the sites painted by the Impressionists, and at the weekends they generally drove into Paris. On finishing his duty as an enlisted man, he decided to avail himself of the further art training offered at two British colleges under the terms of the American G.I. Bill, choosing the Ruskin School of Drawing and Fine Art at Oxford in favour of Edinburgh. He and his wife made the journey by car.

It was a lonely drive because Suez had just been invaded and there was no petrol to be had in Europe. I had a supply in cans from the Army and I was just about the only car on the road. I had just read the two volumes of Will Rothenstein's *Men and Memories* and so I knew something of the life I was driving into.

II CERTAIN FORMS OF ASSOCIATION

By the time Kitaj arrived in Oxford at the beginning of 1958, aged twenty-five, he had led several lives and educated himself about a considerable range of art, politics and literature. An indication of the diversity of his artistic interests alone can be gleaned from his recollections of *Life* magazine:

First, it was where a lot of us saw mainstream modernism for the first time if one didn't live in N.Y. – Picasso to Pollock in technicolor. But also there were alternative conventions which many artists of a certain age must carry somewhere in the back of their mind. Along with the great European Moderns were pages and pages of what I guess you could call American Romantic art, swerving from downright realism to surrealism and symbolism: Blakelock, Eilshemius and the magnificent Albert Ryder; Eakins and Homer (best of breed); the Ashcan School; Hopper, Marsh, Soyer, Bishop, Bellows, Tchelitchev and Ivan Albright; I first saw Arthur Dove there and O'Keefe, Marin, Nadelman, Cornell and Marsden Hartley, as well as the Romantic Surreal roots of abstraction in Gorky, Pollock, De Kooning and Rothko . . . I could go on and on because these pictures, first in reproduction, and a few years later in N.Y. in the flesh, are printed inside me.

It was above all to the Surrealist tradition, however, that the young Kitaj looked for guidance. Referring to himself even today as 'a grandchild of Surrealism', he openly acknowledged the parentage as early as 1961, when he appropriated the title of his mysteriously wispy canvas, Certain Forms of Association Neglected Before, from André Breton's first Surrealist Manifesto of 1924:

ENCYCLOPEDIA. *Philosophy*. Surrealism is based on the belief in the superior reality of certain forms of association neglected before, in the omnipotence of dream, in the disinterested play of thought.³

It is telling that it was to Breton's second definition of Surrealism, as a philosophy or frame of mind rather than as a technical method of 'psychic automatism' as outlined in the first, that Kitaj made reference, since from the start he was a neo-Surrealist in attitude rather than a follower of orthodox Surrealist painting. The intuitive means by which Kitaj composed his pictures in the early sixties found further sustenance in the artist's encounter, later in the decade, with Carl Gustav Jung's concept of the 'active imagination', by which, as Kitaj explains, 'consciousness is only an agent, noting what comes up in one's fantasy as it arises... One is instructed (by C.G.J.) to be "uncritical" of these fantasies, to actually write them down, as if describing a dream or a play, without editing or criticism! This was a revelation for me because I'd been in the habit of painting like that anyway.'

The deliberate scattering of attention across the surface of Kitaj's early paintings provides an inducement for the mind to wander, focusing attention randomly on specific images as an equivalent to the mind's habit of jumping suddenly from vague reverie to a specific idea. At a time when much 'advanced' painting was marked by a reductive tendency for the sake of visual and emotional impact, Kitaj found it truer to his own experience to incorporate in his work as many different kinds of complexity as he could. The fragmentary nature of the early paintings, their stylistic jumps and clues to further meanings, far from threatening their coherence, provided an apt visual metaphor of the diversity both of modern culture and of the artist's own background.

One aspect of Surrealist method that was of use to Kitaj in establishing his own practice of picture-making was that of collage – as exemplified by the composite engravings such as *Une Semaine de Bonté* (1934) by Max Ernst – which provided a means of bringing together surprising and thought-provoking conjunctions of images. Much of Kitaj's earlier work was collage-based, either literally in the incorporation of pasted additions to the paintings and in the composition of the screenprints from various types of ready-made material, or, obliquely, in the translation of a number of sources onto a single surface painted or drawn entirely by hand.

At Oxford Kitaj encountered Edgar Wind, the University's first Professor of Art History and a leading scholar in the field of iconographic studies established by Aby Warburg; at the same time he came across the Journals of the Warburg and Courtauld Institutes in the Ashmolean Library, journals which he soon began to collect for his own use as source material. For Kitaj this newly-discovered material, with its fascinating juxtapositions and its persuasive thesis on the capacity of images to give form to ideas, provided both an extension of, and complement to, his devotion to Surrealism. 'Warburg', in his view, 'was like a Surrealist: he tried to bring odd things together like Breton did: 'Magic and logic flowering on the same tree''. Somehow the two strains came together.' He recognized, moreover, a direct connection between Surrealism and iconographic studies, for instance in the 'Warburg-type' material published in the American Surrealist magazine View in the 1940s:

Iconological studies had caught my interest by the time I was eighteen or so in New York. I had read into Panofsky long before I heard of Wind. You see, it was the weirdness, the unfamiliar ring of so much of the 'art' they would use to illustrate their theses... If you were a young romantic like I was, having been drawn inexorably to modernist Surrealism and arcane Duchampism as a precocious teenager, these studies, with their fabulous visual models and sources in ancient engravings, broadsheets, emblem-books, incunabula, were like buried treasure! Like a latter-day Student of Prague, stumbling into an alchemist's library... akin to Breton and Kafka and Borges, all of whom, in those days, danced in my brain. So – one of the first turn-ons had been purely visual... appropriate, after all, for a painter...

But, of course, there were, for me, ideological discoveries in those obscure readings... It dawned on me that here were people who had spent their lives re-connecting pictures to the worlds from which they came.

The paintings that Kitaj began after transferring to the Royal College of Art in London in the autumn of 1959 were in many instances based directly on illustrated essays in the *Journals of the Warburg and Courtauld Institutes*. A paper by Rudolf Wittkower entitled 'Marvels of the East', concerning the monstrous races and animals invented by the Greeks as sublimations of instinctive fears, provided Kitaj with imagery for *Pariah* (1960), *Welcome Every Dread Delight* (1962) and *Isaac Babel Riding with Budyonny* (1962).⁷ Not only were the profuse illustrations that accompanied this article attractively bizarre, they also provided a meeting ground between iconology and Surrealism through psychology. In another Warburg Journal article Kitaj discovered the late medieval figure of Nobody, represented as a man with padlocked mouth, a symbol of Society's tendency to create a scapegoat on which to blame its ills.⁸ Kitaj seems to have been attracted to the idea of resurrecting an image which had finally died out after centuries of use and endless transmutations in popular illustrations, so it emerges as the protagonist of paintings such as *Yamhill* (1961) and *Notes towards a Definition of Nobody* (1961).

The figure of Nobody, his mouth forcibly shut as a sign of his inability to defend himself, was treated by Kitaj largely as a symbol of political rebellion, as was *Pariah*, in whose facial features one critic has detected reference to the 'exiles of visionary socialism' such as Herzen or Bakunin, who make their appearance in *The Red Banquet* (1960). Indeed the roots of Socialism and themes of political martyrdom are major preoccupations of the artist as early as *The Murder of Rosa Luxemburg* (1960), a painting about which he has recently written one of his most revealing essays. In retrospect, however, the twin themes of exile and of guilt borne for unknown deeds carry strong echoes of the equally mysterious fate endured by the protagonists of Kafka's novels, a connection that Kitaj agrees has some foundation, even though it may have been subconscious at the time. The painful sense of being cut off from communion with one's fellow men is one that re-emerged in the figures with hearing-aids who feature as protagonists in various paintings of the mid-seventies, though in both cases there is the suggestion that sight can heal the suffering caused by silence, that communication by visual means can go some way towards eliminating the barriers of speech.

In his work of the early sixties, in a way unparalleled in the art of his contemporaries, Kitaj made use of the written word. An anxiety that visual means alone could prove insufficient led him to append handwritten or printed material within the picture itself as a means of clarifying its theme, for instance in the collaged note on The Red Banquet, in the captions that accompany the images in Reflections on Violence, and in the handwritten 'bibliography' attached to the surface of Specimen Musings of a Democrat. Kitaj was particularly keen to connect his pictures with the literary material that supplied him with some of his ideas, drily noting in an essay published in 1964 that 'some books have pictures and some pictures have books'. 12 Many of these references were listed in footnotes in the catalogues of his first two one-man exhibitions in 1963-5, a practice that he discontinued for several years out of impatience with the frequent misinterpretations of his motives but that he has begun to take up again in a new way: witness the artist's texts published in the present volume. Citing as a precedent the elaboration of themes by means of footnotes in T.S. Eliot's The Waste Land, Kitaj likewise suggested to the viewer the possibility of delving deeper into the significance of the images he was using or of exploring ideas at a tangent to the central subject. 13 Kitaj explained in his 1964 essay that even after the paintings had left his studio they could be retitled or have further texts associated with them as a way to 'carry on his dialogue with his work' and to 'help to leave the question of "finishing" a painting open'. 14 These are practices that Kitai still favours, while continuing to express his doubts about their role in his work.

Picture-making as a form of communication is the implicit theme of *Erasmus Variations*, painted in Oxford in 1958 and regarded by Kitaj as one of his first substantial pictures. The imagery and format alike are adapted from a plate in a book on Desiderius Erasmus illustrating a sequence of doodles made by the philosopher in the margin of one of his manuscripts. ¹⁵ Some of the images, notably in the top left, are obscured by smudging, so that clarification is achieved only through comparison with the source. These scribbles of cartoon-like simplicity seem slight and of no great

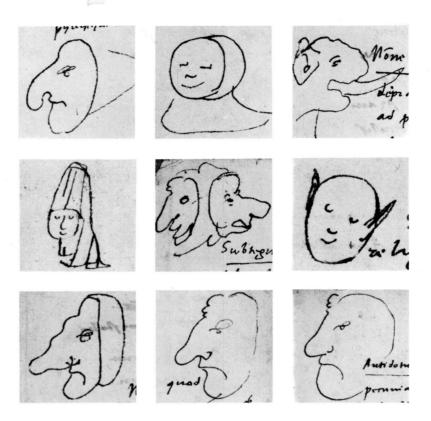

Fig. 2. Doodles by Erasmus in the margin of one of his manuscripts, from Erasmus of Rotterdam by J. Huizinga, Plate V.

formal interest, but once their identity is known they take on a talismanic quality as autographic examples revealing the workings of a great thinker's mind. We are thus presented with a historical prefiguration of the Surrealist method of automatic writing as the key to true thought 'in the absence of any control exercised by reason', as defined by Breton in the First Surrealist Manifesto of 1924. Kitaj was aware of the persistence of this interpretation of handwriting as an agent capable of revealing personality in the Abstract Expressionist concept of 'gesture', and makes the historical connection explicit by quoting the style and technique from De Kooning, style and image thus reinforcing each other in conveying the theme.

Kitaj extended this notion of images as a kind of visual writing by quoting American Indian pictographs in several paintings in 1960–2. The author of the 1893 Smithsonian Institution study from which Kitaj borrowed his material defined picture-writing as a form of notation which aims at 'expressing thoughts or noting facts which at first were confined to the portrayal of natural or artificial objects'. In *The Bells of Hell* (1960) Kitaj quotes literally from the illustrations in the Smithsonian report in order to produce a modern version of a historical narrative picture, one that deals with an actual event – the decimation of Custer's cavalry at the Battle of the Little Big Horn – both through the eyes of contemporary witnesses and from the perspective of an artist living a century later.

The references to pictographs tie up with Warburg's visit to the American Indians in 1895–6, described by Fritz Saxl as 'a journey to the archetypes', during which he formed his conclusions on the persistence of visual symbols in 'the social memory'. As a specific example Saxl cited the Indian representation of lightning in the form of a snake, an image that is found in Kitaj's *The Red Banquet* (1960) both in the rain-clouds and in the snake-like form of the pictograph-derived figure at the far right. The imagery of this painting, in fact, derives largely from illustrations to Saxl's *Lectures*, particularly from the discussion concerning the interrelationship of art and science as the meeting of two separate realms of facts, 'the world of rational experience and that of magic'. In Kitaj's painting there is a deliberate disjunction between the revolutionary mid-nineteenth-

century figures and the Modernist setting of a Le Corbusier villa in which they are contained, echoing Saxl's free range of references united by theme. Kitaj painted the setting from a photograph in Saxl, where it was paired with a painting by Salvador Dalí as a contrast between logic and irrationality, the two primary forces of human behaviour. The relationship of figures to setting, to which our attention is directed in the Kitaj painting, is also discussed by Saxl, who explains the development of perspective in the Renaissance as a method of imposing a mathematical construction of space on reality. Likewise Saxl states that the belief that 'nature is governed by rational conditions' directed the search for an abstract system of proportion to describe the human body, seen in extreme form in the geometric figure studies of the thirteenth century architect Villard d'Honnecourt; these are quoted by Kitaj in the diagrammatic skeleton near the centre of the picture.¹⁹

Kitaj's intention in quoting from such sources is not to impress or dazzle the viewer but rather to deal with a complex of themes in an economical but open-ended fashion: the urge towards a visual logic as part of a larger effort to express the harmony of the universe, the coining of symbols as a means of grasping difficult concepts, and the inconsistencies of human behaviour all come into play within the context of revolutionary activities, encompassing industrial and scientific evolution as well as aspirations which are fundamentally Romantic. The handwritten note attached to the lower-left provides a lead in identifying the subject, the figures, the architecture and the literary source on which the scene is based.²⁰

American Indian pictographs are referred to once more in Reflections on Violence (1962) in the two panels along the lower-right edge, this time with the source identified in a caption above the image. Other textual material, including a newspaper cutting headed 'When nuns may use birth control', is scattered across the surface, interspersed with images of varying legibility around a number of themes suggested by Sorel's book of the same title.21 The organization of the picture in a seemingly random scatter directs the eye not to any one image but to their interrelationships, a vivid instance of a compositional technique which Kitaj used to term 'plural energies'. The more clearly-defined grid structure of Specimen Musings of a Democrat (1961), although reminiscent of some of Robert Rauschenberg's paintings of the mid-fifties - themselves adaptations of Abstract Expressionism to a figurative context - was, in fact, based on an alphabet table devised by the thirteenth-century Catalan logician Ramón Lull, which Kitaj discovered in yet another article in the Warburg Journals. Just as Lull drew up a system in which 'ten questions are to be asked of the "subjects" with which the Art deals', Kitaj planned to show the modifications of selected image-types by six influences.22 Although he then added other image-types and changed the number of categories, the chart-like organization was maintained and many of the subject headings listed in the 'bibliography' (three rows across, four up) were later taken up in other paintings. Conventional compositional methods and illusionary space were dispensed with, since the painting could support itself on its own internal logic. Form and structure themselves thus became carriers of meaning.

Specimen Musings, both in its subject matter and in the source that triggered it off, represented a meeting-point for some of Kitaj's most passionate concerns: Socialist politics and anarchism; Catalonia, to which he was becoming increasingly attached; the Spanish Civil War and its implications for the American leftist milieu in which he was raised. 'Spain meant a lot to me', he recalls simply. 'It was the focus of a tremendous romance for me in its civil war against fascism (...). I had been raised in a milieu for which Spain was a place of destiny. (...) I was so very moved to be journeying through that defeated land.'

Kennst Du das Land?, painted in London in 1962, is referred to by Kitaj as his 'ikon for that sentimental journey'; the personal significance of the picture is indicated by the fact that he bought it back a few years ago to hang it in his home. The picture deals with the Spanish Civil War not simply as an isolated historical occurrence but as a more general indication of the tragic consequences of human frailty. The romantic views of foreigners towards other countries is

revealed with self-conscious irony in the borrowing of the title from Goethe, transposed by Kitaj from Italy to Spain.²³ Style and image, in turn, are quoted from Goya as a means of commenting on the disservice of certain Spaniards to their country and as a reminder of the continual undercurrent of political rebellion in Spain as exemplified by one of her greatest artists.²⁴ The Spanish Civil War theme is central to other paintings of the period, such as *Interior/Dan Chatterton's Town House*, painted in the summer of 1962 at San Felíu; the logic, as Kitaj recalls it now, was that 'Dan Chatterton was a legendary anarchist and Catalonia had been the hotbed of anarchism.' *Junta*, on which the artist himself expands in a separate essay in this book, deals more directly with Durruti and other Spanish anarchists; as far as the artist can remember, this picture, too, was begun in that summer at San Felíu.

In dealing with the recent past rather than with the present, Kitaj establishes a historical distance which allows him to idealize and romanticize his political impulses, just as he has done by identifying with compassionate socialism rather than Marxism, which has never interested him. 'Yes, I am a romantic', Kitaj admits. 'Romance provides some of my happiest times: sexual romance, the romance of picturemaking, the romance in books, the romance of big city streets and political-historical romance.' He rightly maintains, however, that the implications of the recent events on which he has touched are still with us today and that, moreover, a certain amount of historical distance can help to produce a more lasting statement. 'Tolstoy wrote maybe the greatest novel ever written about wars that were fought 30 years before he was born. Three-quarters of the greatest paintings ever painted may've been painted "about" quite ancient events (Crucifixions and all that) or about "rumoured" events or downright fantasy, like Titian's Marsyas we've just had in London, maybe my favorite easel painting ever.' As to his own political views, he maintains that he has 'always been more drawn to certain persons (people I know or people I read about) than to ideology', adding that in spite of a certain disenchantment he continues to believe that the promise of socialism is still with us.

Socialism was always another word for compassion in my life, but obviously freighted and complicated by all kinds of history. I hope always to be unreconstructed as to compassion but as to the performance of institutional Socialism in most of its guises (as well as institutional Religion et al), I remain at best unimpressed and at worst (Gulag) disgusted and fearful. The only good thing I can think of about our experience of Socialism is the often very brief *hope* it offers to very poor people and some of the reforms which persist (such as National Health and Social Security systems) long after many other hopes are either bashed against a bloody wall or just dissolve in a grey 'life' of mediocrity, slogans and gloom.

Kitaj's excursions into historic events, it is fair to say, thus betray his own personality and outlook rather than giving an objective picture of our era. He recognizes that in speaking for himself about matters to which he is passionately and intimately committed, he is more likely to be speaking also on behalf of others than if he set himself up to make grandiose abstract statements.

Kitaj early acknowledged that poetry and literature served as an essential backdrop to his work as a painter. He prefaced the catalogue to his first one-man exhibition in 1963 with a citation from Horace which succinctly defined his ambition – 'as in painting, so it is in poetry' – and remarked in an interview two years later that 'For me, books are what trees are for the landscape painter.' Although it could be said that poetry was a more significant source for Kitaj's art in the sixties than it has been in subsequent years, the artist himself is the first to point out that such hard-and-fast divisions make little sense in the case of a man whose 'book-craze' and 'false-scholarship' have led him to devour an enormous range of writing. Kitaj today explains that it is the great writers such as Baudelaire, Tolstoy, Dickens, Dostoyevsky and Kafka, as well as the transcendent painters, by whom he sets his ambition, but adds that 'It is because one is that ambitious (foolishly) that one pushes through smaller doors (Pound, Benjamin, Babel) where one detects an opening through to

a corridor, all one's own, down which, maybe, someday, a passage may lead to an ante-chamber to the main rooms in the Castle!'

It was, in fact, in a picture inspired by T.S. Eliot, *Tarot Variations* (1958), painted at Oxford at about the same time as *Erasmus Variations*, that Kitaj first glimpsed the possibilities for his own highly personal form of picture-making. Painted from Tarot cards, the real subject of the picture is rooted in *The Waste Land*, specifically in the first section, 'The Burial of the Dead', in which Tarot images are treated as archetypes of the past. The picture, however, is no more an illustration of the poem than was to be the case many years later with *If Not, Not* (1975–6), which took the same poem as one of its sources. Though Kitaj used to read deeply into both Eliot and Pound and has always acknowledged the profound ways in which they affected his thinking – for better and, as he himself has admitted, sometimes for worse, in the difficulties created by their private and arcane frames of reference – it is an influence which has permeated his work as a whole rather than one which can be pin-pointed in particular pictures. 'Pound's great advice was enough: that demarcation he spoke of between a symbol which in effect exhausts its references and a sign or mark of something which constantly renews its reference. Poems etc. act as signs in my experience, often not "understood".'²⁶

Just as Kitaj took political and historical themes as a means of expressing his own world view, so he felt free to make literary sources serve him rather than making himself a slave to particular texts. Both linear narrative and conventional logic were dispensed with, and Kitaj often brought in sources that were historically unrelated but which helped to elaborate his own theme or the mood that he sought to convey. Such was the case with $T\bar{e}d\bar{e}um$, based on a photograph of a New York stage production of Sartre's No Exit just after the War, but incorporating at the right an image of Goethe as a giant figure.²⁷ 'The Goethe figure in $T\bar{e}d\bar{e}um$ ', Kitaj explains, 'adds a Romantic image of transcendental stasis (someone seen from the back, in a room, gazing out the window) to a picture "about" tedium, discontent ... ennui ... The lovely Sickert by that name was on my mind in those days also.'

It would be fruitless, too, to seek in *Isaac Babel Riding with Budyonny* a direct parallel to the *Red Cavalry* stories. The painting has only the most general connection with the stories in its sense of violence and chaotic movement and in its military and equestrian imagery; it relates more closely to Babel himself and to the Revolutionary circumstances from which he drew his inspiration, and in that sense qualifies more as a portrait or as an icon of Kitaj's own standpoint as a young leftist and a Jew than as an illustration of a literary text.²⁸

The imagery of Kitaj's early paintings is of such seductive complexity and mysterious force that it can easily dominate one's attention, as it has mine in these pages. It is in the imagery, moreover, that the greatest problems of decoding lie, thus necessitating what might appear to be an undue amount of explication at the expense of the formal and technical procedures by which the paintings were made. The ways that Kitaj devised for applying paint in his early work are as varied as the sources of his imagery: brushed on impulsively over bare canvas, applied thinly as a glaze of colour, worked up to a physical density with the addition of collage elements, or treated as a concise form of line drawing, the latter being of particular use in translating an image from a ready-made source. Techniques borrowed from Abstract Expressionism, Surrealism, the example of Robert Rauschenberg29 and of Francis Bacon all come into play, but with such a high degree of self-consciousness that it would be misleading to speak here of 'influence'. Kitaj, in effect, was quoting technique as well as style - jumping suddenly from one idiom to another, each often possessed of its own historical associations - in largely the same spirit in which he borrowed much of his imagery: as a means of appropriating whatever he found of interest, of extending his range and of declaring the possibility of speaking in whatever voice was most suited to the things he wished to communicate on any particular occasion.

Kitaj has periodically expressed regret, particularly in recent years, about the impenetrability of much of his work, but he is unrepentant about the ambiguities and mysteries that will linger in his

paintings no matter how often they are 'explained' by him or by others. Mystery is a quality that he cherishes in the art of the past as well as a characteristic of much twentieth-century art, literature and music, which often presupposes on the part of the audience a prior knowledge of the artist's terms of reference. Kitaj cites in his support the writings of William Empson:

I used to dip into his wonderful books and poems from my Oxford days. His Seven Types of Ambiguity had an influence on me. One of his types allows for the poet (artist) to find his intention in the course of writing (read – painting), to discover his idea after he's begun. This is very important for my own work. Why should I not discover intentions, ideas, meanings long after, it occurred to me...

Kitaj holds, as ever, to Empson's view that 'The machinations of ambiguity are among the very roots of poetry.'30

III AN AMERICAN IN ENGLAND

When Kitaj began his studies at the Ruskin School in Oxford at the beginning of 1958, he was excited by the prospect of living in England and conscious of the history of Americans who had preceded him there or to Europe generally: Henry James, Gertrude Stein, Pound, Eliot, Hemingway, Whistler, John Singer Sargent among others. He could have had little idea, however, that the country was to become his permanent home, for if he had not been accepted at London's Royal College of Art in the autumn of 1959 he might well have returned to the United States at that time. In the event, the sense of estrangement, of being an outsider caught between two cultures, has given him the sharp perspective as well as the bitter-sweet sense of loss which runs through all his work.

My sense of national belonging (...) is both confused and not confused. I feel very 'American' ... always will ... The American language and culture and one's childhood secures that belonging and it is sustained by deep American friendships and interests and always renewed contact with America; nothing much in American life escapes my notice one way or another.

I seem to belong, now, to England and to London after all these years ... but I can say without hesitation that I don't fit in here and never will in any comfortable way. I've noticed that some exiles do become very English and Some Do Not. I won't name names. The Jewish Thing is also so complex ... it will have tempered much for me ... the life, the art, the American times, the English passage Even those periods in my youth when I didn't feel like a Jew, of course.

Kitaj's introduction to British life happily met his expectations. He was pleased by Oxford and by the quiet school's academic insistence on life drawing as part of the daily routine. A group of about a dozen drawings from this period, and a similar number of small life paintings done as part of the course, are still in the artist's hands. The best of them, such as the pencil drawing of Miss Ivy Cavendish (1958), are characterized by marks that look bold, almost reckless, but which were in fact the product of an intense and prolonged period of scrutiny of four or five hours a day for two or three days. Kitaj now bitterly regrets that he did not continue the practice of drawing on a regular basis during the decade following his departure from the Royal College in the summer of 1961, but regards his time at the Ruskin, along with his previous training in New York and Vienna, as essential background to the work he is doing today, with its strong emphasis on drawing.

In the autumn of 1959 Kitaj moved to London to begin a post-graduate course at the Royal

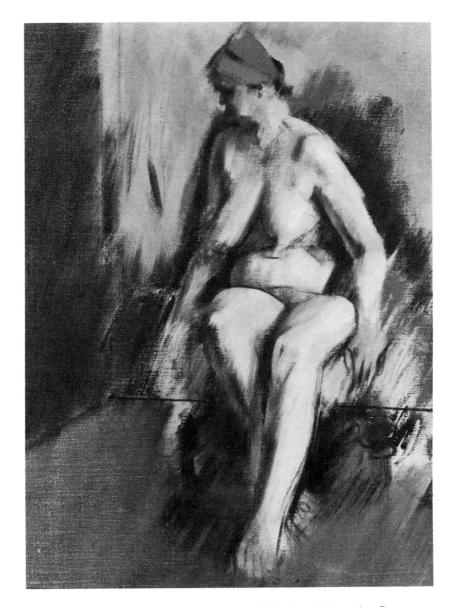

Fig. 3. Ivy Cavendish, c. 1958. Oil on canvas. Collection of the artist. Cat. no. 5.

College, where he met and befriended another student in his year, David Hockney, who was to become a lifelong and intimate associate. His influence on Hockney and on other students at the College such as Derek Boshier, Patrick Caulfield, Allen Jones and Peter Phillips, all of whom were to make a considerable impact as Pop Artists on leaving the College in 1962, is a subject in itself but one which would take us beyond the realm of the present discussion.³¹ Kitaj, apart from the unwanted confusion of being identified with a movement for which he had little sympathy, was hardly changed by the Royal College experience, in part because he was in his late twenties by the time he arrived there, already well-entrenched in his own forms of picture-making, and in part because his presence at the College under the terms of the G.I. Bill allowed him to go his own way rather than follow the prescribed course. The students in Kitaj's year were fiercely independent; in fact it was Kitaj himself to whom some of the liveliest of them looked for guidance. What seems to have been more important for Kitaj was the opportunity he now had to live in London.

I liked Oxford very much but I was happy I got a place at the Royal College and I was anxious to live in a great city again and to learn London, a dream of my youth. I couldn't have

thought beyond the College ... I'm really a big-city boy through and through and I would always seek what Flaubert called its 'bitter undertaste'. When that's lacking, I miss it and look for it.

As a student, Kitaj lived with his wife and new-born son on Pickwick Road in Dulwich Village, a suburb of South London, later moving around the corner to a bigger house near the Dulwich College Picture Gallery, on Burbage Road, where they remained until 1967. During this period, Kitaj taught briefly during 1961–3 at Ealing Technical College and at Camberwell School of Art and Crafts, where he gave a life drawing class in the department headed by Robert Medley, and from 1963 until 1967 he did occasional day visits at the Slade School of Fine Art on the invitation of William Coldstream. It was largely a time of consolidation for Kitaj – giving himself to his paintings, on which he has always worked slowly – and of family life, with the adoption of a daughter of Indian extraction, Dominie Lee, in 1964. Summers, from 1962 onwards, were generally spent in San Felíu, the Catalonian town which Kitaj first visited with his wife nine years earlier and in which he was to buy a house in 1972.³²

In February 1963 came Kitaj's first one-man exhibition at Marlborough Fine Art in London. The headline with which *The Times* preceded their glowing review – 'An Eagerly Awaited First Exhibition'³³ – was indicative of the immediate success which greeted the thirty-year old painter, a success marked, too, by the purchase of *Isaac Babel Riding with Budyonny* by the Tate Gallery. The praise and encouragement, Kitaj agrees, helped drive him on to produce work of ever-growing ambition and scope.

IV THE AGE OF MECHANICAL REPRODUCTION

A new grandeur of conception, boldness of idiom and clarity of image characterize the paintings that Kitaj began to produce in 1964. Still relying on his intuition, the artist continued to explore the themes which had interested him - poetry, history, politics, heroes and villains - replacing, however, the tentative nature of his earlier statements with a far more transparent sense of purpose. The sense of painted collage and of intentionally jarring juxtapositions of image and style remain, for instance, a vital ingredient of paintings such as Erie Shore and Walter Lippmann, both of 1966, but the images are now phrased in a much harder language and pieced together with a graphic precision as part of an overall surface design. The Surrealist element, moreover, attains a subtlety and eloquence beyond that of the previous pictures, the unexpected unfolding gradually as in the case of Where the Railroad Leaves the Sea: the composition at first sight appears virtually symmetrical, but on closer inspection all manner of inconsistencies begin to emerge, culminating in the almost shocking recognition that the arm of the man draped around his lover is not visually attached to his own body. One person is literally depicted 'giving himself' to another, a poignant image of the loss of self by which we recognize love. The figures that in Kitaj's previous paintings had tended to be mere ciphers – even when treated on a fairly large scale, as in Nietzsche's Moustache (1962) - take on a more convincing corporeal reality, still expressed in largely graphic terms, allowing Kitaj to effect distortions of human anatomy as expressive in their own way as were those of Ingres more than a century earlier.

Kitaj's pictures continued then, as they do now, to have 'secret lives'. Without being told, for instance, one would have no means of knowing that Where the Railroad Leaves the Sea took as its setting the end of the line at San Felíu of a now defunct railroad from Gerona. This private significance, however, enriches the meaning of the image rather than interfering with it. Evidence,

2 I

moreover, now begins to be incorporated within the paintings themselves of the elements that are the cause of their enigmatic and often disturbing air, as in *Apotheosis of Groundlessness* (1964), an apparently straightforward architectural image which achieves its sense of shifting weightlessness through the simple device of multiple viewpoints. It would be inaccurate to maintain that Kitaj's work in the mid-sixties suddenly became easily comprehensible; the subject matter of the more complex pictures needs to be teased out as much as before, and many of the works require at least a title or further clue for their meaning to be unravelled. What is true, however, it that Kitaj was now sufficiently at ease to be able to vary the tone and nature of his work by shifting from visual and conceptual complexity to a much more direct and down to earth approach. He has spoken of his desire to be like a 'switch hitter' in terms of painting, an apt metaphor for an artist who in 1967 was to paint a delightfully direct series of pictures on a subject always dear to his heart: baseball. The tone of these pictures, which declare his lifelong love of a popular sport, is an appropriately humble and unpretentious one.

A tiny canvas of 1965 called *The Rival Poet* provides a vivid instance of the balance between the straightforward and the difficult, which continued to mark Kitaj's work. Like two other canvases of that year, *They Went* and *Alone*, it is but a section of a much larger work, *Primer of Motives II (Intuitions of Irregularity)*, which Kitaj had painted in New York and then destroyed, keeping only these three pieces. Kitaj says of it:

I have no memory of what the original picture meant, although the title would suggest a compendium. It is, on the one hand, the compendious nature of certain modern poets and writers which has interested me: Joyce, Pound, Eliot, Mann, Benjamin, Ashbery, Duncan, et al... those who try to get the whole world in, and, on the other hand, I love the more intimate, confessional ones like Creeley, Lowell, Emily Dickinson, et al... whose world-view is more in their own mirror. The picture would seem to have been an anthology of irregular, intuitive (freely associated, that is) parts ... the motivating principle being, I would guess, that of collage as a free-verse game to play in art.

Kitaj's decision to give a new identity to his *Rival Poet* by removing the image from its original context brings to mind two of the artist's constant practices over the years: that of recycling images, including figures, from one picture to another – their identity shifting according to context – and that of reproducing in his catalogues details from the pictures in such a way as to suggest that, removed from their customary context, they have the potential of another life. The faces and figures thus treated strike a familiar chord, but it is a haunting and surprising form of familiarity; one senses them not merely as segments of a larger whole but also as different views or reconstructions of a single character, altered in memory. These practices, which have allowed Kitaj's characters to adopt, or at least to feign, another life, were to have great bearing on Kitaj's plans in the mid-seventies to create a stock of characters equivalent in visual terms to those found in works of fiction.³⁴

The separate strands of poetry to which Kitaj refers – the 'confessional' and the 'compendious' – were paid tribute in two canvases produced in 1964. One of these, An Urban Old Man, Who Never Looked at the Sea, Except Perhaps Once, is an imaginary portrait of Constantin Cavafy in Alexandria; the title of the picture was a description of the poet that the artist had read, though he no longer recalls the source. Years later Kitaj was to paint another reverie about Cavafy, Smyrna Greek (Nikos) (1976–7). Kitaj's interest is as much in the man as in his poetry; or to be more accurate, he has chosen to portray the poet and his work in terms of his melancholic personality and of the circumstances of his life. The confessional aspect of Cavafy's poetry is alluring to Kitaj and pertinent to his own work, particularly in the suggestion that the most intimate, even sordid, experiences, can be retrieved morally through their transformation into art. It is a theme on which Cavafy touched in many of his poems, such as 'Their Beginning', in which, having described the feelings of guilt occasioned by a furtive sexual encounter, he concludes:

But for the artist how his life has gained. Tomorrow, the next day or years after will be written The lines of strength that here had their beginning.³⁵

The second portrait of 1964, Aureolin, which emerged also as a screenprint called Yaller Bird in the same year, after a line in a translation by Ezra Pound, is of the American poet Jonathan Williams, whom Kitaj had met in 1962 or 1963 at a poetry-reading in a pub in Dulwich Village. Williams, who to this day continues to divide his time between North Carolina and Dentdale, Cumbria, is also a major publisher of contemporary poetry through his Jargon Press. 'I was hooked on Pound, Eliot and their crowd when I met Jonathan Williams,' recalls Kitaj, 'but it was he who led me to post-Pound American poetry and particularly to Olson, Creeley and Duncan (all of whom he'd published when they were unknown).' Kitaj was later to pay homage to this younger generation of poets, some of whom, like Creeley, Duncan and Ashbery, were to become close friends, in a series of screenprints produced from 1966 until 1969, now known collectively as Some Poets.³⁶ In the meantime a group of poems by Williams, which he was to publish in 1966 as Mahler, started Kitaj off on another series of screenprints, Mahler Becomes Politics, Beisbol, which he began in 1964 and completed in 1967.³⁷

As important as poetry may have been to Kitaj during the sixties, it was by no means his only or even his most important source. Ready-made visual material continued to exercise his imagination. The paintings of historical subjects, such as *The Murder of Rosa Luxemburg* and *Kennst Du das Land?*, were often charged with the sense of actuality which one associates with documentary photographs printed in newspapers and magazines; the association, deliberately played on, lends credence to the scenes as accounts of real events. By 1962, in *Good News for Incunabulists*, Kitaj was to base an entire composition on a photograph by Edward Steichen of a stage production of *The Front Page*.³⁸

Given Kitaj's immersion in photographic material and reproductions of all kinds, as well as his introduction in 1963 to screenprinting – as a way of recycling ready-made images by means of photo-mechanical reproduction, in editions which made his work more generally available – he was well-prepared to absorb the writings of Walter Benjamin, which he came across in the midsixties. Benjamin, of whom Kitaj produced an intimate and introspective lithographic portrait in 1966, became an exemplar at once, recalls the artist, 'because of the impossible-to-categorize quality of his creative, highly fragmented texts'. Although it was not until the early seventies that Kitaj began work on two major paintings about this German Jewish writer, the views expressed by Benjamin in essays such as 'The Work of Art in the Age of Mechanical Reproduction' (1936) had a more immediate bearing on the paintings that Kitaj was already producing. What better example than Kitaj's own work could there be for Benjamin's thesis that the position of the artist had been irreparably changed by the introduction of mechanical reproduction, which, in making possible the wide dissemination of images, threatened the sovereignty of the unique work of art just as the cinema was seducing the public away from painting?³⁹

'Movies, and particularly frame-enlargements, have been in my work what engravings and such were for artists in the distant past, what printed illustrations were for painters like Manet and Van Gogh, what photographs were for Degas and Cézanne and later for Sickert and Bacon . . . no more and no less.' Kitaj is quick to admit that he envies the scope of the cinema and its sense of modern life, but he stresses that this is only one force among many in his work and that there is a distinction between those films that have acted upon him generally and the isolated cases in which he has based an image on a film still.

The film references in Kitaj's paintings of the mid-sixties onwards can be as tentative as the appropriation of a title, as in *Shanghai Gestures* (1968), or they can go so far as to inform the very format and composition of a major work such as *Walter Lippmann* (1966).⁴⁰ The latter includes what could be construed as episodes of a ruptured narrative: the man holding a drink, Kitaj later

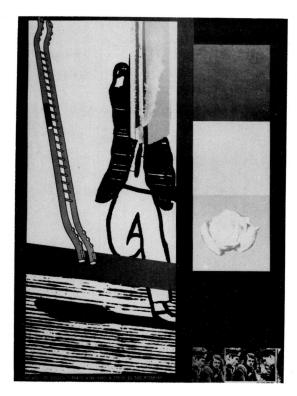

Fig. 4. Go and Get Killed Comrade – We Need a Byron in the Movement, 1966, from Mahler Becomes Politics, Beisbol.

Screenprint, 32 × 21⁷8 in.(81.3 × 55.6 cm.).

recalled, had as one of its sources the actor Robert Donat; the confrontation in the background between a pretty girl under lamplight and a trench-coated man in shadow, a paraphrase of an archetypal romantic scene from Hollywood films, was to reappear as a separate subject in subsequent pictures such as *Little Romance I* (1969) and *Femme du Peuple II* (1975).⁴¹ A cinematic sense likewise informs more modest pictures of this period, such as *Screenplay* (1967), the punning title of which defined painting as a realization of a concept that could be regarded as its text and also as a screen on which an image is projected, with a further pun arising from the openwork 'Moorish/Matissean' screens which inspired the framing device. The central landscape image was derived from a photograph by Bill Brandt of Top Withens, the windswept site in Yorkshire traditionally identified as Emily Brontë's Wuthering Heights.⁴²

As if consciously resisting the threat of depersonalization that is implicit in the use of found material and images produced by machine, Kitaj during this period developed a highly personal facture and graphic style. Abrupt changes of pace remain an essential device, but the inventory-like assemblage of images of the early sixties paintings increasingly gives way to a more homogeneous and illusionistic space. There is a new generosity of scale even in the small canvases, which allows for easier legibility of the image, an urge to make contact with the spectator further aided by the strong descriptive contours, surfaces paradoxically dry and restrained but seductively tactile, and juxtapositions of hot and acid colours as surprising and compelling as the conjunctions of images.

In spite of Kitaj's harsh self-indictment, it could truthfully be said that he never stopped drawing during the sixties. On the one hand he produced several groups of tiny canvases, which, though executed in oil, he himself regarded as drawings: works such as *In the Social Memory* (1964) and *His Cult of the Fragment* (1964); the baseball pictures of 1967 and portraits of friends such as Hockney, Francis Bacon and a group of contemporary poets; plus the occasional photographically derived portraits of historical figures such as *Unity Mitford* (1968) and *La Pasionaria* (1969). The paintings

themselves made independent drawings largely superfluous because, with few exceptions, they were essentially graphic in nature, their structure built up through drawing in quite a traditional manner. Kitaj explained in an interview with Maurice Tuchman published in 1965 that he rarely worked from drawings in building up a painting and that the composition as a whole was rarely clear in his mind to begin with.⁴³

Just as Kitaj's technical control was reaching a new level of assurance, so his grasp of the subjects that most concerned him achieved during this period a far greater sense of purpose. This is not to say, however, that the meaning was necessarily any more self-evident. A Disciple of Bernstein and Kautsky, for instance, takes as its title a phrase that the Chinese used to describe Khrushchev, but this is used not to 'explain' the image of the aviator - mysterious enough in itself - but to add to it another level of enigma. The relationship of image to title here, Kitaj recalls, was like that of AnAndalusian Dog to the film made in 1928 by Luís Buñuel and Salvador Dalí; the Surrealist romance was still very much to the fore. Yet the impulse to ambiguity for its own sake was beginning to fade, making way for the directness of the baseball pictures and of the small portrait studies. Private meanings linger still in a painting such as Little Slum Picture (1968) – which incorporates references to Barcelona's red light district, the 'Barrio Chino', where Kitaj had been looking for a flat - but the scene itself is sufficiently familiar for the viewer to be able to relate it to his or her own experience without knowledge of this biographical context. Synchromy with F.B. - General of Hot Desire (1968-9) similarly contains certain conjunctions of image, the meanings of which are not readily apparent, but these serve to embellish what in the first instance is a clear statement of homage to a painter Kitaj has long admired, Francis Bacon. One needs only the most basic familiarity with Bacon's work and its homosexual eroticism to appreciate the mischievous inclusion of a disturbingly disjointed and overtly sexual female nude. What continues to come over most powerfully is the massive presence of the figures themselves, nearly life-size and enveloped in an environment of luscious colour.

Kitaj's treatment of political themes in paintings such as The Ohio Gang and Dismantling the Red Tent, both produced in 1964, remains allusive in terms of imagery but is more powerful than ever in evoking the mood of the time. Criminality, thuggery, games of power and control, corruption and moral degeneracy have been all too current in our century; it hardly matters whether one reads into The Ohio Gang references to low-life gangsterism or treats it as a metaphor of Fascism, for in either case it captures a general malaise of our time. Even in dealing more openly with contemporary events – as is the case with Dismantling the Red Tent, an allusion to the assassination of President Kennedy in 1963, or Juan de la Cruz, a bitter icon of the Vietnam War – Kitaj's concern is to go beyond documenting a historical situation in order to contemplate its wider significance as a manifestation of human weakness, wickedness and failure. As if to make the general application abundantly clear, Kitaj brings in deliberately anachronistic elements such as the late nineteenthcentury etching by Alphonse Legros that is collaged onto the surface of the Red Tent as a complement to the main scene, or the scene of rape and piracy on high seas that occurs in the background of Juan de la Cruz. Here the disruption of both style and tone has a similar function in the depiction of the rapist as a cartoon figure, disturbingly at odds with the violent situation itself.

Erie Shore (1966), inspired by a newspaper account of the death by pollution of Lake Erie, incorporates what the artist terms 'psycho-dramatic links to a dream of Ohio boyhood', literally depicted at the far right of the canvas, within the context of 'a kind of allegorical, hardly explainable apocalypse'. The derivation of certain images from pre-existent sources – the falling figures at the extreme left, for example, are taken from an engraving by Gustave Doré – hardly seems to matter here, so overwhelming is the anxiety and sense of loss that the picture as a whole conveys. Difficult and puzzling as this and other pictures of the mid-sixties remain, one could ask for no better evidence of the strides that Kitaj was making to convey to his audience a coherent and compelling world view.

V UNSETTLED YEARS

Life was never quite the same for Kitaj after his first solo exhibition. Welcome as it may have been to be the object of critical enthusiasm and commercial success, the pressures to become a public figure and to concentrate on the work at hand in the studio, knowing that there was a waiting list for pictures not yet completed, were rather more difficult to bear. Kitaj in 1964 found himself for the first, but by no means the last, time in the role of polemicist, delivering slide lectures in Cambridge, Oxford and London, and invitations to take part in group exhibitions began to multiply.⁴⁴

In February 1965 Kitaj had his second one-man show, this time at Marlborough-Gerson Gallery in New York. The reception was more mixed than in London, but Alfred H. Barr Jr. purchased *The Ohio Gang* for the Museum of Modern Art, New York, and later in the year Maurice Tuchman was curator of Kitaj's first museum show for the Los Angeles County Museum of Art. In the autumn of 1967 Kitaj accepted a Visiting Professorship at Berkeley, California. 'Apart from my saddening marriage, it was a memorable year of baseball and American poetry and the three terrific Bay Cities and I fell in love with all the kids I taught and my "art" got subsumed in all that, which may not have been such a bad pause after all.' Kitaj saw much of Hockney, who had just moved back to Los Angeles after a spell of teaching at Berkeley; he also befriended the poet Robert Duncan and his companion, the painter Jess Collins, and visited Creeley in New Mexico.

Kitaj returned to England only to experience the death of his wife in 1969, a traumatic event about which he is still loath to speak. With his children he returned to North America, staying in Los Angeles until 1971.

I'd accepted another professorship at UCLA for the school year. We took a house right in old Hollywood, overlooking the Sunset Strip, and lived a crazy year during which I began to devote myself to raising the children. I only had two morning classes and I tried to work in a studio they gave me but I couldn't work well. The children were my real life. Lem and I visited some of the great old directors like John Ford and Renoir, Mamoulian, Milestone and Billy Wilder. I sketched them for a painting I never made about Hollywood, but I really did those visits for Lem. It was a year jampacked with friends, for which I was grateful. Lee

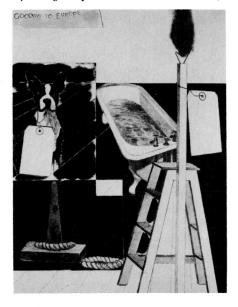

Fig. 5. Goodbye to Europe, 1969. Oil on canvas. Private collection. Cat. no. 123.

26

Friedlander was teaching there that year and we've been very close ever since. I admire him greatly and lose myself in the poetry of photography whenever I'm with him. For the Art and Technology show, I did a lithograph at Gemini, where I met a beautiful young woman, Sandra Fisher, working there as Ken Tyler's assistant. We were both otherwise involved at the time, but she was destined to change my life.

In 1970 a retrospective exhibition of Kitaj's paintings was organized by the Kestner Gesellschaft, Hannover, which was then toured to the Boymans-van Beuningen Museum in Rotterdam; a selection from this exhibition was subsequently shown at Marlborough Fine Art in London. Kitaj does not remember how he felt about this opportunity to reassess his past production. As so often happens with such projects, however, the mental and physical energies expended in looking over previous work, combined in Kitaj's case with the upheavals in his private life, seem not to have spurred him to work with renewed vigour but rather to have created a temporary sense of confusion about his future direction. It should come as no surprise that it was precisely during the period 1969–71 that Kitaj 'committed my most extreme acts of ordinary modernity' – two series of screenprints, *In Our Time* (1969) and *A Day Book* (1971), and the objects produced in relation to the Art and Technology project organized in 1969 by the Los Angeles County Museum of Art – and that it was the least productive period in his life as far as painting was concerned. Life and work alike, however, would soon be looking up again.

VI IN OUR TIME

In Our Time (1969), subtitled 'Covers for a small library after the life for the most part', was the main project on which Kitaj occupied himself in the year of his wife's death. Taken as a whole, the set is a vivid record of the artist's preoccupations and as such is also a useful key to his paintings and drawings. Though he remains fonder of some of the prints in this series than of many of the collage-based screenprints that he produced earlier in the decade, he admits that they constitute his most blatant excursions into 'Duchampism' and that he has reservations about them, too. 'They're like first drafts', he says now. 'I'm not really reconciled to them. I'd like to destroy 2/5ths of them and eventually I will do that to proofs in my possession.'

Much of Kitaj's time during the unsettled period of the late sixties and early seventies was spent on printmaking projects. Most of these, like the portfolio A Day Book (1971), on which Kitaj collaborated with the poet Robert Creeley, were in the form of screenprints made with the assistance of Chris Prater, 'surely the world's greatest screenprinter'.⁴⁶ Prater acted both as a technician, translating the artist's ideas into printed form, and as a collaborator with a creative as well as a practical role.⁴⁷ Kitaj's substantial body of graphic work, though much admired, is regarded by the artist himself as an area of only peripheral interest in the context of his work as a whole.

When Kitaj's confidence as a painter returned in 1972, it was thanks in some measure to his friendship with the young American painter Sandra Fisher, whom he had met again in London in the previous year. He turned for guidance to his own large figure paintings of 1967–8, such as *Juan de la Cruz* and *Synchromy with F.B.*, seeking through expansiveness of scale and lusciousness of colour to support the powerful human presences conjured by line. The first completed canvases, a series of full-length figures of *Superman*, *Batman* and *Bill at Sunset*, reveal a chastened sensibility, one bent not just on the study of heroic failures, as had been the case from the early sixties, or on the elevation of popular figures to a nobility of status, as in the baseball portraits of 1967, but dwelling

on pretence and on false roles. Kitaj put much of himself into these paintings, so that what appears to be light-hearted, even flippant, on the surface – sweet colour and references to comic strips – only half-conceals an underlying tone of bitterness and despair.

Superman (1973) appears in a half-way state between 'mild-mannered Clark Kent' and his powerful alter-ego, but what comes across of the figure is his intense vulnerability. It was based on a drawing of the comic book hero by a psychotic child. The rather sinister-looking Batman (1973) bears an even more tenuous relation to its comic book source, as it was derived instead from a portrait of Beethoven taking a walk; he appears to be hiding his identity behind a mask not for the greater good of humanity but for the sheer malicious pleasure of deceit. These single figure studies, encased in compositions of a simplicity heretofore unknown in Kitaj's work, remain mysterious and enigmatic. Perhaps because they themselves seem to be lost in their thoughts, they lead us in turn to ponder their identities, their frames of mind and their future actions.

It was in this group of single figure paintings that Kitaj began to formulate a plan that was to have major repercussions on his subsequent work: that of devising characters as a novelist would, suggesting that their fictional lives might continue beyond the confines of the canvas or the page.⁴⁸ In an interview published four years later, Kitaj remarked: 'I like the idea that it might be possible to invent a figure, a character, in a picture the way novelists have been able to do – a memorable character like the people you remember out of Dickens, Dostoyevsky, Tolstoy.'⁴⁹ The challenge is one which continues to preoccupy him. 'If the pictured character were to last and stick in people's minds', he adds today, 'it would be a *visual* triumph, an achievement of the terms of painting.'

Superman and Batman were rather anomalous figures for Kitaj to tackle, but he was soon to begin populating his pictures with characters of his own invention. The first of these was Bill, derived from a movie still which Kitaj can no longer locate: an image, assumed by the artist to be the self-portrait of a tramp, crudely drawn on the side of an American railroad boxcar. The attraction of the image may subconsciously be linked to Kitaj's reveries about the drifter father he never knew, but it also has connotations of an imaginary self-portrait set in the future: 'I often imagine I may end up as a tramp myself or more likely as a refugee.' First pictured in Bill at Sunset (1973), the character reappears in the background of another painting of the same year, Kenneth Anger and Michael Powell.

Kitaj cites as a visual precedent for the scheme of character inventions, which he instigated in the seventies, the work of Honoré Daumier, and, in particular, individuals such as Ratapoil and Macaire, who recur in Daumier's pictures and sculpture as police spies and agitators.⁵⁰

Discovering these characters, invented not by a novelist but by a painter/sculptor/draftsman was another of those happy shocks of recognition because the very idea had been haunting me for years (...). I've known Ratapoil all my life but never knew his details, the sense of him, until maybe the early seventies. In any case, I'm happy to credit Daumier with a major kick in the ass.

Also in the back of Kitaj's mind must have been the example of Manet, whose prints he had begun to collect by this time and whose paintings of the early 1860s likewise played with the idea of a stock of characters that reappeared from one picture to another. The reaction of Manet's contemporaries to such transpositions in his work, recounted by George Heard Hamilton, bears a curious resemblance to the accusations that have been directed at Kitaj:

What made his paintings seem so strange and peculiar to his contemporaries was the grotesque character of contemporary scenes arranged in imitation of the grand manner. The compositions of Velázquez and Goya, of Titian, Tintoretto, and Raphael, had been contemporary in their day and had arisen logically out of situations within their own experience. An air of masquerade or worse was the inevitable result when men and women of the 1860s posed in attitudes originally determined by other customs and costumes. Here are to be found the reasons for their hesitation, felt even by those who were inclined to admire

Manet.... It accounts for Baudelaire's remark that Manet had been 'touched by romanticism from birth'. They were bewildered by his failure to create an art wholly of his own time.⁵¹

Kitaj's imaginative compositions of the period such as *The Man of the Woods and the Cat of the Mountains* (1973) and *Pacific Coast Highway* (Across the Pacific) (1973), though dreamlike in atmosphere and heavy with a sense of allegory, have a weight and conviction equivalent to that of scenes of real people, thanks to a large degree to the sheer physical presence and emphatic sense of personality with which the figure inventions were now endowed. The representations of actual people, in turn, may include elements of fantasy, as in the intrusion of Kitaj's invented alter-ego Bill into the double portrait of film directors *Kenneth Anger and Michael Powell* (1973).⁵² Scenes from life straightforwardly depicted may, moreover, have an underlying symbolic intention. This is the case with *To Live in Peace* (*The Singers*) (1973–4), a representation of an Easter feast celebrated by a group of the artist's close friends in Catalonia at the time that Franco was still in power: an image of tranquillity and an emblem of the quiet rebellion possible even in the shadow of Fascism.

The complex text that Kitaj assembled for his major painting of this period, The Autumn of Central Paris (After Walter Benjamin) (1972-3), when it was shown in London in 1977, provides manifest evidence of his continuing devotion to the 'picture puzzle'. 53 Set in a Parisian café in the autumn of 1940, a time that witnessed not only Benjamin's suicide but the fall of France to the Nazis, this canvas represents a meeting point for the many strands of Kitaj's interests for which Benjamin has been the most eloquent exemplar. The figures act as signs representing different segments of society. The man with the pickaxe, for example, who is painted red and who reappears in *Pacific* Coast Highway, still trampled underfoot, stands for the labourer obediently going about his work. The man with the hearing-aid, identified in Kitaj's text as 'the police spy/secret agent', could be taken as an image of the artist himself - he was advised to wear a hearing-aid in the late sixties and has been doing so since the mid-seventies – in the guise of an intruder who listens in on the lives of others. Such a role was, indeed, taken on by figures in later paintings such as If Not, Not (1975-6) the witness in the lower left is not, as is often assumed, T.S. Eliot – and The Jew Etc. (1976–9). The subject of the 'café as open-air interior', which Kitaj appropriated from Benjamin, itself has strong associations and precedents in the history of painting, particularly in the work of Manet, Degas and the Impressionists, highly appropriate for this Parisian scene. Even the format of the picture carries meaning, as the artist himself is the first to point out, in its associations with film posters, with collage and with Benjamin's notion of the 'barricade'.

The Autumn of Central Paris and the accompanying Arcades (After Walter Benjamin) (1972–4) summarize and give form to many aspects of Benjamin's thought with which Kitaj has felt the greatest affinity. Most evident are the parallels with the essayist's obsession with fragments and with quotation; with his probing of the Baudelairean spirit; with his ambivalent role as an assimilated Jew; with his views on the isolation and loss of self of the city-dweller; and with the image of the city's streets as the corridors inside a house, at once anonymous and intimate.⁵⁴ The derivation of certain images, though, remains tangential and idiosyncratic.⁵⁵ Kitaj says simply that he finds whatever he needs for his pictures, whatever seems relevant to his concept or to his formal terms, and he cites in his support a comment ascribed to Picasso: 'If I don't have red, I use blue.'

Though the sources may remain abstruse, Kitaj's ability to transcend them so that what matters in the end is not the derivation of a picture, but its physical presence and its emotional and intellectual dimensions, is nowhere more evident than in *The Man of the Woods and the Cat of the Mountains*. The sources of this picture are many and include a portrait of the novelist George Sand – which perversely, perhaps, served as the model for the man's face – and a still from an early Soviet film, Ermler's *Fragment of an Empire*; the scene as a whole was based on an early nineteenth-century satirical engraving attributed to Thomas Lane.⁵⁶ Having used these sources to start him off, however, Kitaj develops in his painting a narrative and theme of his own. A dusky atmosphere fills the room, but outside things seem to be coming to life, suggesting a glimmer of hope. The

29

gentle gaze that the man of the woods directs to the cat of the mountains, and the poignant manner with which he clutches her hand, suggests that a more benevolent future may lie in companionship. It is not, perhaps, far-fetched to interpret the image as a private gesture of the artist's romantic attachment and commitment to Sandra Fisher, nor to attribute the cautious optimism that begins to appear in Kitaj's work to the security of their relationship.

VII TOWARDS A BETTER LIFE

The Better Life announced by Kitaj in one of the prints of the In Our Time portfolio in 1969, began to materialize for him only two years later, when two events occurred: the purchase, on his return from California, of a large house in London, and the renewed contact with Sandra Fisher, destined to become his companion and eventually his wife. Herself a painter, she has had major repercussions on Kitaj's life and work, not only by giving him moral support but also by encouraging him to draw again. Kitaj has likewise been sustained during these years by his close friendships with other artists who are too numerous to mention, many of them in some way connected to the 'School of London' to which Kitaj was to pay tribute in the Human Clay exhibition

Fig. 6. Towards a Better Life, 1969, from In Our Time. Screenprint, $31 \times 22\frac{1}{2}$ in. $(78.7 \times 57.2 \text{ cm})$.

in 1976.⁵⁷ Above all there has been the sense of solidarity with his closest friend from the Royal College days, David Hockney, whom he visited frequently during the latter's stay in Paris from 1973 until 1975 and with whom he has maintained a constant and intimate correspondence over the years. When one takes into account, too, Kitaj's friendship with the poets already mentioned and with figures from the British literary world, there begins to emerge a sense of the rich artistic milieu within which he has produced his work. Ambitious art, as Kitaj himself maintains, requires a strong context. 'A lot of good and regular art gets made because of who you talk to', he remarks. 'No one is immune to human contact, and art is not made in a vacuum. History is full of flourishing milieux in which all kinds of people act upon one another. Who is terrific and who is less terrific gets sorted out often after death.'

It was in 1974, during one of his visits to Hockney in Paris, that Kitaj experienced the pastels of Degas as a sudden revelation of major significance for his own art. 'Sandra had begun to work in

pastel', he explains today, 'but I used to discourage her, saying it was not an accurate enough medium. She didn't listen and persisted ahead of me.' The drawings in the collection of the Petit Palais made a particular impression on him and set him on an almost fanatical course of reeducation as a draftsman which he maintains with great intensity to this day. 'The giant Degas late pastel-drawings of the Rouart children really got me thinking to do pastel seriously and I began to buy the very expensive Roché pastels still made in the Marais by two old ladies whose grandfather made pastels for Degas.' Hockney, too, suffering at the time from something of a painting block, was giving himself to a period of drawing solidly from life. Together the two artists began to question what was lacking in late Modernism and to seek the possibility of tracing back another route to the turn of the century. Kitaj took as his measure the great figure inventions achieved by Degas and Cézanne in their old age. His absorption in late nineteenth-century art, already evident in The Autumn of Central Paris, soon took on an overwhelming importance for him, to the extent that in 1980 he could maintain that 'I, for one, feel like a Post-Impressionist.'58

The excitement that Kitaj shared with Hockney about drawing the human figure and about pondering the lessons of nineteenth-century art led them both to become embroiled in a heated polemic, which was to fill the pages of the British art press in the late seventies. ⁵⁹ Kitaj, who had always managed to maintain a low profile, was suddenly in the public eye to an extent that he began to find uncomfortable. In addition he held two exhibitions of his work at the Marlborough Gallery in London (1977 and 1980) and a third at the Marlborough Gallery in New York in 1979. A major retrospective followed at the Hirshhorn Museum, Washington, in 1981, travelling afterwards to the Cleveland Museum of Art and the Städtische Kunsthalle Düsseldorf. Also, Kitaj was asked by the Arts Council of Great Britain to purchase pictures on their behalf for a period of a year and to use these as a centrepiece for an exhibition – which Kitaj titled *The Human Clay*, after a line in a poem by W.H. Auden – held at the Hayward Gallery, London, in 1976 and then taken around the country. It was in this group exhibition and in the fervent text for the catalogue which accompanied it that Kitaj made public his impassioned interest in an art deeply rooted in human concerns.

Linked in Kitaj's mind to these reversions to drawing and to the late nineteenth century were his 'reversionist instincts toward a Jewishness'. Gradually he had come to recognize that even a non-practising, agnostic Jew like himself was conditioned and defined by the fate of other Jews in the past and in our own time. In a lecture delivered to a small congregation at the synagogue in Oxford in 1983, Kitaj explained that 'It is the case, for now anyway, that Jews and what happens to them fascinate me more than Judaism does; We, more than the God of the Jews; the phenomenal history of anti-semitism tantalizes me more than a faith I never knew.' The origins of his art, Kitaj felt more strongly than ever, were indissolubly connected to the origins and terms of his life:

It strikes me that these crucial reversions of mine are three and that the three epiphanies were not sudden but evolved slowly over the same period, picking up around 1970 or so and are today still gathering toward unknown futures – Degas the draftsman, Cézanne the (late) painter, and Kafka the Jewish artist are the indwelling choir of this very uncertain church of mine. I say church because these three large tendencies seem to gather in one quiet place – at least I hope they will ultimately gather in an (old age?) synthesis. Around 1900, Kafka began to turn toward his own very original and fearful Jewishness (as did many fascinating others); Degas was bringing to a (near-blind) head the greatest drawing performance since the Renaissance, and Cézanne was instigating what, for Picasso, Matisse and Bonnard would become the light which would illuminate their way, and what, for me, suggests a depictive mystery-play which somehow agitates my own powers, whatever they prove to be.

I just don't accept what 78% of our art people take for granted – that one acts upon the art of one's immediate past. In 1947 and in 1952, Bonnard and Matisse were *still* absorbing lessons from Cézanne!

Kitaj remarks facetiously that he qualifies as a Post-Impressionist by virtue of the fact that he was born six years after the death of Monet, and adds: '1880–1920 was the last time the depictive blood ran so strong (and innovating), so why not go to school where the real stuff left off? It's funny that the new young guys are getting off on Picabia, Nolde and Kirchner etc. I guess it suits them.'

Having allayed his homesickness for America with a few months as artist-in-residence at Dartmouth College in 1978, followed by a year in New York City - where he produced, among other things, keenly-observed drawings such as Ninth Street under Snow (1979) - Kitaj decided in the spring of 1982 to move with Sandra Fisher to Paris for a year. It was a way for both of them to consummate their long romance with the city and its artistic heritage, and turned out to be a memorable and, in their view, an unrepeatable, year. Kitaj did a substantial amount of life drawing during this period, using both professional models and friends. With the encouragement and assistance of one of his closest friends in Paris, Aldo Crommelynck - the master printer best known for his work with Picasso but who in the mid-seventies also worked with Hockney on the remarkable Blue Guitar series - Kitaj made a group of soft-ground etchings, most of them selfportraits but including also a highly atmospheric view of the Place de la Concorde. As far as painting was concerned, there were too many unusual distractions for it to be a very productive year for Kitaj. He and Sandra saw not only the Crommelyncks but also artist/scholar Avigdor Arikha and his wife, the American poet Anne Atik. 'We met or talked together almost every day and I felt hidden away from my usual habits and entered into a Paris I had never known, partly through the flowering of this friendship and partly inventing a Paris of my own.'

On 15 December 1983 Kitaj and Sandra Fisher were married in London's oldest and most

Fig. 7. Place de la Concorde, 1983. Charcoal on paper. Private collection, Paris. Cat. no. 351.

beautiful synagogue, the congregation of Spanish and Portuguese Jews in Bevis Marks. With David Hockney as best man and with a minyan (ten Jewish men) which included some of their closest painter friends – Frank Auerbach (who gave away the bride), Lucian Freud and Leon Kossoff – Kitaj and his wife could have found no better means of declaring a future together both as Jews and as artists.

VIII THE WORLD'S BODY

'Images with a meaning peculiar to their own time and place, once created,' wrote Fritz Saxl in 1947, 'have a magnetic power to attract other ideas into their sphere; ... they can suddenly be forgotten and remembered again after centuries of oblivion.' The conviction that the entire history of art was available as potential source material had been held by Kitaj as early as his student days, when he was immersed in the writings of Saxl, Wind, Warburg, Panofsky, Wittkower and other scholars intent on unravelling the meanings of the great art of the past. In his early work, however, Kitaj had approached the art of the masters in a tangential fashion, plucking images from the past and inserting them into his paintings along with obscure images from iconographic studies, literary quotations, personal references and details borrowed from more popular sources such as photography and film. The treasuring of images and their translation into a modern idiom were the primary goals; the original intentions and singularity of vision of the art thus referred to were somehow sidetracked and transformed along lines established by Modernism in the twentieth century.

In the mid-seventies Kitaj began to deal with the past art about which he cared passionately as far as possible on its own terms. The change in attitude was a fundamental one, as he reflected in a letter early in 1980:

I did love the grand masters when I was young but I did not know what to do with them.... They were like roots deep in the earth (Giotto, Michelangelo, Rembrandt, Goya, Degas, Van Gogh, Cézanne)... and like so many young people, I was attracted by the pretty, frail wisps growing on the surface – the dandelion weeds (Duchampism, collagism, montage, Surrealism, the chimerical 'freedoms' young artists cherish so). These dandelions are so easy to pluck, so much easier to get at than the deep roots ... They seem now like fool's gold in my own practice. I must leave their distinct potential to others.

In a period when many artists have been tempted to take as their model the work of their immediate predecessors or even of their contemporaries as a way of ensuring their modernity, it has been left to some of the most ambitious artists – artists, that is, who wish to ensure a lasting substance for their work rather than instant success – to look for guidance, as self-demanding artists have always done, to the work of the great masters. Kitaj is not alone of his generation in doing so, but even among like-minded colleagues he is unusual in aligning himself so openly and unreservedly with the artists whom he regards as his real mentors. In the second half of the seventies this meant, in particular, precedents in late nineteenth-century French art: Van Gogh's monumental single figure drawings, Cézanne's bathers, the brothel scenes of Toulouse-Lautrec, the distracted women of Degas and the Tahitian nudes by Gauguin, scenes of café life by Manet, Degas and others, Seurat's atmospheric conté drawings, and pastels and drawings by Degas, Redon and Rodin are among the specific sources to which he has made reference. Kitaj, however, is no mere pasticheur. Rather he has taken this body of work – which thrills him for its wealth of invention and for its omnivorous delight in making contact with everyday life in all its richness – as a set of premises on which to build a strong and contemporary art filtered through his own sensibility.

The aura of the turn-of-the-century art which Kitaj had decided now to take as his prime model, allied to his experience of Modernism and to direct study from life, is particularly evident in the pastel drawings which he began to produce in 1974. Femme du Peuple I (1974) heralds a series of female nudes drawn from life and sets the tone for these with its frank eroticism and in its liberties with the human form both for the sake of expressive distortion – note the almost violent manner in which the left leg is flattened and joined to the thigh – and as a means of asserting the physical gestures made in establishing the marks, in the way, for instance, that the left arm trails out into nothing. In illusionistic and spatially convincing drawings such as Marynka Smoking (1980) one senses still a Modernist attention to the surface - for instance, in the pools of colour deposited by dragging the pastel across the rough texture of the handmade paper - which firmly establishes these drawings as of their own time. Many of the most touching and psychologically penetrating drawings are of the artist's own children, of poet and artist friends, of people well-known to him, so that the act of drawing is itself a symbolic recognition of the nature of that relationship. Who but a friend, for instance, could convey so perceptively the sadness and introspection beneath the brittle and witty surface of Quentin Crisp, former life model and self-styled 'Naked Civil Servant'? Conscious of the years lost when he did no drawing on paper, Kitaj seems to have taken a cue, in intention, if not in style, from the specificity of his own life drawings of the late fifties and early sixties:62

I was always a particularist and more so now than ever I like to think that universal values will prosper and reside in the most particular, subjective origins ... that is to say that those origins are precious to me and I don't want to neglect them. This is the most emphatic 'lesson' I ever have to give a young painter – first, to try and register what you think you can see in that person posing there and, in one's more conceptual practice, to be true to what you are, to try to find out what you are, as opposed, for instance, to what much modern practice dictates. That's really harder to achieve than it sounds. Many many artists spend their lives the other way round – universalist, internationalist ambition drives away what may have been very special in the person.

Kitaj's convictions about drawing from the model have repercussions that go far beyond the confines of the life class. The artist points, for instance, to *Communist and Socialist (Second Version)*(1979) as an example of the way in which dealing head-on with the people who sit for him could act as a bridge in his work for conveying his views about contemporary events. Drawn from life in two separate poses, the picture depicts a Communist and a Socialist – both Catalans and one of them, José Vicente Roma, a friend of the artist of nearly thirty years' standing – 'arguing in a cafe at a moment in Southern Europe, a few years ago, when nervous alliance between such people was in the balance'. We don't, of course, know what they are saying, but we are reminded through this very direct image that in politics interaction between people is as important as the theoretical views to which they are committed.

In Study for Miss Brooke (1974) Kitaj developed another function for life drawing which has remained of continuing importance to him: that of using an actual person as a starting-point for the creation of a fictional character, which then takes on a life of its own. As the title suggests, this is an imaginary portrait of a character in George Eliot's novel, Middlemarch. 'George Eliot had said (about Miss Brooke) that St Teresas are born every hour but that circumstance does not permit these wonderful people to become as extraordinary as St Teresa, or words to that effect; so I had just drawn this unremarkable girl and I just gave her the name from the novel I was reading.'

The portrait of Miss Brooke remains a rare and isolated instance in Kitaj's work of a figure invention directly related to a literary source, but it pointed the way to the sustained series of single figure paintings of the mid to late seventies, which remain some of the artist's greatest achievements: The Arabist (1975–6), The Orientalist (1975–6), Smyrna Greek (Nikos) (1976–7), The Jew Etc. (1976–9), The Mother (1977) and The Hispanist (Nissa Torrents) (1977). In creating this cast

of characters Kitaj had at the back of his mind the example not only of Daumier's figure inventions, Ratapoil and Macaire, but of the characters which he himself had created a few years earlier in Superman, Batman and Bill at Sunset. There are two crucial differences, however, between those precedents in his own work and the emblematic portraits that he now began to create. Rather than working purely from the imagination or from other representations, Kitaj now painted some of the figures directly from life: this was the case with The Mother (not, incidentally, a portrait of his own mother); with Smyrna Greek, an imaginary portrait inspired by the poet Constantin Cavafy for which the artist's friend Nikos Stangos, himself Greek and a poet, posed; and with The Hispanist, a portrait of a Catalan friend resident in London. Secondly Kitaj was now taking as his subjects not ready-made characters but figure types of his own invention, each of whom represents a particular condition or role in life. Kitaj recently explained:

I want to distinguish between prototype which bores me and a type one tries to coin, which I believe succeeds to the extent I can make him memorable. That doesn't mean I will succeed, but I can try. So far, many of my fictive representations seem underwritten to me, to borrow a term from a sister art. When I can solve that I will have taken a giant step toward depictions which might lodge in the Social Memory.⁶⁴

The literary tag so often flung at Kitaj as an accusation is triumphantly flaunted in these canvases, in which the painter's role is redefined as that of a novelist whose raw material is the image rather than the word. Though the pictures have their subtexts – *The Orientalist*, for example, in Hugh Trevor-Roper's biography of Backhouse; *The Arabist*, previously known as *Moresque*, in the life and work of a number of scholars in the field – the thrust of the portraits is a wholly visual one. ⁶⁵ Of relevance to these pictures also is the devotion manifested in Kitaj's earlier work to iconography. Although he is now inclined to play this down, it is precisely because of his awareness of the richness of meaning achieved through transmutation of context that he is now able to quote from the repertory of his own images, creating a personal iconography from which to draw.

In The Jew Etc. we witness the first appearance of a character whom Kitaj was to name Joe Singer, after a friend of his mother's whom he remembered vaguely from his childhood, and who was to be spied again in later works such as Bad Faith (Riga) (Joe Singer Taking Leave of his Fiancee) (1980), Study for the Jewish School (Joe Singer as a Boy) (1980), The Jewish School (Drawing a Golem) (1980), The Listener (Joe Singer in Hiding) (1980) and, most recently, Cecil Court, London WC2 (The Refugees) (1983-4). In each episode we learn a little more about the figure, his past and his present predicament. Singer is for Kitaj what K. was to Kafka in The Trial and The Castle: an archetype representing a condition of man, and more specifically of the Jew, in the twentieth century, the anxious uncertainty of his fate made all the more urgent through the artist's identification with him. 66 It was several years after applying the name Singer to his invention that Kitaj learned just how appropriate a model he had found:

In the late thirties, my mother was dating a guy named Joe Singer. He was a lawyer and they were part of a circle of anti-fascist, bookish people typical of that period, which included refugees from Nazism. (...) I remembered his name and began to use it. Then my mother told me she had expected him to ask her to marry him but meanwhile she fell in love with a handsome young refugee chemist from Vienna named Kitaj in their group of friends, and married him instead. I thought: how piquant, I happened to chance upon a dimly remembered name from my childhood to give to a character I would draw and paint and imagine, a figure who would offer a certain secular impression of Jewishness, a representation as it were of a Jewish presence in painted pictures which, it could be argued, was kind of taboo (...) and, behold, the guy almost became my dad and I almost became R.B. Singer!

The fate of the Jews has become one of Kitaj's main preoccupations in recent years and a theme central to such major paintings as If Not, Not (1975-6), The Jewish School (1980) and Rock Garden

INTRODUCTION 35

(The Nation) (1981). Echoing Cézanne's ambition to do Poussin again after nature, Kitaj explained in the lecture on Jewish art which he delivered in 1983 that 'I took it into my cosmopolitan head that I should attempt to do Cézanne and Degas and Kafka over again, after Auschwitz. That may be the synthesis of my undoing, or, it'll make a mensch of me because artists tend to create their precursors.'

A single gatehouse at Auschwitz actually figures in If Not, Not as one of a number of sinister intrusions into an otherwise idyllic landscape inspired by Giorgione's mysterious masterpiece, La Tempesta. At the back of the artist's mind was a report, by someone who travelled to Auschwitz many years after the War, which remarked on the loveliness of the scenery en route. The presence of death and disaster within a scene of seductive exoticism and beauty thus becomes a metaphor for the shock and incomprehension with which Jews must have met their fate. Several critics have detected in this painting an allusion to Matisse's Bonheur de vivre (1905–6), in which a number of figures loll in innocent nudity within a tranquil and paradisical landscape. Two world wars later, that idyll no longer seems possible, even as a fantasy; Kitaj's figures are shown not resting, but crawling fearfully away from imminent danger or even lying dead and abandoned. The tone of the painting and the kinds of imagery it employs have their basis largely in Eliot's The Waste Land, written in the aftermath of the traumatic carnage of the First World War. It is a measure of Kitaj's growth as an artist that nearly two decades after first using the poem as the inspiration for one of his pictures, Tarot Variations, he should create such a compelling reply to its harrowing content, with its dark premonitions of the wholesale destruction of human life.

Land of Lakes (1975-7), conceived as a pendant to If Not, Not, represents an optimistic response to the despair of the other picture. In the essay that the artist had hung next to it when it was shown at the Hayward Annual in 1977, he described it as 'much more of an impersonal meditation than its bleaker companion' and as 'a token of better times to come'. 69 The pictures concerning Jewishness and particularly anti-semitism - 'a daily grind with me' - tend, however, to be among the most sombre and harsh in tone of all Kitaj's works. There might, at first, appear to be an almost light-hearted side to Marrano (the Secret Jew) (1976) in the hints of transvestism that form part of the picture's theme of dissimulation; the man is trying so hard, moreover, to be what he is not that even his head is not his own but a copy from a Giotto fresco. 70 Yet when one considers the identity of the figure in the light of the enforced conversion of Spanish and Portuguese Jews to Christianity in the late Middle Ages, the image takes on a much more sinister aspect. There is a confessional sense, too, in the implicit understanding that this is an image of the artist himself, openly avowing his Jewish origins. Non-Jews may find it difficult to understand why this should be such an issue, but in a century that has seen the wholesale murder of Iews and continuing and insidious anti-semitism, it would, in the artist's view, be an abdication of responsibility and a betrayal of his forebears for even a non-practising Jew like himself not to stand up and be counted with the others.

'I believe that you can "invent" yourself,' explains Kitaj in particular relation to his fabricated Jewish characters:

I can, at least, attest to the profound fun, sometimes exhilaration, and more rarely revelation and insight caused by this game of remaking and making oneself... especially through one's art practice. By inventing characters, I can say, I think, that I go some way toward deciding what kind of character I may be myself. For instance, one's life, and thus one's art-life, has been a preparation for becoming a *kind* of Jew, etc., *what* kind, I have to try and invent!

Kitaj's most recent paintings on Jewish themes, such as *The Jewish School*, *Rock Garden* and *Cecil Court*, all owe a debt, he says, 'to the rediscovery of the world and teaching and destruction (murder) of the Hassidic Zaddikim (magical holy men)'. Each of these pictures contains a narrative about the fate of the Jews, their exile and dispersal.⁷¹ *The Jewish School*, closely modelled on a section of a nineteenth-century German anti-semitic engraving, transforms what in the

original source was merely a swipe at the alleged anarchy of Jewish behaviour into a metaphor for the Jews' inability to defend themselves adequately against their persecutors. The meaning hinges on a single but crucial transformation from the source: the boy at the far right, who in the engraving is simply shown writing on the blackboard, in Kitaj's picture is drawing a golem, who in Jewish legend is an artificially created human being brought to life by supernatural means. The golem, however, is incomplete; he will not come to life in time to save them. *Rock Garden*, one of the cruellest and most anguished images which Kitaj has yet created, represents 'our Ghost-Nation, called by a Hebrew poet the great empty Kingdom of Death'. Only *Cecil Court*, which treats those whose lives were set off-course, but not destroyed, by anti-semitic persecution, gives much cause for hope.

Fig. 8. Detail of G. E. Opitz, Die Judenschule, as reproduced in The Judensau by Isaiah Schacher, Warburg Institute Surveys, V, 1974.

In the late seventies Kitaj spent an intense and concentrated period drawing, the subjects covering a wide range from straightforward life studies to imaginative compositions and allegories such as *The Rise of Fascism* (1979–80) and *Sighs from Hell* (1979). The group of *Bather* pastels, which constitute some of the most affecting works of this period, take their inspiration from Cézanne's paintings on a similar theme, which Kitaj admires not only for the usual formalist reasons, which have guaranteed their place in twentieth-century art, but also for their expressive awkwardness and sense of mystery.⁷³ Having decided to work for a couple of years solely on paper, in using pastels and in working sometimes on a large scale Kitaj was able to give these pictures the range and density of paintings. In the sixties, by contrast, he had worked for a long period exclusively on canvas, but had produced small-scale works on that support, which he himself regarded as drawings. It is as if the decision to concentrate more or less exclusively on one medium made it necessary for him subconsciously to find the means of making that medium do the job of both painting and drawing.

When Kitaj began painting again in 1980, he made a conscious decision to effect a radical change in his technique, 'disturbing' the paint to a far greater extent than he had been accustomed to. Not since the early sixties, in fact, had he used paint in a manner at all akin to this. Underdrawing has remained important, but as a working tool rather than as an end in itself to be protected and preserved at all costs. The initial drawing is readjusted until a satisfactory integration of the parts has been achieved, bringing with it a density of surface through the addition of successive deposits of paint and increasingly variable brushing.

INTRODUCTION 37

There are, of course, evergreen precedents, techniques from the past which painters often like to use and, among those, I'll be found happily playing and daubing . . . for instance: Monet's interesting technique of piling layer upon layer of dried, rough stroking, allowing the previous colors to show through the brushmarks in a kind of opaque dazzle, led me to try something like that in *The Sailor, Jewish School, Rock Garden et al.* At the same time, I'd been moving away from the, what shall I call them – perfectionist, closely-ordered techniques of painting, culminating in *The Orientalist* and *If Not, Not* etc. . . . and my brushing was to become more painterly, gestural, but no less careful The large Cézanne *Bathers* in the National Gallery was constantly on my mind and, also, before my eyes, and literally in my hands, during that very crucial moment, those many months doing the *Artist's Eye.* . . . I go there every week, still, drawn mysteriously to that picture – my favorite in the collection.

Kitaj remarks that if there is an expressionist aspect to his recent painting, its roots lie above all in Cézanne.

Kitaj's abiding concern in recent years with the human figure has found one essential outlet in portraiture, primarily in the form of drawings from life but culminating, too, in a pair of double portraits conceived, perhaps, in a spirit of friendly rivalry to those painted in earlier years by Hockney. The first of these, From London (James Joll and John Golding) (1975–6), depicts John Golding – an intellectual with a cosmopolitan background and wide cultural interests, an abstract painter of considerable refinement and one of the great historians of Cubism – with his companion James Joll, the historian of anarchism. The picture is strewn with attributes of their interests (the books of Gramsci, Wollheim and Léger and the Mondrian exhibition poster), to the domestic tranquillity of their relationship and to their work; the very structure of the portrait, subdivided into three bands of unequal width, refers to the characteristic format of Golding's paintings of that period. The picture is both a private record of the friendship of the two men with each other and with the artist, and a synthesis of the various strands of modern European art and thought of which they are a part. In the depiction of Joll in strict profile, the contours of his head 'crumbled away' as if they were part of an early Renaissance fresco, one gains a sense, too, of the uncovering of history that men such as these represent for Kitaj.

Kitaj's friendships with American poets of his generation have continued to make their mark on his paintings, as is evident from the second of the double portraits produced by him in the midseventies, A Visit to London (Robert Creeley and Robert Duncan) (1977), a straightforward memento of the mutual respect binding these men together. In the previous year Kitaj had painted Houseboat Days (for John Ashbery) with a view to it being used as the cover illustration for a new volume of poetry with that title. Shortly after receiving the manuscript, he had remarked:

Ashbery explained to me that the title 'Houseboat Days' (of the book and of the title poem) had no real meaning for the poem . . . it was just a chance treasure found in an old National Geographic. But that grand and sweet title will live on with the poem and in the social memory. Sometimes I think a title is remembered, like you remember a human face, a visage, which stands in the mind for a whole person.⁷⁵

Though the image created by Kitaj in this painting recalls that of one of the book covers, *The Pursuit of the House-Boat*, used in the *In Our Time* series, it was, in fact, based on a film still of Simone Simon in *Lac Aux Dames*, directed by Marc Allégret in 1933. Even without knowing the specific source, one can detect in the tonal greys of this painting a photographic or cinematic origin. Films continue to provide imagery for other pictures as well, such as *His New Freedom* (1978), which conflates a beautiful Rubens portrait of his first wife with a leering mouth from Carl Dreyer's film, *Vampyr*, to create a gruesome but memorable image of moral and physical decay.⁷⁶

A more ambivalent attitude towards corruption can be detected in another drawing derived

Fig. 9. A Visit to London (Robert Creeley and Robert Duncan), 1977–9. Oil and charcoal on canvas. Collection Thyssen-Bornemisza, Lugano. Cat. no. 206.

INTRODUCTION

39

from a film still, *His Hour* (1975). The seated voyeur in the foreground of this picture was taken from Meyerhold's 1915 film adaptation of Oscar Wilde's *The Picture of Dorian Gray*,⁷⁷ but Kitaj maintains that he did not have the fictional character in mind when he made his pastel drawing. Moreover, he admits, 'I might've liked to have been in that chair in my picture myself, or in the place of the other man.' In the background – drawn in outline only, as if they were partaking of another level of reality, another area of experience, to which the watching figure is not privy – a naked couple are shown in the blatant act of making love.

The dual themes of eroticism and prostitution have long featured in Kitaj's art, at least as far back as Where the Railroad Leaves the Sea (1964), Walter Lippmann (1966), Erie Shore (1966) and Juan de la Cruz (1967), and openly treated as the central subject by the time of Casting (1967-9) - conceived in the spirit of broadsheets advertising the wares of American brothels - and Shanghai Gestures (1968). In a series of drawings begun in the mid-seventies, however, Kitaj started to make images that themselves were erotic in intention, rather than merely about eroticism: images verging on the pornographic, such as Communist and Socialist (1975), others, such as Femme du Peuple II (1975), taking up the image of the street and of the romance of prostitution and chance encounters earlier proposed in Little Romance I (1969). The attraction to brothel life is both personally rooted – as the artist confesses in incorporating his self-portrait in the background of Smyrna Greek (Nikos) (1976-7) - and linked to a historical romance with fellow 'sleepwalkers': 'Degas, Baudelaire, Flaubert, Lautrec, Benjamin, Giacometti, Picasso, Kafka, Morandi and many others who seem to have known such places well, prowling those districts at night.'78 Kitaj lists as one of his 'great literary influences' in this respect the anonymous and encyclopedic two volumes of sexual confessions first published in the Victorian era with the title My Secret Life. 79 The precedents in the visual arts, however, are equally important, as is attested by the evident relationship of a painting such as Frankfurt Brothel (1978) - which the artist now regards as one of his failed pictures - to the brothel pictures of Toulouse-Lautrec and Degas.

Kitaj has deliberately set out to explore the fine and explosive line between eroticism and socalled hard-core pornography, which he has used on occasion for details and poses. At a time when pornography itself has been under the close scrutiny of feminists as a measure of male violence against women, the mere use of such material, as Kitaj well knows, is problematic and dangerous. He remains, however, challenged by the possibilities of such subject matter.

Although I must admit I'm now rethinking this sort of sexual art in a spirit of something verging on contrition, . . . I just don't want to be told what I can and can't do in art. Doesn't that confirm my pre-eminent modernism, as against those who think I'm reactionary, old-fashioned, retrogressive, anti-modern etc., etc.? In fact, most of the places I try to take my art are condemned by many of those who think they themselves represent modernist freedom!—So my pictures are pornographic, or they're obscurantist, or they're literary, or autobiographical, or they hark back before last year's art, or they're (badly) political, or my drawing is academic and worse etc. Now, I've even heard that my Jewish pictures won't fly; that they're sentimental and nostalgic, naturally. I just don't think the last word has been said about so many of these taboos in art and I feel downright incorrigible . . . I don't really know what pornography is or what art is. I'm a strong feminist but feminism, like socialism and modernism and humanism, has many differing faces.

The task that Kitaj has set himself is a formidable one: that of producing an art which not only gives pleasure to the senses and stimulation to the intellect and to the emotions, but which also touches on his own life, and on that of his contemporaries, directly and without recourse to irony. If at times his meaning is still not clear, or if, in the pursuit of the depictive tradition as an anchor for his own inventions, Kitaj sometimes depends heavily on the aura of his sources, one should not be too harsh, for these are only signs of a vulnerability that other artists would seek to conceal. There is very little in the art of our century that is both challenging and self-evident: think, for

instance, of surrealism, with its private and inward-looking imagery, or of the highly-specialized body of theory that is taken for granted by the practitioners of abstraction, of conceptual art and of other forms of late modernism. This is not to excuse Kitaj the difficulties that his own work creates, but one should at least give him credit for admitting that they exist and for doing what he can, both in his pictures and by means of his explanations, to reduce the barriers between his audience and himself. His intentions – flawed, on his own admission, as they may be – remain honourable ones.

IX A CONFESSIONAL ART

'I happen now to be in the grip of what I suppose to be great changes in my thinking and, I hope, in my practice,' Kitaj wrote at the beginning of 1983, 'which are related to what may be called autobiographical or confessional directions in my art.' These tendencies are intimately related, for him, to his growing concern over the past few years with his identity as a Jew, but they go beyond that to a desire for his pictures to be 'enshrouded' by a 'confessional aura'. As he remarks:

A great deal of poetry and art is 'confessional' anyway, in the sense that it is a personal, subjective record of one's state of mind and feeling but now I like to explore a deal more into that autobiographical realm where one's own history and interests get more of a hearing within the complex of (my) confounding pictures, especially because our modern art has discouraged that practice so much – not only abstractionism, but most of the artists I am close to would, I think, wish to refuse confession, as they do explanation. I've heard that getting something off your chest (and into your pictures??) is good for you; so, we'll see.

The roots of this confessional art in the circumstances of Kitaj's private life are implicit at least as far back as *The Man of the Woods and the Cat of the Mountains* (1973), which I have interpreted as an image of the painter's relationship with Sandra Fisher, but the personal terms in that instance are concealed by secrecy and conveyed by metaphor. A more recent drawing such as *The Green Blanket* (1978), on the other hand, openly depicts the supportive friendship which sustains the couple; the source of the image in a self-portrait by Goya, rather than complicating the issue, helps to clarify its significance. ⁸⁰

Confession takes many forms in Kitaj's current work. The matter can be as straightforward as recording the memory of a prostitute's bedroom, as in *The Room (Rue St Denis)* (1982–3), an eloquently simple image painted in Paris in a matter of days; though the theme is one that Kitaj has treated on many occasions over the years, never before has he dealt with it so directly. *The Garden* (1981), too, speaks for itself, as a loving refabrication of the garden that he had designed for his home in the previous year and which had now been planted according to his instructions.⁸¹

Cecil Court, London WC2 (The Refugees), painted over the winter of 1983/4, was the first major canvas completed by Kitaj upon his return to London from Paris. Conceived in a spirit of competition with Balthus's paintings of The Street, on view at that time in Paris as part of the large Balthus retrospective, Ritaj regards it as his most ambitious painting in recent years. A reverie on the way in which his own life has been touched by that of refugees from the holocaust, the picture is a compendium of images rich in personal significance: the setting, an alley of specialist and antiquarian bookshops running between Charing Cross Road and St Martin's Lane, which has been one of the artist's constant London haunts; at the far left, Seligmann, one of the refugees who ran an art bookshop there for many years; at the far right, Kitaj's recently deceased stepfather; behind him, a shop inscribed with the name 'Joe S', for Joe Singer, the man who almost became Kitaj's stepfather and who as a fictional character has peopled many of his recent pictures;

INTRODUCTION 4I

and in the foreground, a self-portrait based on the cover illustration of a pulp novel, the artist dressed in the clothes which he had worn at his recent wedding and seated on a famous chair designed by Le Corbusier.⁸⁴

Two canvases on which the artist is engaged at the time of writing – Amerika (John Ford on His Deathbed), based on his own photograph of his favourite film director, and Amerika (Baseball), a large canvas loosely based on a landscape by Velázquez and the fruit of a longstanding ambition to produce a big baseball picture with elements of fantasy and reality⁸⁵ – introduce a major group of new pictures on the theme of his home country. Kitaj explains that he has used the spelling from Kafka's novel 'because I want to register my American self from afar and in exilic fantasy, to which (fantasy) I feel drawn. Kafka never went to America and my Amerika will allow me all the craziness I may need, upon his inspiration.'

'I carry themes in my mind for years before I will try to compose them', Kitaj remarked in 1980. 'I've got themes that will last me now till I die.'86 Indeed he has another decade to think about the British Library mural first proposed to him by the architect Colin St John Wilson in the midseventies, which he originally planned as a *Waste Land* picture but which he is now inclined to consider in terms of a London theme of his own. 87 Whatever direction Kitaj takes his work in the future, the evidence suggests that he will continue to place himself in the role of the *Listener* or the *Messiah Watcher*, forever vigilant both of the forces that shape his life and of the sense of purpose and ambition that guides him in his art.

Fig. 10. The Messiah Watcher (detail), 1978. Pastel. Private collection, Connecticut. Cat. no. 226.

NOTES TO THE TEXT

- 1. All quotations from the artist, unless otherwise credited, are from my correspondence and interviews with him, dating back as far as April 1976 but primarily from August 1982, when I began research on this study, to July 1984. The artist has read through my complete text, and in doing so has made slight changes to his own writings for the sake of clarity. With regard to punctuation, ordinary ellipsis is the artist's own, but ellipsis in parentheses indicates that part of his text has been edited out by me.
- 2. 'I would get to encounter this viperish, cockeyed sort of genius in London in the late 60's just before he died, and I made a little painting of a ship gone on the rocks for a Dahlberg Festschrift.'
- 3. Another painting executed in 1961, The Disinterested Play of Thought, took its title from the same source. This picture is unpublished but a photograph of it is on file at Marlborough Fine Art, London.
- 4. On our first meeting Kitaj remarked that 'The great Surrealists, for me, are not the orthodox Surrealists, who are generally lesser artists, but people like Picasso, Bacon, Balthus, and so many others.' In a letter written several years later he expanded on his views of the movement: 'Surrealist ideas like bringing images together in unlikely and unfamiliar conjunction (in hope of producing magic), and other such ideas, attracted me when I was young. Now I can see that what may have seemed outrageous and valuable in that practice was often only an exaggerated form of what is substantial and even lifegiving in all art ... I mean to say that so much of what I care about in art has to do with the unfamiliar, prodigious, surprising character of what a truly original artist does in his pictures anyway.'
- 5. 'Ernst certainly was, for me, the best of the orthodox Surrealists, but most of Ernst doesn't interest me. What did interest me were the great steel engraving collages: the Semaine de Bonté. I'm a bibliomaniac. I've been a bookman all my life. I remember when I was at the RCA I was chatting with a bookseller friend, and an old cockney man came in with a package under his arm and said, "This has been giving me nightmares for twenty years." It was the Semaine de Bonté, published in five parts in the 1930s. He sold it to my friend for two pounds and I bought it back for two pounds ten. I've still got it.'

Another artist whose work was grounded in Surrealist collage was the Scottish sculptor Eduardo Paolozzi, now regarded as one of the founders of Pop Art in Britain, whom Kitaj met on the occasion of a lecture by the other artist in Oxford. They formed a close but brief friendship after Kitaj's arrival in London in 1959 and went so far as to collaborate on two works: Warburg's Visit to New Mexico (1960–2) and Work in Progress (1962).

6. 'I saw Wind quite often. I went to all his lectures and classes and he invited me to his home a few times. Many years later, he surprised me by saying he had followed my progress as an artist

after I left Oxford.... He was such an Olympian figure, I just never thought that he would make any time for new art.'

- 7. See R.B. Kitaj, exhibition catalogue, Kestner-Gesellschaft Hannover, 23 January-22 February 1970, cat. no. 122, for a reproduction of Welcome Every Dread Delight. In the exhibition catalogue R.B. Kitaj: Pictures with Commentary/Pictures without Commentary, Marlborough Gallery, London, February 1963, p. 9, cat. 12, the artist himself provided the reference to Rudolf Wittkower, 'Marvels of the East: A Study in the History of Monsters', Journal of the Warburg and Courtauld Institutes, V (1942), pp. 159-97.
- 8. In the 1963 catalogue, p. 5, cat. 3, Kitaj referred to Gerta Calmann, 'The Picture of Nobody: An Iconographical Study', *Journal of the Warburg and Courtauld Institutes*, XXIII/1-2 (January-June 1960), pp. 60-104.
- 9. Mark Haworth-Booth, 'Kitaj/Brandt/Screenplay', Creative Camera, June 1982, p. 547.
- 10. Kitaj's new text about this picture was written after its purchase by the Tate Gallery, London, in 1980, in response to a request from one of the Gallery's curators to provide some information for the entry published in their *Illustrated Catalogue* of Acquisitions 1980-82 (1984), pp. 156-7.
- 11. Kitaj remarks that 'a feeling for Kafka touches, I believe, Nietzsche's Moustache, Lemuel, Pariah and other early things as well', and he reveals that, 'The central scene out of the window in the Toledo Nobody is taken from the Annagasse flat of my friend F.L. Sprague in Vienna a distinctly Kafka-like place for a Kafka-connected picture (...).' Notes Towards a Definition of Nobody A Reverie (1961) is reproduced in the catalogue of the retrospective exhibition, R.B. Kitaj, Hirshhorn Museum and Sculpture Garden, Smithsonian Institution, Washington, D.C., 17 September–15 November 1981, cat. 6, republished in a slightly altered design by Thames and Hudson, London, 1983.
- 12. R.B. Kitaj, 'On Associating Texts with Paintings', Cambridge Opinion, 37 (undated: January 1964), pp. 52-3.
- 13. 'I was very very impressed with *The Wasteland* and I think I imagined it would be all right to append notes to, and even *in* pictures. I thought maybe no one had done that before.'
- 14. 'On Associating Texts with Paintings', op. cit.
- 15. J. Huizinga, Erasmus of Rotterdam (London: Phaidon Press Ltd., 1952), plate V. There were precedents in recent American painting for schemes by which the entire composition was based on a found source, e.g. Washington Crossing the Delaware (1953), a paraphrase by Larry Rivers of the famous picture by Emanuel Leutze, as well as the flag and target paintings of Jasper Johns, which achieved instant notoriety when they were shown in New York in 1958.
- 16. Garrick Mallery, 'Picture-Writing of the American Indians', *Tenth Annual Report of the Bureau of Ethnology, 1888–89* (Washington: Smithsonian Institution, 1893), pp. 25 ff. Kitaj

refers to this study, unfortunately with an erroneous date, in the catalogue of the exhibition he held at the Marlborough-Gerson Gallery, New York, in February 1965, cat. 5, and on the surface of *Reflections on Violence* (1962).

- 17. Fritz Saxl, 'Warburg's Visit to New Mexico', Lectures (London: The Warburg Institute, 1957), vol. I, pp. 326 ff. Kitaj quoted extensively from this chapter as an accompaniment to the painting Warburg's Visit to New Mexico (1960–2), on which he collaborated with Eduardo Paolozzi (1963 cat., pp. 7–9, cat. 9). Closely related to this is another painting, Warburg as Maenad (1962), a detail of which is reproduced in the 1963 cat., p. 8. On p. 15 of the same catalogue Kitaj reproduces a photograph of 'Warburg and a Pueblo Indian', from plate 231 of Saxl's Lectures, vol. II.
- 18. Saxl, 'Science and Art in the Italian Renaissance', *Lectures*, I, pp. 117-24.
- 19. Saxl, Lectures, II, plates 62 ff. For a further discussion of this picture see Richard Francis, 'The Red Banquet by R.B. Kitaj', Walker Art Gallery, Liverpool, Annual Reports and Bulletin, vols. II–IV (1971–4), pp. 84–7, and Walker Art Gallery, Liverpool, Foreign Catalogue, 1977, text volume, pp. 96–7.
- 20. E.H. Carr, The Romantic Exiles (Harmondsworth, 1949).
- 21. Georges Sorel, *Reflections on Violence*, translated by T.E. Hulme and J. Roth, originally published in 1908. Kitaj refers to this book and identifies a number of the painting's themes and images in the 1963 cat., p. 9, cat. 16, and in the 1965 cat., cat. 14; the latter entry also includes a reproduction of the title page from the edition of Sorel's book which Kitaj owned.
- 22. Frances A. Yates, 'The Art of Ramon Lull: An Approach to it through Lull's Theory of the Elements', Journal of the Warburg and Courtauld Institutes, XVII, pp. 115–73, and Yates, 'Ramon Lull and John Scotus Erigena', Journal of the Warburg and Courtauld Institutes, XXIII, 1960 (January–June), pp. 1–44. These are listed by Kitaj in the 1963 cat., p. 5, cat. 4. The reference is from p. 2 of the 1960 article.
- 23. The lines from Goethe's Wilhelm Meister, in Carlyle's translation, are quoted in the 1963 cat., p. 6, cat. 8.
- **24.** The drawing of a woman pulling on her stocking, collaged onto the surface in the upper register, is a copy after a study of a prostitute by Goya in preparation for plate 17 of the Caprichos. It is illustrated in André Malraux, Goya: Drawings from the Prado (London, 1947), pl. 6. Kitaj has taken over the outline but not the style of Goya's drawing. The machine-gunners below, however, are drawn in thick smudged contours apparently achieved by dabbing the wet paint with a rag, in imitation of the effect of Goya's later sepia drawings (see, e.g., plates 68 & 72 in Malraux's book). For an analysis of the Goya image which Kitaj borrowed here, and of related themes in other prints from the Caprichos, see F.D. Klingender, Goya in the Democratic Tradition (London, 1948), pp. 87 ff.
- **25.** 1963 cat., p. 3, and 'Painting: Literary Collage', *Time*, 19 February 1965, p. 42.
- **26.** Kitaj has produced two 'portraits' of Pound a reproduction of the cover of his *How to Read*, in the *In Our Time* series (1969), and *Ezra Pound II* (1974), a screenprinted drawing of Pound upon a reproduction of a Matisse as well as a third, *Yaller Bird* (1964), the title of which was taken from a Pound poem; the latter reproduces one of Kitaj's paintings of the same year, *Aureolin*. These, along with the pictures related to Eliot, are, says Kitaj, 'enough from a restless type like me, hungry for newer soul-food'. There was also a painting, *Cracks and Reforms and Bursts in the Violet Air* (1962), the title of which as Kitaj acknowledged in the entry on this painting in the 1963 cat., p. 12, cat. 20 was taken from line 372 of *The Waste Land*; the

- composition itself, with its collaged images laid out in horizontal rows, suggests the format of a poem.
- 27. See Kitaj's letter about this picture published in R.B. Kitaj, exh. cat., Kestner Gesellschaft, Hannover, 23 January–22 February 1970, n.p., and the note in the 1965 cat., cat. 19.
- **28.** Kitaj points to Lionel Trilling's introduction to the 1957 edition of Isaac Babel's *Collected Stories* (republished by Penguin Books, 1961) as an indication of his own, very similar, reactions to Babel's work. 'Trilling catches the complexity of the Babel conundrum. It was that complexity and ambiguity which determined my picture (and its failures). The discussions in Trilling about the place of Violence in the life of a thinking man, creative artist and much else is worth your attention. He also talks about *Benya Krik*. I had found an extremely rare book in English by Babel called *Benya Krik*, which purported to be a film-novel (I think it was actually made into a (lost?) film). I used the cover unaltered in the *In Our Time* group (...).'
- 29. 'Rauschenberg', Kitaj recalled in 1976, 'had derived from De Kooning, Cornell, Duchamp and Surrealism and that context was very interesting in my youth.' More recently, he speculated that he must have seen the work of Rauschenberg and Johns in New York in the mid-fifties. 'I, too, had been fascinated by the collage and symbolising modes of the Breton circle as they (R. & J.) obviously were, but someone like Rauschenberg put his heart and soul into that practice; Johns too. I never did; I was too young and stubborn and confused to know where to row and I had no milieu to goad me (...).'
- **30.** William Empson, Seven Types of Ambiguity (London, 1953), third edition (revised), p. 3. The book was first published in 1930.
- 31. See M. Livingstone, *David Hockney* (London, 1981), pp. 18, 36 & 42, and M. Livingstone, 'Young Contemporaries' at the Royal College of Art, 1959–1962 (M.A. Report, Courtauld Institute of Art, London, May 1976), p. 7, for a further discussion of this influence.
- 32. Kitaj made periodic visits to San Felíu in the seventies but eventually sold his house there at the end of the decade, symbolically severing his relations with Spain with a final painting on the theme, *Goodbye to Catalonia* (1979–83). 'Something happened to me. I lost interest in a (Catalan) culture that was not my own. What the hell business did I have learning Catalan instead of Hebrew? My love affair with Mediterranean Romance from my youth had faded. I was approaching 50. The kids never used the house and Sandra and I hardly did. The Jewish interest, really close to the bone, was growing and so it was time to move on. I just sold the old house to a Catalan writer. So the place returns to its own. I feel heartsick about it.'
- 33. The Times, 7 February 1963. The reviewer was not named.
- 34. For instances of a figure reappearing from one work to another see, for example, the incorporation of the running figure from Tēdēum (1963) into the screenprint Go and Get Killed Comrade - We Need a Byron in the Movement (1966), or the appearance of the same head in two prints made in 1967, I've Balled Every Waitress in this Club and In his Forthcoming Book on Relative Deprivation (Loneliness). The latter three prints are reproduced in the Hannover cat., op. cit., cat. nos. 25f, 25j and 25k. The collage basis of Kitaj's screenprints facilitated such transferences and may have encouraged him in this new approach. In the mid-seventies Kitaj decided not to produce any more such prints, preferring to give himself to drawing or painting directly from the human figure: a decision which led him away from screenprinting in favour of etching and lithography. The experience of re-using elements from one screenprint to another, however, seems to have conditioned his

attitude towards the recycling of images in his more recent work

- **35.** C.P. Cavafy, *Poems*, translated by John Mavrogordato (London, 1951), p. 124.
- 36. The eight portraits, drawn in most cases from life on canvas and then transferred photographically to silkscreen, are of Robert Creeley, Hugh MacDiarmid, Ed Dorn, Robert Duncan, Morton Feldman, Charles Olson, Kenneth Rexroth and John Wieners. They are reproduced in the Hannover cat., op. cit., cat. nos. 26a-h of the 'Complete Graphics' section. The Creeley print is titled For Love after the poem of the same name published in Robert Creeley, Poems 1950–1965 (London, 1966), p. 159.
- 37. Of this series, Kitaj remarks: 'The prints are very free collages, assembled in response to the Mahler Symphonies, not to Jonathan's poems. Free Verse like that. Jonathan loved Mahler and wrote his poems to the music. I came to Mahler then for the first time and did my visual poems to the music. They're kind of nutty but maybe not so bad as "citations" (in Benjamin's practice), aberrant quotations and pickings from the world.' See also *The Tate Gallery 1968–70*, pp. 90–1, for further background and for the artist's comments.
- **38.** See Van Deren Coke, *The Painter and the Photograph: from Delacroix to Warhol* (Albuquerque, New Mexico, 1972), pp. 125 and 129 for a discussion of this painting and for Kitaj's reasoning in using the photograph as its source. The original film version of *The Front Page* was directed by Lewis Milestone in 1931; it was one of the first 'talkies'.
- **39.** Benjamin wrote of 'the tremendous shattering of tradition' effected by films: 'Its social significance, particularly in its most positive form, is inconceivable without its destructive, cathartic aspect, that is, the liquidation of the traditional value of the cultural heritage.' *Illuminations*, translated by Harry Zohn (Glasgow, 1973), p. 223; this translation was copyrighted in 1968 by Harcourt, Brace & World, Inc., and first published in Great Britain in 1970 by Johnathan Cape Ltd.
- **40.** Kitaj says that although the painting has no direct connection with Josef von Sternberg's 1941 movie, *The Shanghai Gesture*, he 'used the title to suggest the same somnolent malaise of brothel life'.
- 41. See the letter by Kitaj written in July 1968 about this picture, quoted in Contemporary Art 1942–72: Collection of the Albright-Knox Art Gallery (New York, in association with the Albright-Knox Art Gallery, Buffalo, New York, 1973), p. 149, and the artist's new essay about this work published at the end of this book.
- **42.** See Mark Haworth-Booth, *op. cit.*, pp. 546–9, for a fuller discussion of this picture.
- 43. R.B. Kitaj: Paintings and Prints, exhibition catalogue, Los Angeles County Museum of Art, 11 August—12 September 1965. On occasion Kitaj has produced studies for individual details, particularly in recent years, but it does not seem to be in his nature to build up the structure stage by stage in the form of compositional sketches or cartoons. He continued, instead, to improvise on the canvas itself, guided still by his instincts as a collagist. In contrast, though, to many of his contemporaries, Kitaj laid great stress on the role of under-drawing, which in his paintings of the mid-sixties to mid-seventies is generally allowed to remain visible right through to the finished painting, untampered, to the extent that the very weave of the canvas continues to be seen. The surface, in fact, often appears to have been rubbed down, so that one is left with a large scale drawing overlaid with a film of colour.
- 44. 'I wrote it because I was stimulated to collect my thoughts after a supper at my house with Clem Greenberg and Ken

- Noland which was so interesting, it sparked the polemicist in me.' For an account of the effect that this lecture had on the audience, see Timothy Hyman, 'R.B. Kitaj: Avatar of Ezra', London Magazine, August-September 1977, pp. 53 ff.
- 45. The sculptures which Kitaj made for the Art and Technology project were collectively titled *The Lives of the Engineers*. Four of these pieces are reproduced in *R.B. Kitaj: Pictures from an Exhibition*, Marlborough Fine Art (London) Ltd., April—May 1970.
- **46.** The publication of Creeley's volume of poems, *A Day Book* (New York), followed in 1972.
- 47. See Pat Gilmour, introduction to Kelpra Studio: The Rose and Chris Prater Gift, exhibition catalogue, Tate Gallery, London, 9 July-25 August 1980, pp. 32-4, and R.B. Kitaj, 'Chris A Note Apropos', Arts Review, 5 August 1977.
- 48. See Kitaj's letter of 7 May 1974, quoted in the entry to The Man of the Woods and the Cat of the Mountains in the Tate Gallery Biennial Report and Illustrated Catalogue of Acquisitions 1972-74, pp. 181-3, and his statement in 'Painters Reply...', Artforum, November 1975, p. 28.
- **49.** 'R.B. Kitaj interviewed by James Faure Walker', *Artscribe* no. 5, February 1977, p. 5.
- 50. Robert-Macaire was the subject of one hundred lithographs published by Daumier between 1836 and 1838 and was based on the role of a swindler which had caught the public's imagination in a melodrama of 1823, The Sign of the Turnip, as played by a well-known actor of the time, Frédérick-Lemaître. Ratapoil was devised by Daumier during the Second Republic, in the wake of the Revolution of 1848, and was the subject both of sculpture and lithographs. 'This is the creature sent ahead when Louis-Napoleon travelled, to cheer him at railway stations, dispatched to the farms where peasants needed to be convinced and sent into alleys to club unlucky republicans.' Oliver W. Larkin, Daumier: Man of his Time (London, 1967), pp. 37 ff and p. 103.
- **51.** George Heard Hamilton, *Manet and his Critics* (New Haven, 1954), p. 152. For instances in Manet's work see, for example, the reappearance of the *Absinthe Drinker* (1858–9) as one of a larger group of figures in *The Old Musician* (1862), as well as the derivation from Old Master sources of such major paintings as *Le Déjeuner sur l'herbe* (1863), from an engraving by Marcantonio Raimondi after Raphael, and *Olympia* (1863), from precedents in Titian and Goya.
- **52.** 'Michael Powell is a close friend and taught Lem a great deal; he even gave Lem a good part in his film *The Boy Who Tumed Yellow*. They're still very close (...). Like he was to the young American directors (Coppola, Lucas, Scorsese et al) he was a legend to me and I've loved his films long before I met him (...). Anger, I only knew casually when he was camping out in a derelict house near me, here in London. I've only seen a few of his films. Yes, his life as a renegade is amazing. He's a Satanist, a follower of Aleister Crowley (...). No one ever knows where he is. He's always revising his strange book *Hollywood Babylon*. Once in a blue moon he writes me from a blue moon. I brought Anger and Powell together because they admired each other. They're both quite mysterious and since I introduced them, I painted them together in their disjunction.'
- 53. This highly revealing essay, the first which Kitaj had written about any of his paintings for nearly a decade, was hung next to the picture when it was exhibited at the *Hayward Annual*, Hayward Gallery, London, 20 July-4 September 1977. It is printed in full in Michael Podro, 'Some Notes on Ron Kitaj', *Art International*, March 1979, pp. 19–20. See also Podro's very pertinent discussion of this painting in the same article, pp. 19–21.

- **54.** See, in particular, 'The Task of the Translator' and 'On Some Motifs in Baudelaire', both published in *Illuminations*, *op. cit.*; see also the highly perceptive introduction to Benjamin in that volume by Hannah Arendt.
- 55. The small figure of a woman at the far left is from a photograph of British Troops, Londonderry, N. Ireland (1970), published without this title in Is Anyone Taking Any Notice?: A book of photographs and comments by Donald McCullen. With phrases drawn from the 1970 Nobel lecture by Alexander Solzhenitsyn (Cambridge, Mass., 1973), n.p. The bespectacled man holding a cigarette, whom one might assume to represent Benjamin, was, in fact, painted from a photograph of the American comedy playwright George S. Kaufman, published in Kenneth Anger's Hollywood Babylon (New York, 1975), pp. 196–7; Kitaj evidently used an earlier edition. I am very grateful to Frederick Leen for bringing these two sources to my attention. Among the films made from Kaufman's screenplays are Once in a Lifetime (1932), You Can't Take it With You (1938) and The Man Who Came to Dinner (1941).
- **56.** See the entry on this painting in *The Tate Gallery Biennial Report and Illustrated Catalogue of Acquisitions*, 1972–74, pp. 181–3.
- 57. Some of Kitaj's artistic friendships date back to his time at the Royal College, e.g. with Hockney, Adrian Berg and Peter Blake (who had left the College in 1956 but still had friends there), or to the period immediately after his departure, as with Francis Bacon (to whom he was introduced by Harry Fischer in 1962) and Richard Hamilton. Others, such as Lucian Freud, Howard Hodgkin and Frank Auerbach (whom he met while teaching at Camberwell in the early sixties), he has become close to only since 1970. The Israeli artist Avigdor Arikha, about whom he had heard much from Maurice Tuchman, he met in about 1971 and got to know particularly well in the year he spent in Paris in 1982-3. The one American artist included in The Human Clay (Arts Council of Great Britain, 1976) was Jim Dine, a fellow Ohian whom he had met in New York in January 1965 and with whom he shared an exhibition at the Cincinnati Art Museum in 1973. They were especially close in the mid-seventies, when Dine was making regular visits to London, usually staying with Kitaj, and when they were both drawing intensely from the human figure; Kitaj wrote a revealing introduction to the catalogue, Jim Dine: Works on Paper 1975-76, Waddington and Tooth Galleries II, London, 26 April-21 May 1977.
- **58.** Catalogue to *The Artist's Eye, op. cit.* The sentiment echoed a half-jesting plea to be called a Post-Impressionist in the transcript, revised in December 1979, of the first interview we had held in April 1976. The mammoth *Post-Impressionism* exhibition shown at the Royal Academy, London, 17 November 1979–16 March 1980, was visited by Kitaj on numerous occasions. It made a great impression on him.
- **59.** See especially the conversation between Kitaj and Hockney published in *The new review*, January/February 1977, pp. 75–7, and the interviews with Kitaj conducted by James Faure Walker, *Artscribe*, February 1977, pp. 4–5, and by George MacBeth, *Art Monthly*, April 1977, pp. 8–10.
- **60.** Typescript of the lecture delivered by Kitaj at the synagogue in Oxford, 25 November 1983, published in greatly reduced form as 'Jewish Art-Indictment and Defence: A personal testimony by R. B. Kitaj', *Jewish Chronicle Colour Magazine*, 30 November 1984, pp. 42-6.
- **61.** Fritz Saxl, 'Continuity and Variation in the Meaning of Images', reprinted in *Lectures* (London: The Warburg Institute, 1957), vol. I, p. 2, and in *A Heritage of Images* (Harmondsworth, 1970), p. 14.
- **62.** Two of these early life drawings were included by Kitaj in the opening pages of the catalogue of his April 1979 exhibition

- at Marlborough, New York, as if they were talismen of his current concerns.
- **63.** Kitaj met José Vicente Roma during his first visit to San Felíu in 1953. 'Each day, at about noon, a young man leaned against the front of our house, in the winter sun, reading. His name is José (Josep in Catalan) Vicente and he became one of my closest comrades, like an older brother (10 years older), a guru, one of the handful of saintly creatures I've ever known. He was a clerk all his life in an ancient cork factory and a socialist idealist, always in danger under Franco. He is a man of wide reading but hardly ever left San Felíu. *He* is the reason I returned over and over to San Felíu for many summers. Now he's the Mayor of San Felíu.'
- **64.** See also the comments which Kitaj made in his interview with Tim Hyman, 'A Return to London', *London Magazine*, February 1980, p. 24.
- **65.** Hugh Trevor-Roper, A Hidden Life: The Enigma of Sir Edmund Backhouse (London, 1976).
- 66. Kafka represents to Kitaj 'Jewishness in danger'. He first read Kafka when he was at sea in about 1950, and then seriously in Vienna, 'where my life drew close to his own haunts and to his ghost'. Kitaj's renewed interest in recent years in his own identity as a Jew brought him back to Kafka 'in force', but he explains that 'I'm not interested in representations of his terms. I am interested in my own terms and how a work like Amerika helps toward what I sense to be an oncoming synthesis of those terms of mine.' In his 1983 Oxford lecture he said that 'To my way of thinking, Kafka was the greatest Jewish artist who ever lived; that is merely his measure in my own life-in-art, so you'll have to forgive me for invoking that strange man as much as I tend to do. You see, there has been, for me, no Jewish painter of that quality, that breathtaking invention.' See also Clement Greenberg's essay, 'Kafka's Jewishness', first published in 1956 and republished in his Art and Culture (Boston, 1961), pp. 266-73, a highly stimulating interpretation of Kafka's work in terms of the Jewish condition. Kitaj regards this as one of the best things he has read about the writer.
- **67.** Kitaj knew Edgar Wind's book, Giorgione's 'Tempesta': with comments on Giorgione's poetic allegories (Oxford, 1969), which speculates on the possible meaning of this picture as a 'pastoral allegory' rather than as 'free fantasy' or as an inexplicable story.
- 68. See Timothy Hyman, 'R.B. Kitaj: Avatar of Ezra', op. cit., p. 55, and Michael Podro, op. cit., p. 21.
- **69.** This essay has not been published, but includes background information incorporated into the new text printed in this monograph. Kitaj's painting is based on Ambrogio Lorenzetti's *Good Government in the Country*, one of four frescos on the theme of good and bad government in the city and country, painted in 1338–9 in the Palazzo Pubblico, Siena. In his monograph on *Ambrogio Lorenzetti* (Princeton, 1958), George Rowley reproduces the four paintings, vol. 2, plates 157–60, and discusses them in vol. 1, pp. 99ff.
- 70. Kitaj worked from a reproduction in a magazine, but the image, a detail of Giotto's *The Funeral of Saint Francis* in the Bardi Chapel, Santa Croce, Florence, is also reproduced in Cesare Gnudi, *Giotto* (London, 1959), colour plate LXIV. See also *After Giotto* (1976–9), which makes reference to *The Flagellation* in the Scrovegni Chapel, Padua (Gnudi, plate 111), without being a direct copy. Kitaj views the latter in the context of contemporary social and political issues: 'If you know the Giotto Christ being mocked, the transmutation into an American Black from the Giotto source is not so irrational.' Perhaps the closest of all Kitaj's borrowings from Giotto is the 1980 pastel *Red Eyes*, from a detail of *St Francis Appearing to the*

Bishop and Brother Agostino in the Bardi Chapel (Gnudi, colour plate LXVII).

- 71. See the discussion of *The Jewish School* in Michael Peppiatt, 'R.B. Kitaj: pictures like novels', *Connaissance des arts*, September 1981, p. 33, and Frederic Tuten, 'Neither fool, nor naive, nor poseur-saint: Fragments on R.B. Kitaj', *Artforum*, January 1982, p. 66.
- 72. The head at the top centre of Rock Garden was derived from Jacopo Bassano's Lazarus and the Rich Man, which was one of the artist's favourite pictures in his childhood. For a reproduction of this painting, see the Handbook of the Cleveland Museum of Art, 1978, p. 114.
- 73. Kitaj says that his favourite painting in the National Gallery, London, is Cézanne's late, monumental Bathers, which he included in his Artist's Eye selection in 1980 and a detail from which he reproduced in the catalogue, op. cit., cat. 34. Another painting on this theme which he admires greatly is Le Grand Baigneur (1885-7, Museum of Modern Art, New York), of which he had a number of reproductions tacked on his wall while working on Cecil Court in 1983-4. Kitaj is fascinated by the derivation from a photograph of the painted figure, which is endowed with a convincing corporeal reality thanks to the functions of memory and experience. 'Cézanne transcended the photo because he was Cézanne, because his moment had come (1885), and it hardly mattered whether there was a model or a photo or just his imagination to work from. Even other wonderful things like the late Sickert paintings after photos are as nothing (to me) compared to this Cézanne. The reason lies in the greatness and mystery of Cézanne which I continue to ponder.'

One of the series, Bather (Torsion), is derived from Michelangelo's Last Judgement, which Kitaj calls his 'favorite painting of all time – a preposterous favorite'. Another figure from the same fresco had earlier acted as a source for The Perils of Revisionism (1963). The same reproduction from Life magazine was used by the artist in both cases.

- 74. The philosopher Richard Wollheim is, furthermore, a friend both of the two sitters and of the artist. The cover of his book on aesthetics, Art and its Objects (Harmondsworth, 1970), was designed by Golding. Wollheim himself was drawn by Kitaj in 1976 in preparation for a painting, Three Philosophers, which never materialized, and again in 1980.
- 75. Interview with George MacBeth, op. cit., p. 8.
- 76. There are two versions of the Rubens Portrait of Isabella Brant, his first wife, both dating from c. 1622: a painting acquired in 1947 by the Cleveland Museum of Art (reproduced in their 1978 Handbook, p. 154) and a drawing owned by the British Museum, exhibited in the British Museum's 1977 survey, Rubens: Drawings and Sketches, and illustrated in the accompanying catalogue by John Rowlands both in colour (p. 104) and black and white (p. 115). Kitaj had thus had the opportunity to see both versions at first-hand. The Dreyer detail was taken from a book of frame enlargements from Vampyr, which Kitaj owns, and the cover of which he had used for one of the In Our Time prints in 1969.
- 77. Reproduced in Edward Braun, Meyerhold on Theatre (London, 1969), opposite p. 305.

- 78. See also Kitaj's comments in Hyman, 'A Return to London', op. cit., pp. 26-7.
- **79.** In showing me his copy of My Secret Life, Kitaj remarked on the appeal of its Baudelairean flavour. 'It's about big city life and about the drama and fantasy which a person carries with him and most people don't talk about it or admit to any of it. One wonders how many people have a secret life.'
- 80. Goya's Self-Portrait with Dr Arrieta (1820), reproduced in European Paintings from the Minneapolis Institute of Arts (New York, 1971), p. 504, is inscribed by the artist to his doctor, who 'saved his life during a painful and dangerous illness endured at the end of 1819 in the seventy-third year of his life'. The doctor is shown propping up his patient and offering him a glass of water, a scheme closely followed by Kitaj in his drawing.
- 81. The appropriation of the technique from Monet's late work is particularly apt in this instance, given the precedent of Monet's own paintings depicting the garden which he had designed at Giverny as a peaceful retreat from the world.
- 82. The two versions of Balthus's La Rue, dated 1929 and 1933, had been known by Kitaj 'all my life', particularly as the later version was on display at the Museum of Modern Art, New York, during his youth. They are reproduced in Balthus, exhibition catalogue, Centre Georges Pompidou, Musée national d'art moderne, Paris, 5 November 1983–23 January 1984, cat. nos. 2 and 8 respectively. Kitaj visited the exhibition with Sandra Fisher during their brief honeymoon in Paris just before Christmas 1983.
- 83. While working on *Cecil Court* Kitaj was looking closely at Venetian painting and made repeated visits to the exhibition *The Genius of Venice: 1500–1600*, which was on view during the winter of 1983–4 at the Royal Academy, London. Pinned to his wall were reproductions of two pictures from the exhibition, Titian's *The Flaying of Marsyas* (a major but little-seen late work from an eastern European collection), and *The Washing of Feet*, a huge painting from Newcastle-upon-Tyne's Cathedral only recently reattributed to Tintoretto; the figure at the far left of the latter supplied Kitaj with a suitable head for his portrait of Seligmann. The two paintings are reproduced in the catalogue of the exhibition (London, 1983), cat. nos. 132 and 101 respectively.
- **84.** A photograph taken in 1929 of this chair in a setting also designed by Le Corbusier is reproduced in Henry-Russell Hitchcock and Philip Johnson, *The International Style* (New York, 1966), p. 127. Another classic modernist chair, this time one designed by Alvar Aalto which Kitaj himself owns, appears in *The Hispanist (Nissa Torrents)* (1977–8).
- **85.** The source for Kitaj's painting is Velázquez's *Philip IV Hunting Wild Boar* in the collection of the National Gallery, London.
- 86. Interview with Tim Hyman, February 1980, op. cit., p. 22.
- 87. See Colin St John Wilson, 'Reflections on the Relation of Painting to Architecture', *London Magazine*, April/May 1979, pp. 36–40. Wilson and his wife, M. J. Long, were the subject of an unfinished portrait on which Kitaj worked during the early eighties, called *The Architects*.

PLATES

1a. The sensualist, 1973–84. Oil on canvas, $97 \times 30\frac{3}{8}$ in. (246.4 \times 77.2 cm.). Nasjonalgalleriet, Oslo. Cat. no. 160.

1. Erasmus variations, 1958. Oil on canvas, 41 \times 33 $\frac{1}{8}$ in. (104.2 \times 84.2 cm.). Peter Cochrane, London. Cat. no. 3.

2. MISS IVY CAVENDISH (OXFORD), 1958. Charcoal pencil on paper, $21 \times 16\frac{3}{8}$ in. $(53.3 \times 41.6$ cm.). Collection of the artist. Cat. no. 4.

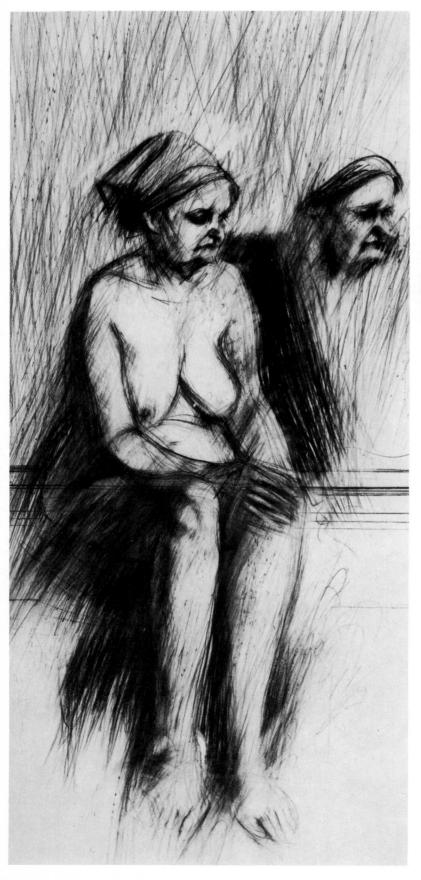

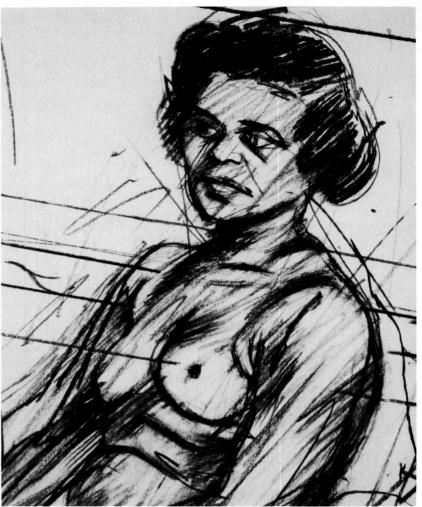

3. Oxford woman, c. 1958. Charcoal pencil on paper, 14 \times 12 in. (35.5 \times 30.5 cm.). Collection of the artist.

4. Tarot variations, 1958. Oil on canvas, 44×34 in. (111.8 \times 86.4 cm.). The High Museum (J.J. Haverty Collection), Atlanta, Georgia. Cat. no. 2.

5. The TWIN BIRTHDATES OF MARTIN LUTHER, 1960. Oil on canvas, 60×40 in. (152.4 \times 101.6 cm.). Private collection. Cat. no. 16.

7. words, 1959. Oil on canvas, 30 \times 24 in. (76.2 \times 61 cm.). The Lefevre Gallery, London. Cat. no. 8.

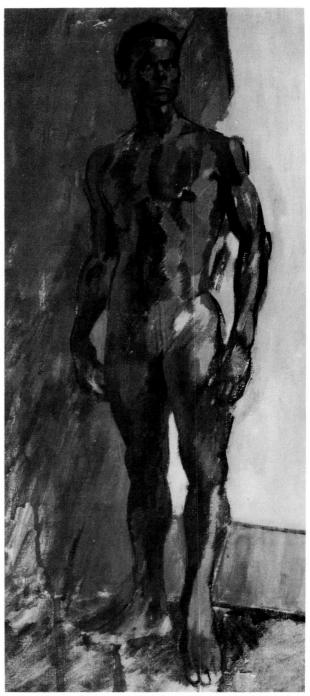

6. Oxford man, c. 1958. Oil on canvas. 15 \times 8 in. (38.1 \times 20.3 cm.). Collection of the artist.

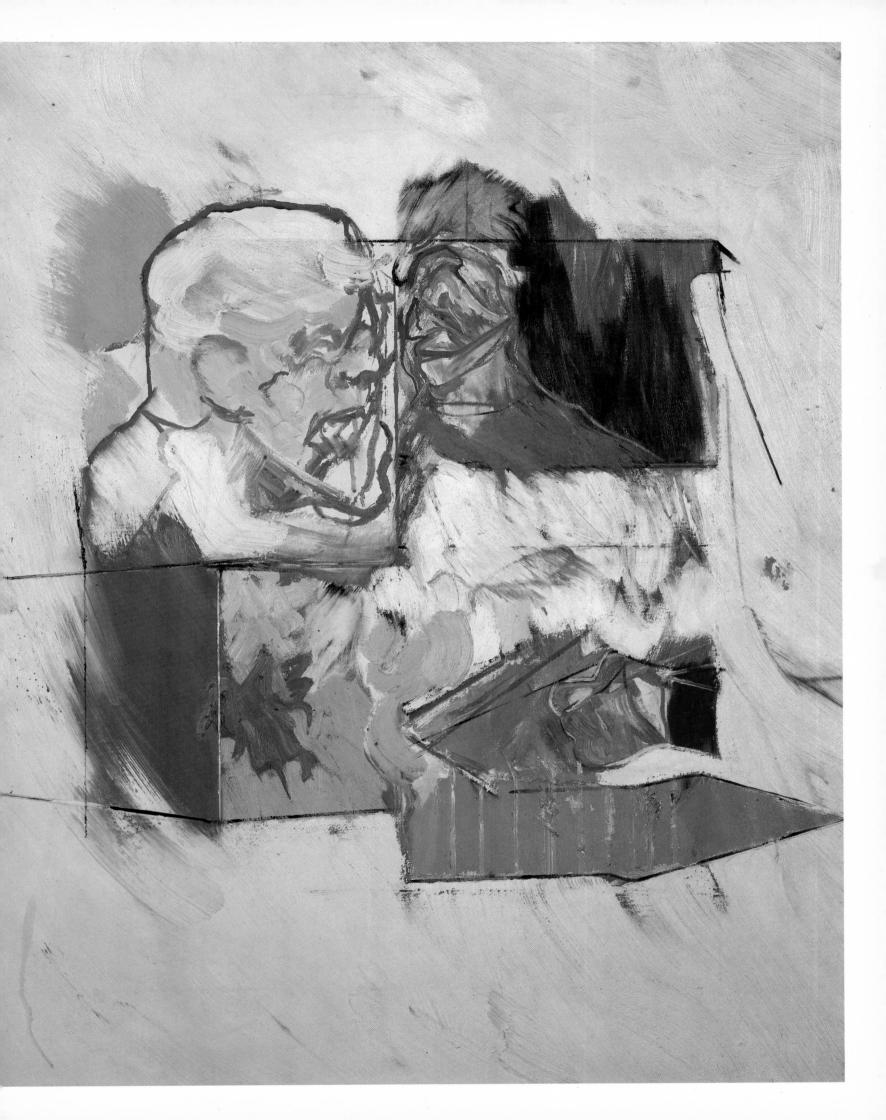

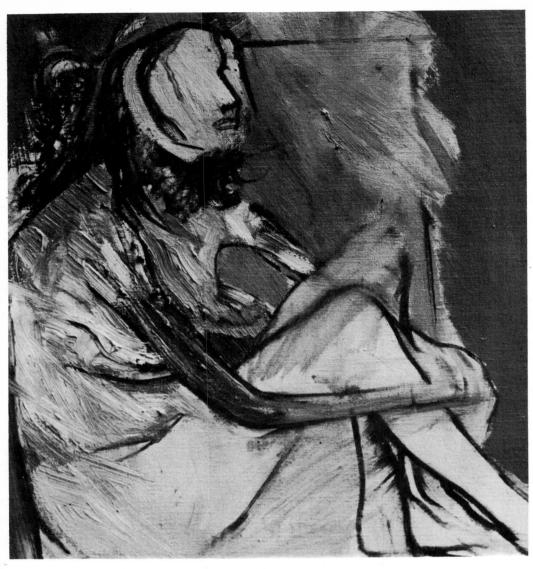

8. RED NUDE, c. 1960. Oil on canvas, 36×36 in. $(91.5 \times 91.5$ cm.). Collection of the artist.

9 (below left). The RED BANQUET, 1960. Oil on canvas, 48 × 48 in. (121.9 × 121.9 cm.). Walker Art Gallery, Liverpool. Cat. no. 10.

10. Homage to H. Melville (detail), 1962. Oil on canvas, 54×36 in. (137.2 \times 91.5 cm.). The Royal College of Art, London. Cat. no. 31.

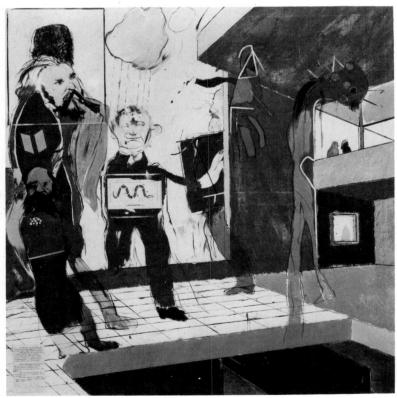

11. Yamhill, 1961. Oil, on canvas, 40×50 in. (101.6 \times 127 cm.). James H. Grady, Atlanta, Georgia. Cat. no. 20.

12. SPECIMEN MUSINGS OF A DEMOCRAT, 1961. Oil and collage on canvas, 40 × 50 in. (101.6 × 127 cm.). Colin St John Wilson, London. Cat. no. 23.

13. GIRL ON A SCOOTER (detail), 1970. Oil on canvas, $36\frac{1}{2} \times 13\frac{1}{2}$ in. (92.7 \times 34.3 cm.). Private collection, London. Cat. no. 141.

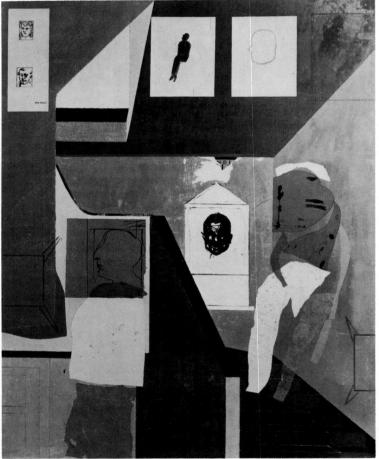

14. INTERIOR/DAN CHATTERTON'S TOWN HOUSE, 1962. Oil and collage on canvas, 60 × 48 in.
(152.4 × 121.9 cm.). Private collection, London. Cat. no. 39.

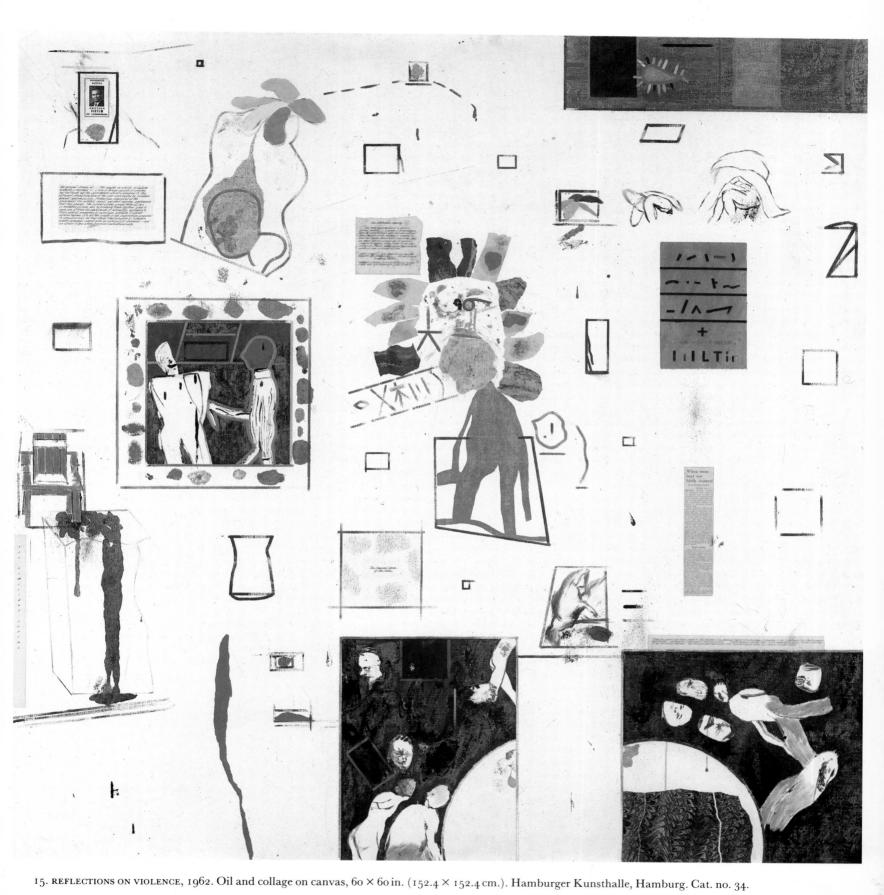

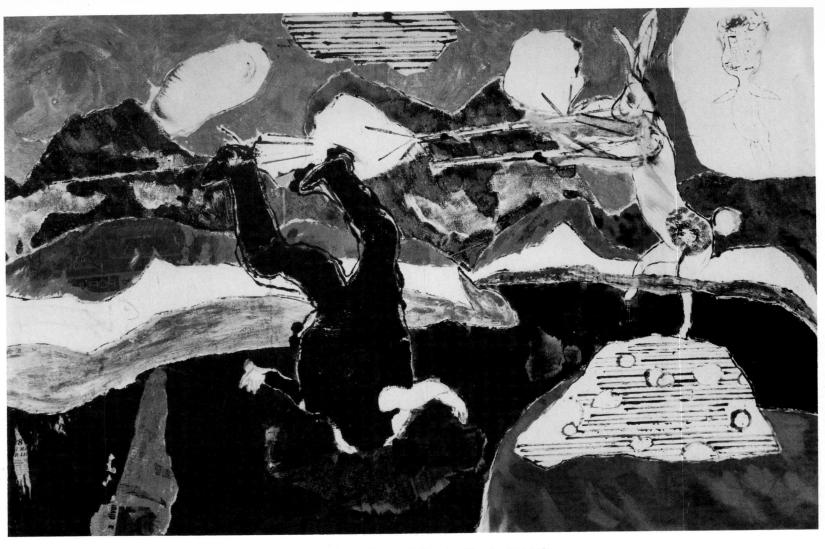

16. он, lemuel, 1960. Oil on canvas, 40 × $60\frac{1}{4}$ in. (101.6 × 153 cm.). Marlborough Fine Art (London) Ltd. Cat. no. 15.

17. Certain forms of association neglected before, 1961. Oil on canvas, 40×50 in. $(101.6 \times 127 \text{ cm.})$. Private collection. Cat. no. 19.

18. Apotheosis of groundlessness, 1964. Oil on canvas, 60×84 in. (152.4 \times 213.4 cm.). Cincinnati Art Museum, Ohio. Cat. no. 52.

- 19 (above left). The first terrorist, 1957. Oil on canvas, $6\frac{1}{2} \times 4\frac{1}{2}$ in. (16.5 × 11.4 cm.). Collection of the artist. Cat. no. 1.
- 20. VALUE, PRICE AND PROFIT (detail), 1963. Oil on canvas, 60 × 60 in. (152.4 × 152.4 cm.). Private collection, London. Cat. no. 17.

21. PARIAH (detail), 1960. Oil on canvas, 40 × 50 in. (101.6 × 127 cm.). Silkeborg Kunstmuseum (Asger Jorn Donation), Denmark. Cat. no. 14.

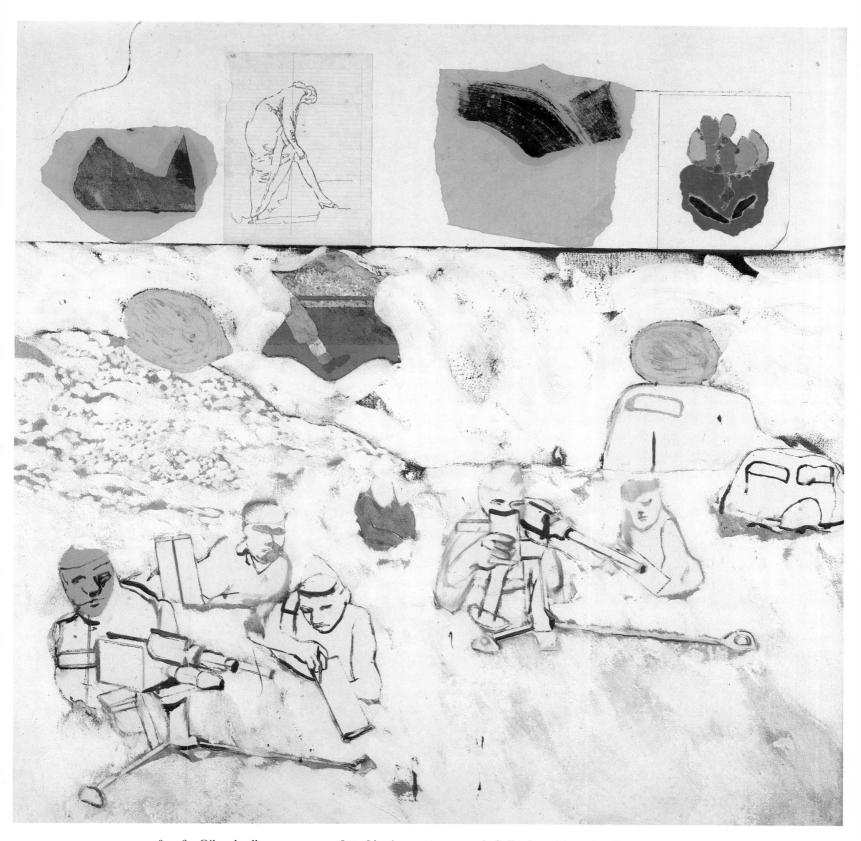

22. Kennst du das land?, 1962. Oil and collage on canvas, 48×48 in. $(121.9 \times 121.9 \text{ cm.})$. Collection of the artist. Cat. no. 32.

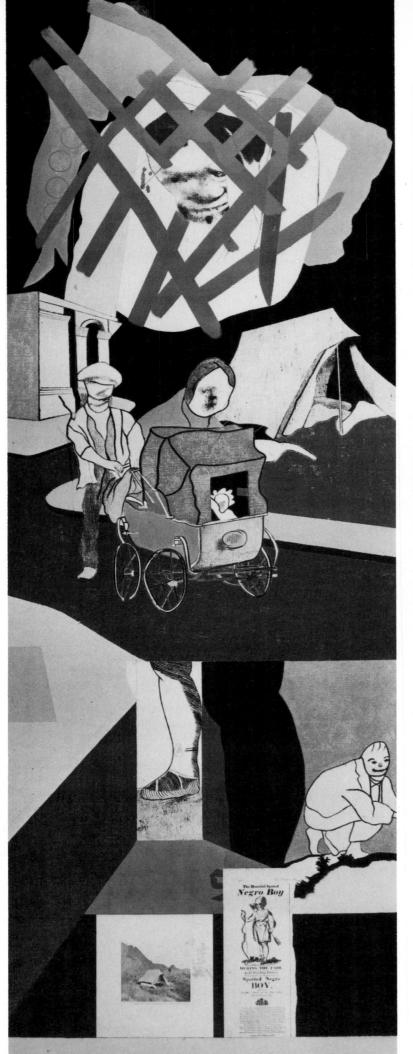

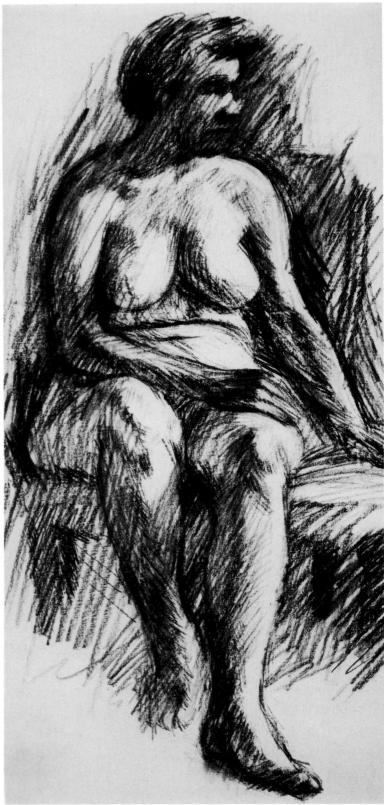

23 (left). The baby tramp, 1963/4. Oil and collage on canvas, 72 \times 24 in. (182.9 \times 61 cm.). Gemeentemuseum, The Hague. Cat. no. 51.

24. Life study, c. 1958. Charcoal pencil on paper, 21 \times 16 in. (53.3 \times 40.6 cm.). Collection of the artist.

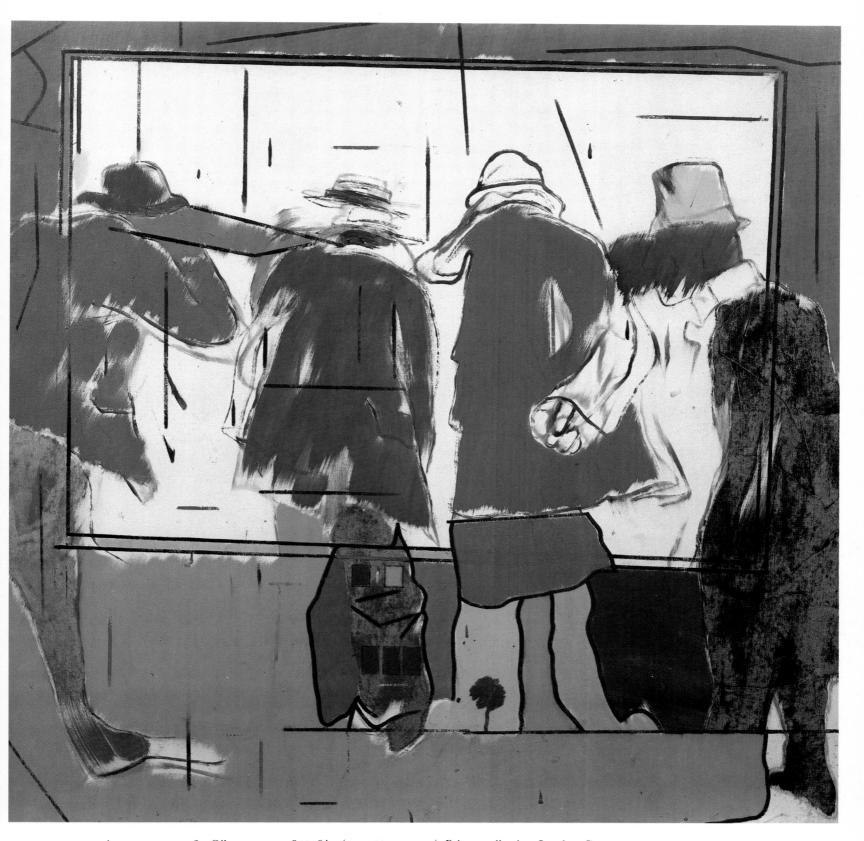

25. Nietzsche's moustache, 1962. Oil on canvas, 48×48 in. (121.9 \times 121.9 cm.). Private collection, London. Cat. no. 29.

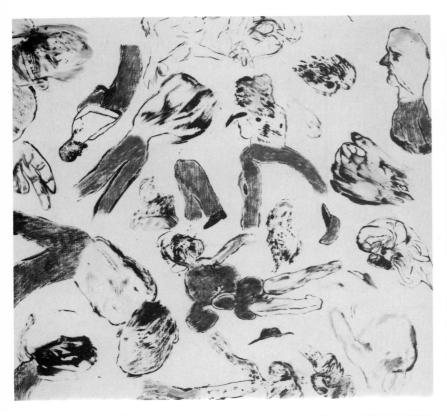

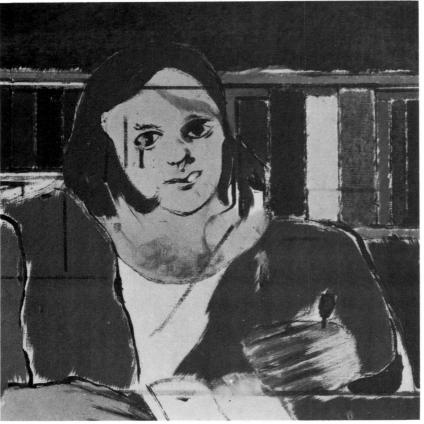

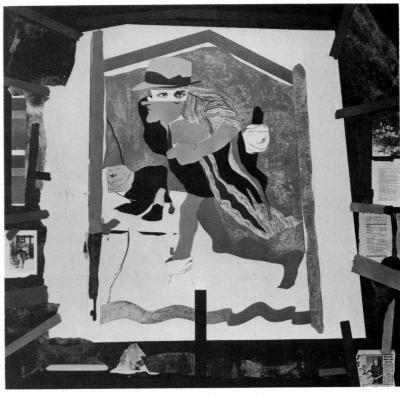

26 (above left). The Bells of Hell(detail), 1960. Oil on canvas, 36×60 in. (91.5 \times 152.5 cm.). Waddington Galleries, London. Cat. no. 12.

27. RANDOLPH BOURNE IN IRVING PLACE, 1963. Oil and collage on canvas, 60×60 in. $(152.4 \times 152.4$ cm.). Private collection, Switzerland. Cat. no. 50.

28. A STUDENT OF VIENNA (detail), 1961–2. Oil and collage on canvas, 36×36 in. (91.5 \times 91.5 cm.). James H. Grady, Atlanta, Georgia. Cat. no. 26.

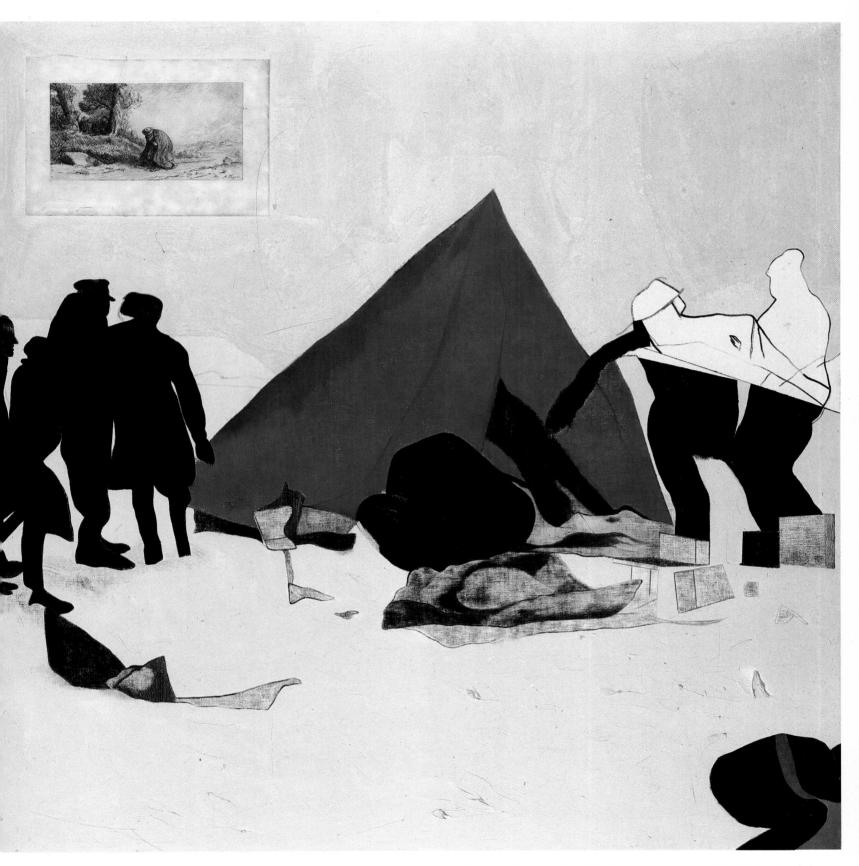

29. DISMANTLING THE RED TENT, 1964. Oil on canvas, including an original etching by Alphonse Legros, 48 × 48 in. (121.9 × 121.9 cm.). The Michael and Dorothy Blankfort Collection at Los Angeles County Museum. Cat. no. 75.

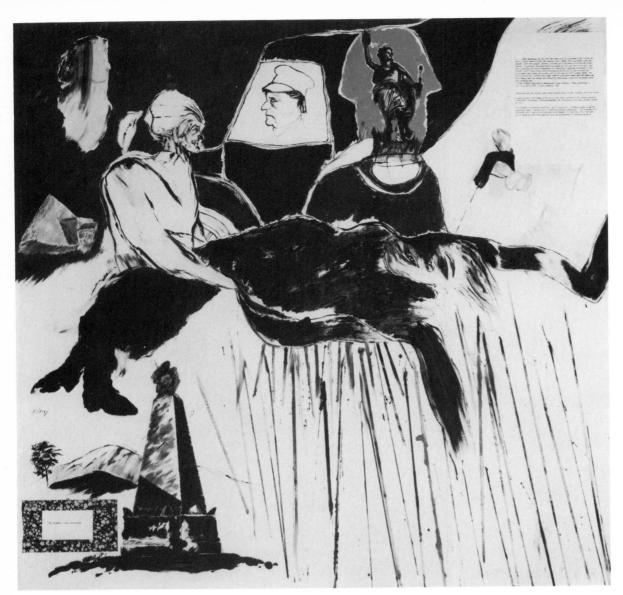

30. The Murder of Rosa Luxemburg, 1960. Oil and collage on canvas, 60×60 in. (152.5 \times 152.5 cm.). The Tate Gallery, London. Cat. no. 13.

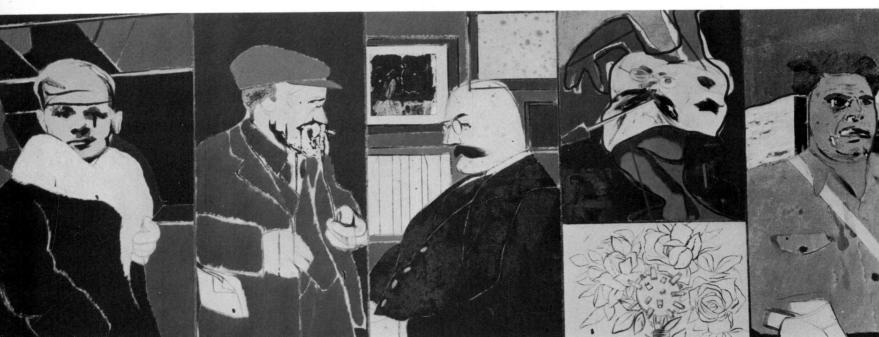

31. Junta, 1962. Oil and collage on canvas, 36×84 in. $(91.4\times213.4$ cm.). Colin St John Wilson, London. Cat. no. 30.

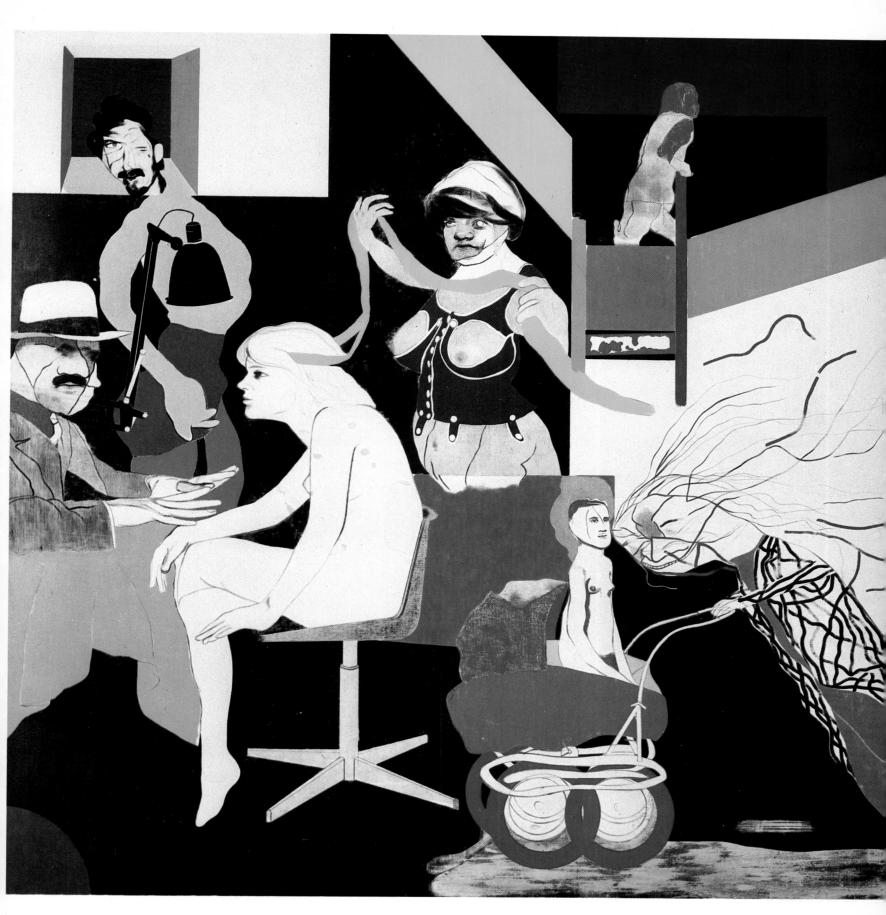

32. The ohio gang, 1964. Oil on canvas, 72×72 in. (182.9 \times 182.9 cm.). The Museum of Modern Art (Philip Johnson Fund, 1965), New York. Cat. no. 53.

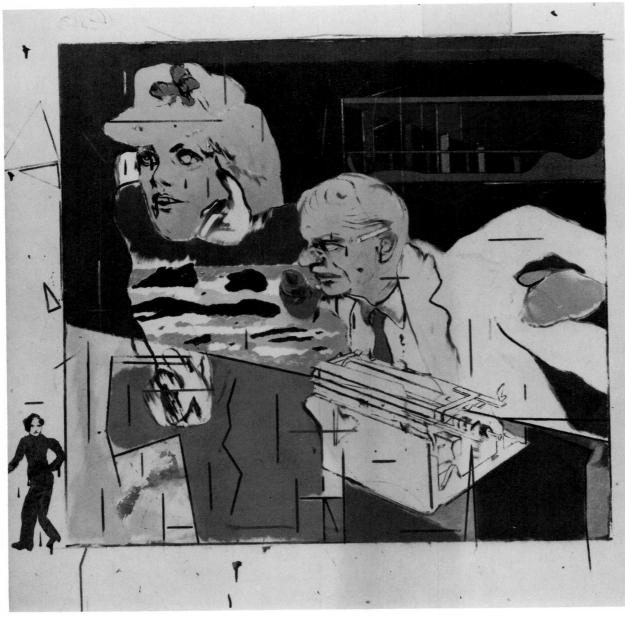

33. GOOD NEWS FOR INCUNABULISTS, 1962. Oil on canvas, 60 × 60 in. (152.4 × 152.4 cm.). Private collection, Germany. Cat. no. 33.

- 34. ISAAC BABEL RIDING WITH BUDYONNY (detail), 1962. Oil on canvas, 72×72 in. (182.9 \times 182.9 cm.). The Tate Gallery, London. Cat. no. 35.
- 35. PRIEST, ETC., 1961. Oil on canvas, 40 × 50 in. (101.6 × 127 cm.). Colin St John Wilson, London. Cat. no. 25.

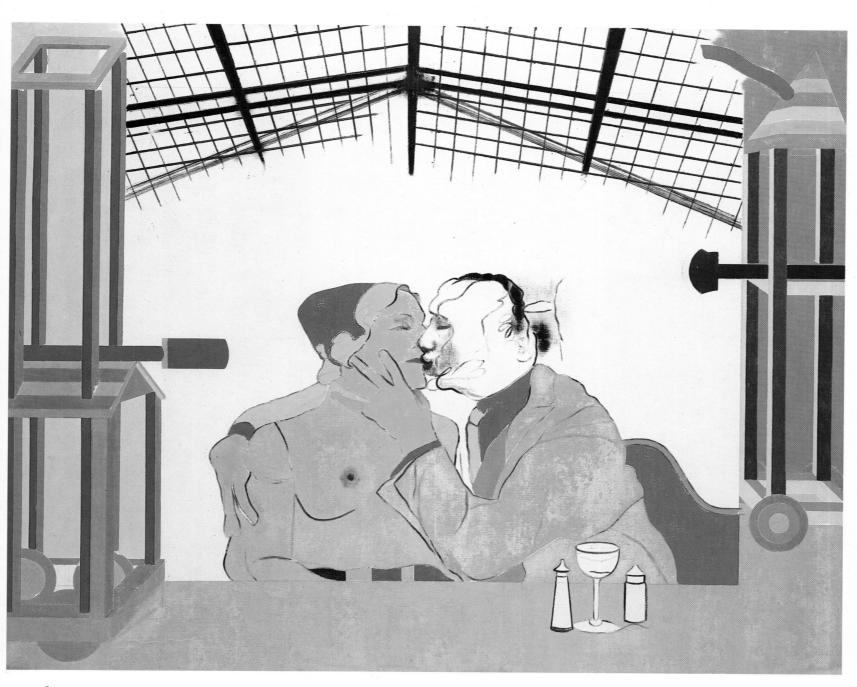

36. Where the railroad leaves the Sea, 1964. Oil on canvas, 48×60 in. (121.9 \times 152.4 cm.). Collection of the artist. Cat. no. 57.

37. MARIA PROPHETISSA, 1964. Oil on canvas, 10×8 in. $(25.4 \times 20.3 \text{ cm.})$. Private collection. Cat. no. 66.

38. Casting (detail), 1967–9. Oil on canvas, $98\frac{1}{2} \times 36$ in. (250.2 \times 91.4 cm.). Museum Ludwig, Cologne. Cat. no. 104.

39. Aureolin, 1964. Oil on canvas, 60×48 in. (152.4 \times 121.9 cm.). Mr and Mrs Ian Stoutzker, London. Cat. no. 76.

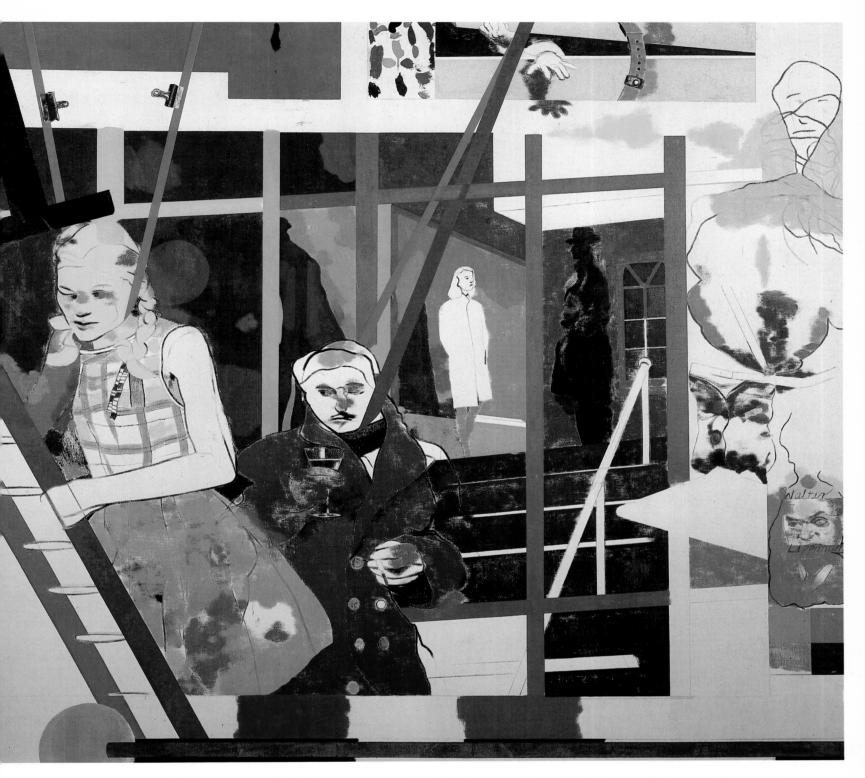

40. WALTER LIPPMANN, 1966. Oil on canvas, 72×84 in. $(182.9 \times 213.4$ cm.). Albright-Knox Art Gallery, (Gift of Seymour H. Knox, 1967), Buffalo, New York. Cat. no. 88.

41. Notes towards a definition of nobody (detail), 1961. Oil on canvas, 48×88 in. (121.9 \times 223.5 cm.). The Toledo Museum of Art (Gift of Dr & Mrs Joseph A. Gosman), Ohio. Cat. no. 22.

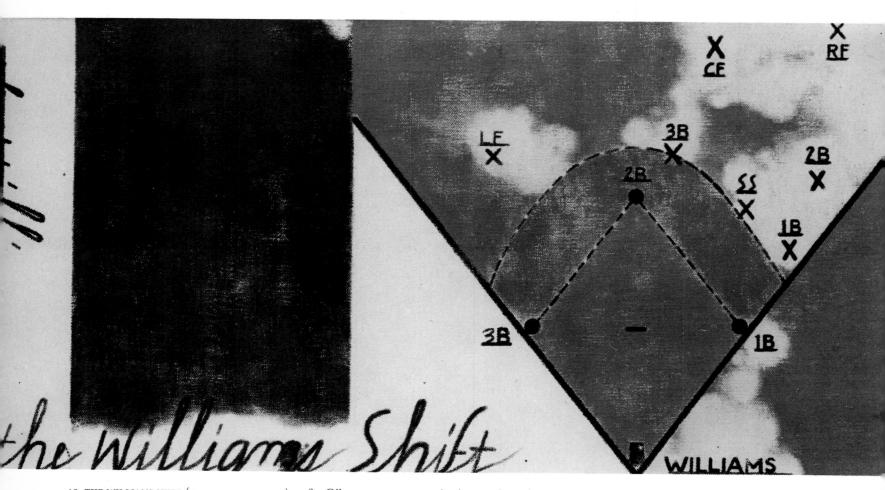

42. The Williams shift (for Lou Boudreau), 1967. Oil on canvas, 12 \times 24 in. (30.5 \times 61 cm.). Private collection. Cat. no. 94.

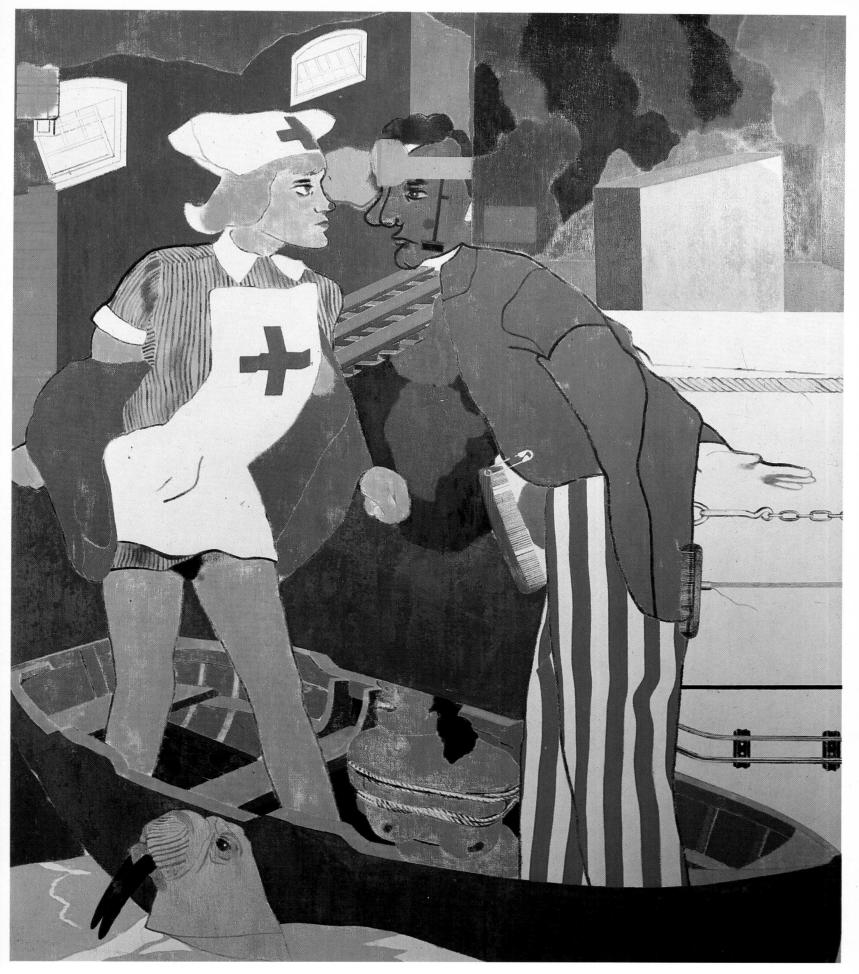

43. ERIE SHORE (detail), 1966. Oil on canvas, 72 × 60 in. (182.9 × 152.4 cm.). Nationalgalerie, Berlin, Staatliche Museen, Stiftung Preussische Kulturbesitz. Cat. no. 89.

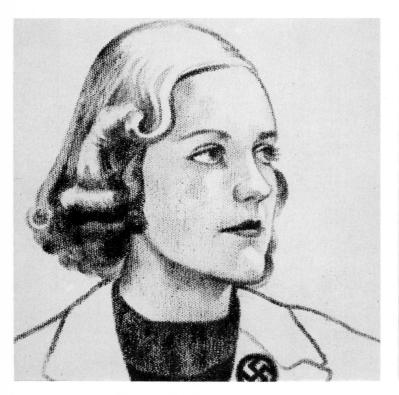

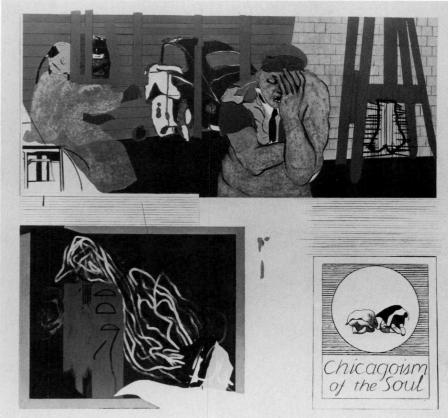

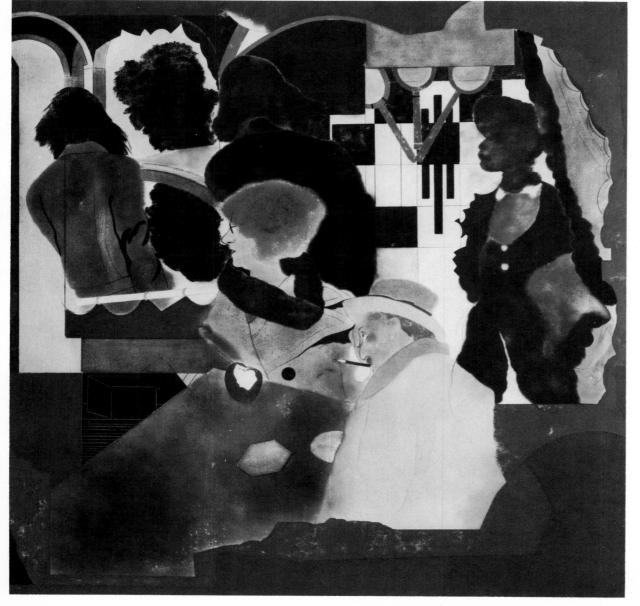

- 44 (above left). UNITY MITFORD, 1968. Oil on canvas, 10 × 8 in. (25.4 × 20.3 cm.). Collection of the artist. Cat. no. 107.
- 45 (above right). The Perils of Revisionism, 1963. Oil on canvas, 60×60 in. (152.4 \times 152.4 cm.). Private collection, New York. Cat. no. 49.
- 46. ARCADES (AFTER WALTER BENJAMIN), 1972–4. Oil on canvas, 60 × 60 in. (152.4 × 152.4 cm.). I.R. Wookey, Toronto. Cat. no. 150.

47. SYNCHROMY WITH F.B. —
GENERAL OF HOT DESIRE
(detail), 1968—9. Oil on
canvas (diptych), each
panel 60 × 36 in.
(152.4 × 91.5 cm.). Mr and
Mrs Ian Stoutzker, London.
Cat. no. 113.

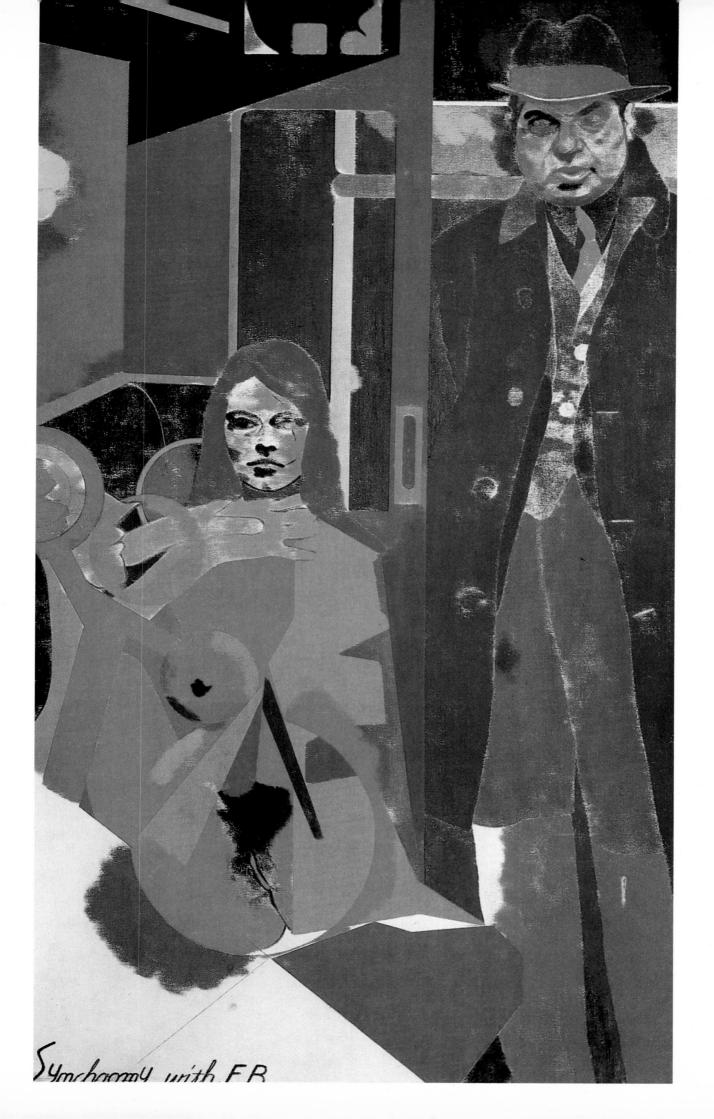

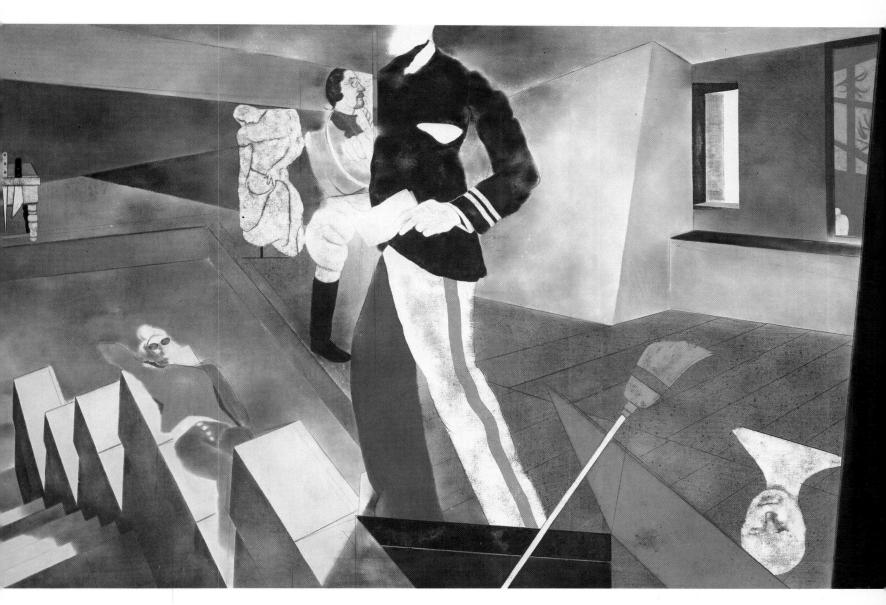

49. Malta (for Chris and Rose), 1974. Oil on canvas, 60×96 in. (152.4 \times 243.8 cm.). Private collection, Belgium. Cat. no. 162.

48. LITTLE SLUM PICTURE, 1968. Oil on canvas, 30×24 in. $(76.2 \times 61$ cm.). Stanley Seeger, Sutton Place Heritage Trust, Guildford. Cat. no. 106.

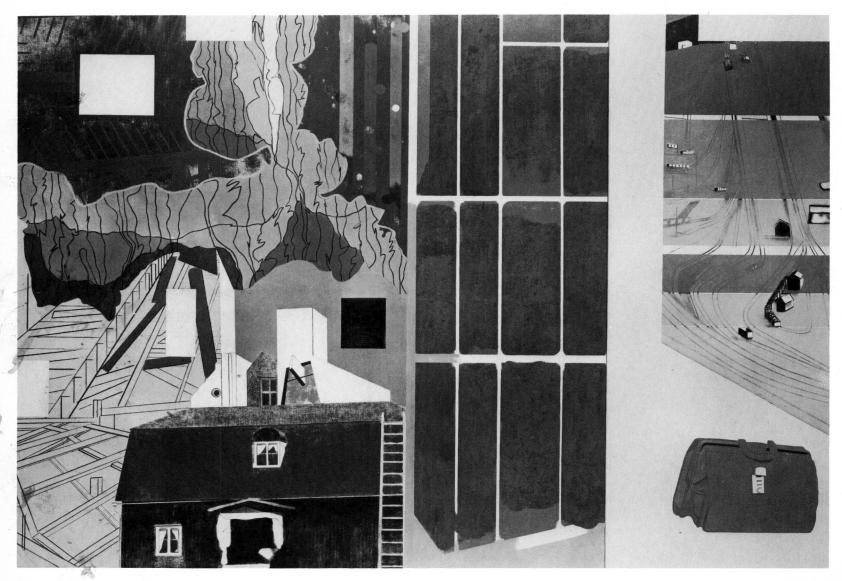

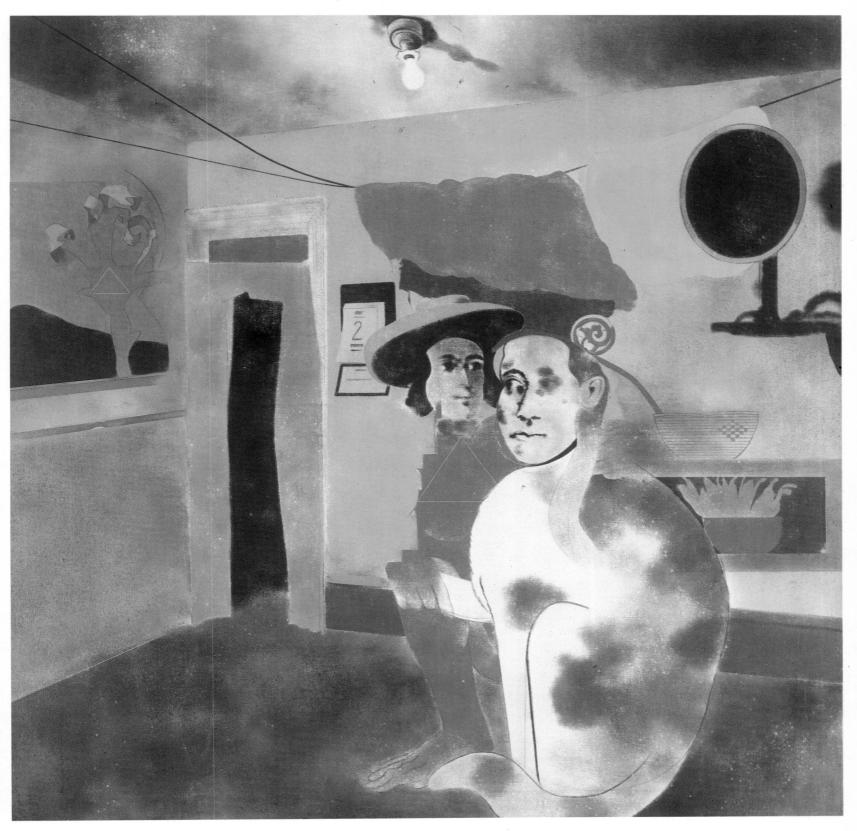

53. The man of the woods and the cat of the mountains, 1973. Oil on canvas, 60×60 in. $(152.4 \times 152.4 \,\mathrm{cm.})$. The Tate Gallery, London. Cat. no. 158.

^{50.} LITTLE SUICIDE PICTURE, 1969. Oil on canvas, 20 × 20 in. (50.8 × 50.8 cm.). The Baltimore Museum of Art (Thomas Benesch Memorial Collection), Maryland. Cat no. 125.

^{51.} La passionaria, 1969. Oil on canvas, $16\frac{3}{4} \times 12\frac{1}{2}$ in. $(42.5 \times 31.8$ cm.). Colin St John Wilson, London. Cat. no. 120.

^{52 (}left). Trout for factitious Bait, 1965. Oil on canvas, $60 \times 83\frac{1}{2}$ in. (152.4 \times 212.1 cm.). The Whitworth Art Gallery, University of Manchester. Cat. no. 84.

54 (top). Little Romance I, 1969. Oil on canvas, 12×10 in. $(30.5 \times 25.4 \text{ cm.})$. Private collection. Cat. no. 116. 55. Jack London Square, Oakland, 1969. Oil on canvas, 24×30 in. $(61 \times 76.2 \text{ cm.})$. Private collection, Belgium. Cat. no. 114. 56 (right). Hugh Lane, 1972. Oil on canvas, 96×30 in. $(243.8 \times 76.2 \text{ cm.})$. Private collection, Switzerland. Cat. no. 148.

57. The autumn of central paris (after walter benjamin), 1972–3. Oil on canvas, 60×60 in. (152.4 \times 152.4 cm.). Mrs Susan Lloyd, New York. Cat. no. 149.

58 (above). St theresa(detail of Plate $6\,\mathrm{i}$).

59 (above right). WASHING CORK (RAMON), 1978. Pastel on paper, 22 × 15 in. (55.9 × 38.1 cm.). The American Can Company, Greenwich, Connecticut. Cat. no. 234.

60. Jose Vicente (unfinished study for the singers), 1972–4. Oil and charcoal on canvas, 48 × 24 in. (121.9 × 61 cm.). Collection of the artist. Cat. no. 151.

61. Juan de la cruz, 1967. Oil on canvas, 72×60 in. (182.9 \times 152.4 cm.). Private collection, Brussels. Cat. no. 93.

62. Kenneth anger and Michael Powell, 1973. Oil on canvas, 96×60 in. $(243.8 \times 152.4$ cm.). Ludwig Collection, Aix-la-Chapelle. Cat. no. 155.

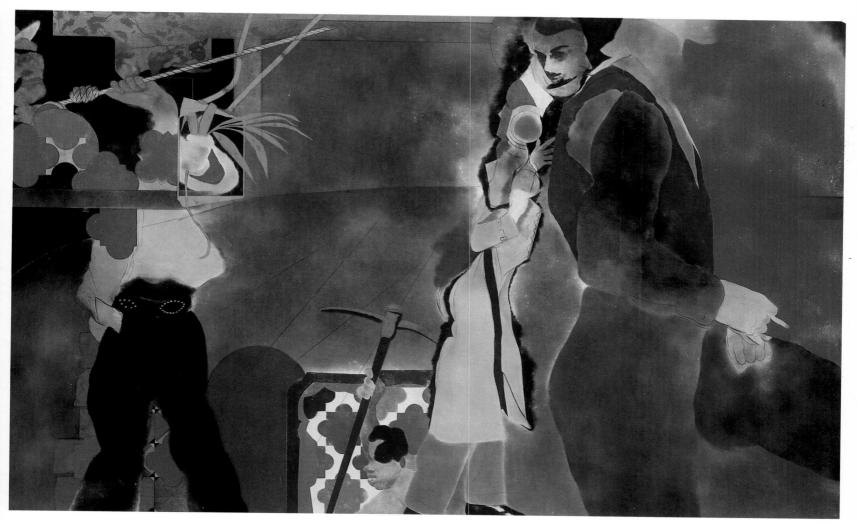

63. PACIFIC COAST HIGHWAY (ACROSS THE PACIFIC), 1973. Oil on canvas, left-hand panel, 96×60 in. $(243.8 \times 152.4 \, \text{cm.})$, right-hand panel, 60×60 in. $(152.4 \times 152.4 \, \text{cm.})$. Colin St John Wilson, London. Cat. no. 154.

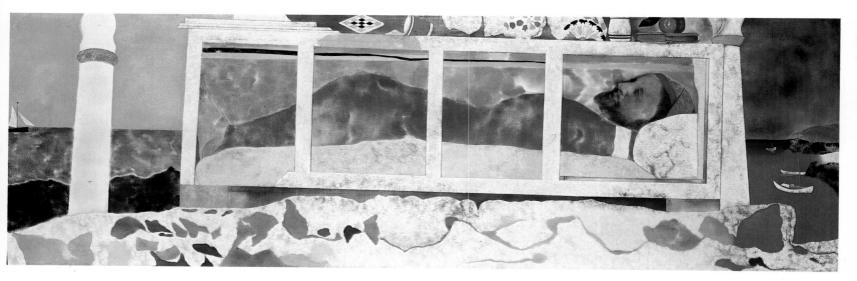

64. CATALAN CHRIST (PRETENDING TO BE DEAD), 1976. Oil on canvas, 30 × 96 in. (76.2 × 243.8 cm.). Louisiana Museum of Art, Humlebaek, Denmark. Cat. no. 64.

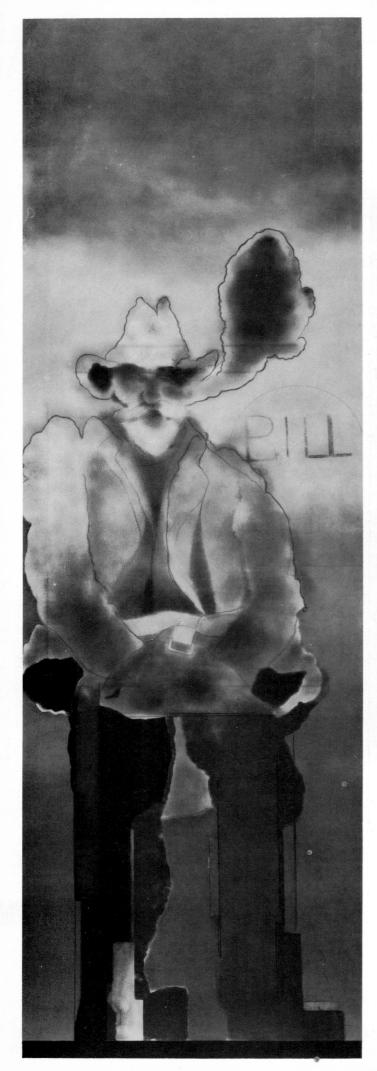

66. Superman (detail of Plate 68).

65 (left). BILL at sunset, 1973. Oil on canvas, 96×30 in. (243.8 \times 76.2 cm.). Private collection, London. Cat. no. 156.

- 67 (right). ватман, 1973. Oil on canvas, 96 × 30 in. (243.8 × 76.2 cm.). Private collection, Cologne. Cat. no. 152.
- 68 (far right). Superman, 1973. Oil on canvas, 96×30 in. (243.8 \times 76.2 cm.). Private collection, Cologne. Cat. no. 153.

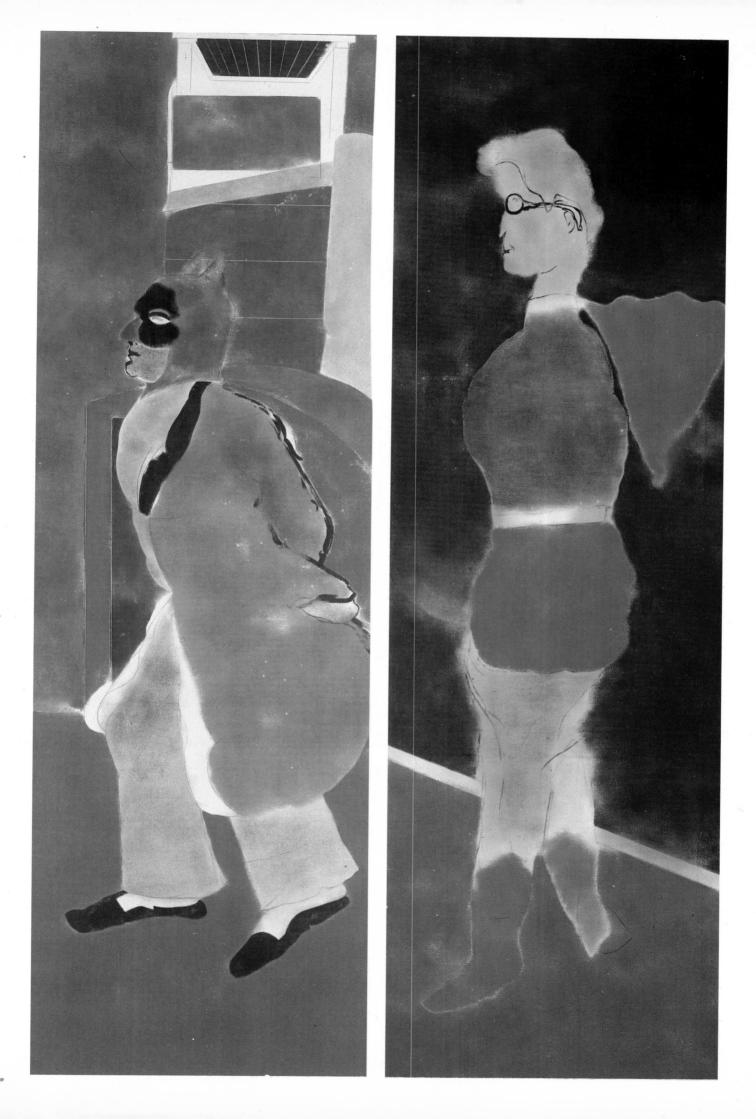

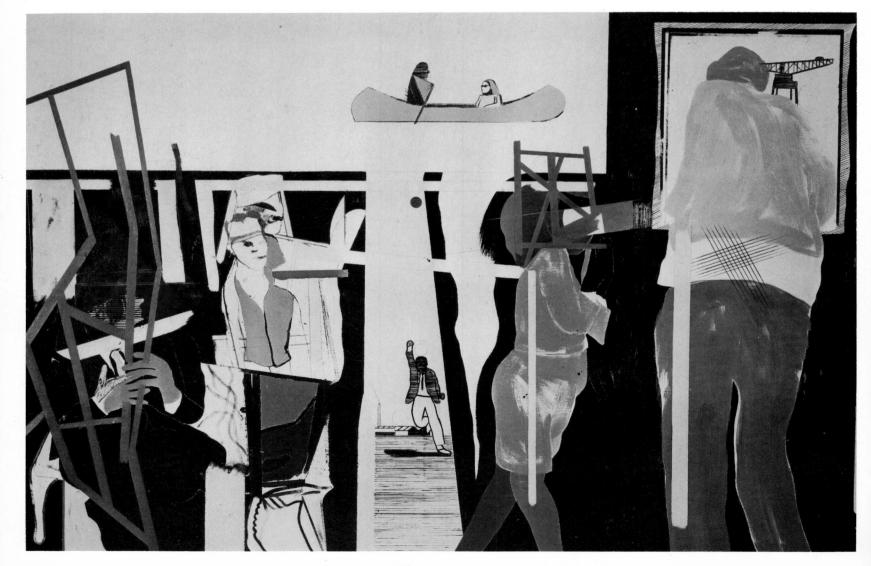

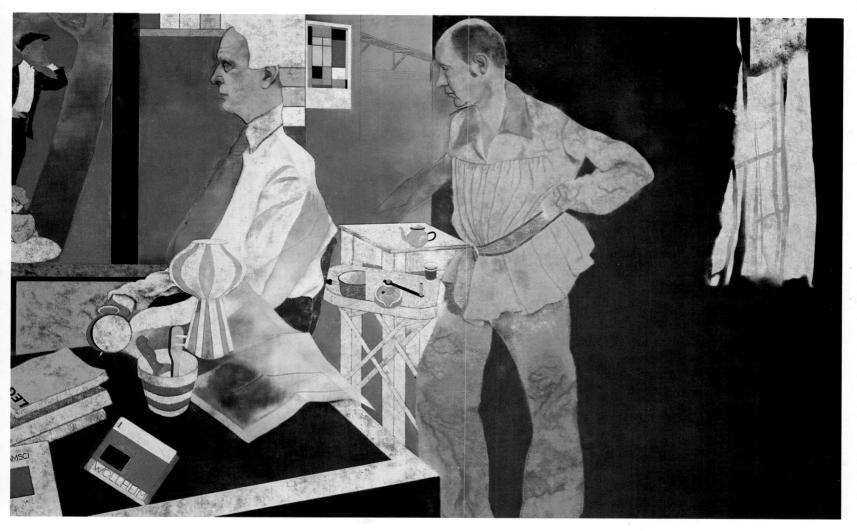

72. From London (James Joll and John Golding), 1975–6. Oil on canvas, 60×96 in. (152.4 \times 243.8 cm.). Private collection, Monte Carlo. Cat. no. 185.

^{69 (}top left). Outlying London districts (in Camberwell)(detail), 1969. Oil on canvas, 96 × 36 in. (243.8 × 91.5 cm.). Private collection, Belgium. Cat. no. 122.

^{70 (}top right). Thanksgiving(detail), 1966–7. Oil on canvas, 60 × 72 in. (152.4 × 182.9 cm.). Colin St John Wilson, Cambridge. Cat. no. 92.

^{71.} тереим, 1963. Oil on canvas, 48 × 72 in. (121.9 × 182.9 cm.). National Museum of Wales, Cardiff. Cat. no. 45.

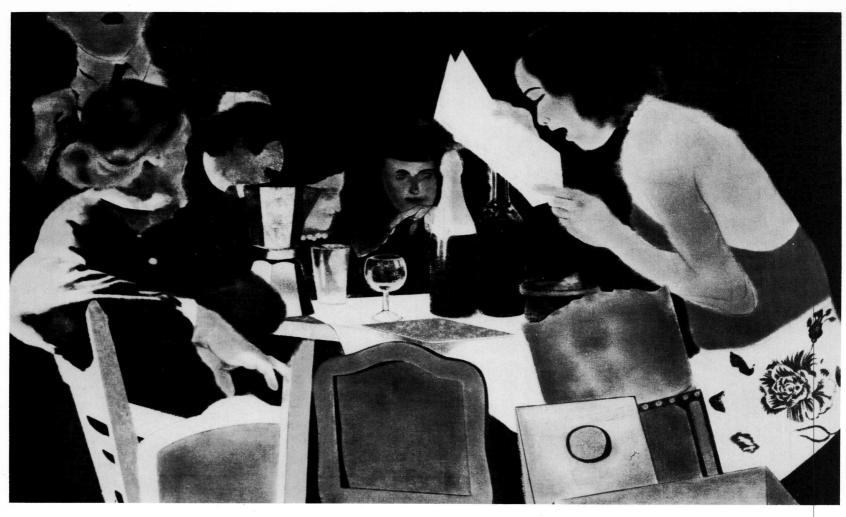

73. TO LIVE IN PEACE (THE SINGERS), 1973–4. Oil on canvas, 84×30 in. (213.4 \times 76.2 cm.). Muriel and David Binder, New York. Cat. no. 159.

74. MY CAT AND HER HUSBAND, 1977. Pastel and charcoal on paper, 15×22 in. (38.1 \times 55.9 cm.). Dominie Lee Kitaj, London. Cat. no. 201.

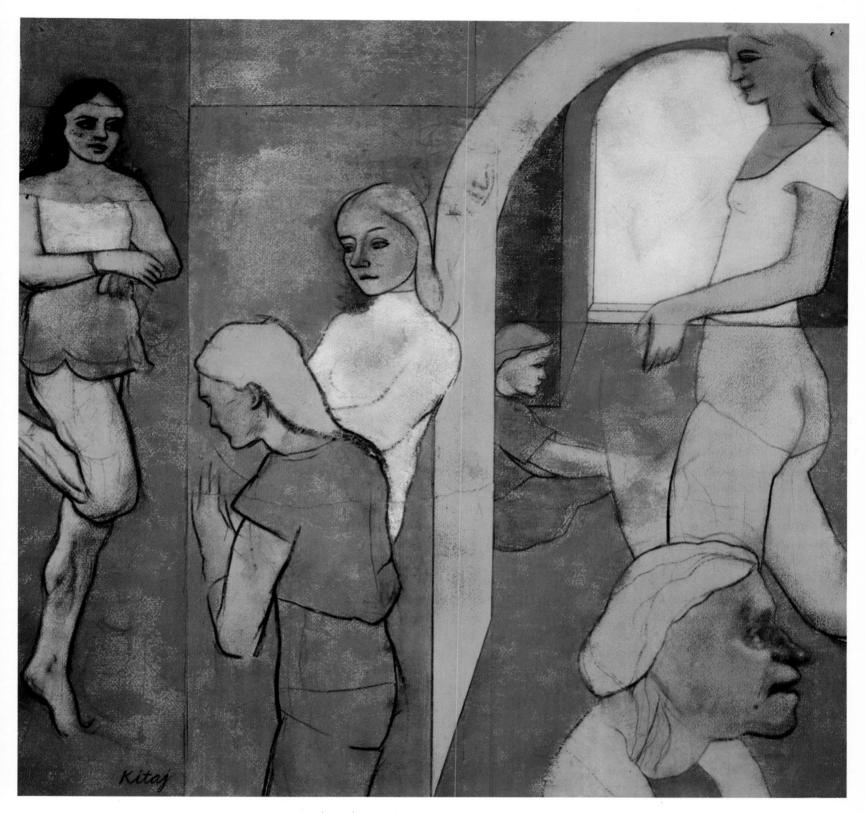

75. SIGHS FROM HELL, 1979. Pastel and charcoal on paper, $38\frac{1}{2} \times 39\frac{1}{2}$ in. $(97.8 \times 100.3 \text{ cm.})$. Edwin A. Bergman, Chicago. Cat. no. 241.

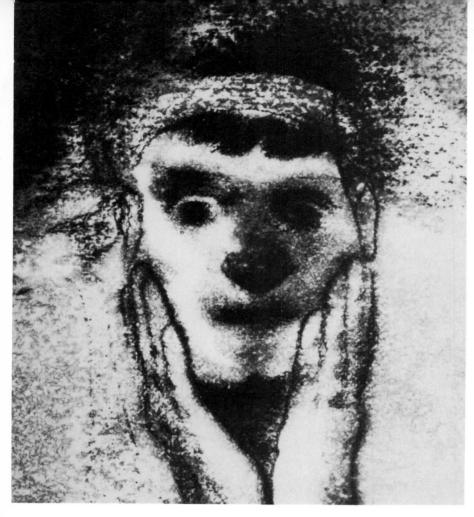

76. Bather (torsion) (detail), 1978. Pastel on paper, $54^{\frac{1}{4}} \times 22^{\frac{3}{8}}$ in. (137.8 \times 56.8 cm.). Sovereign American Arts Corporation, New York. Cat. no. 228.

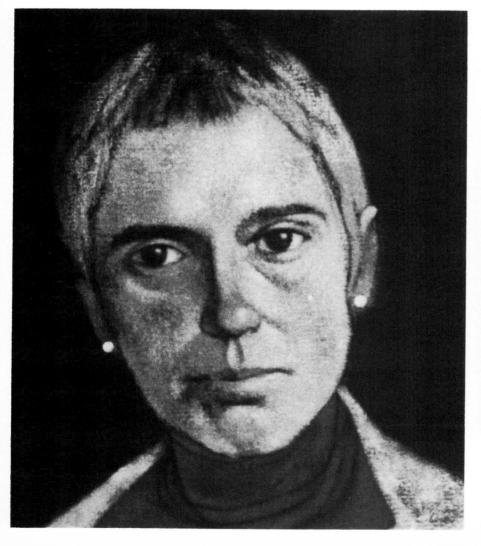

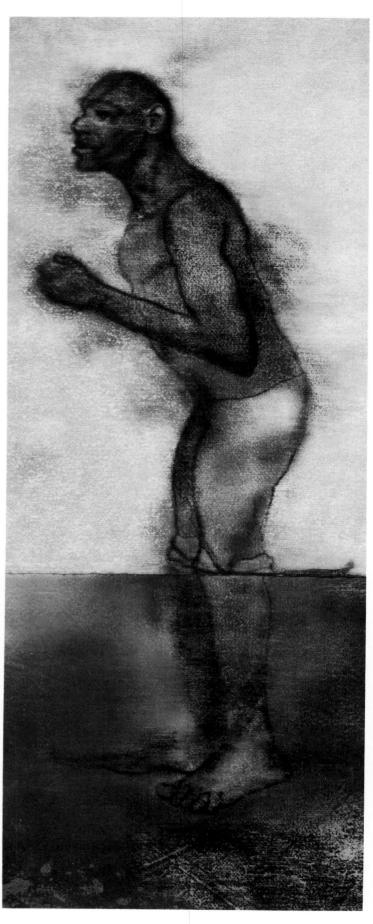

78. Bather (Wading), 1978. Pastel on paper, $48\frac{3}{4} \times 22\frac{3}{8}$ in. (123.8 × 56.8 cm.). Nelson Blitz, Jr., New York. Cat. no. 224.

77. NISSA TORRENTS (detail of Plate 79).

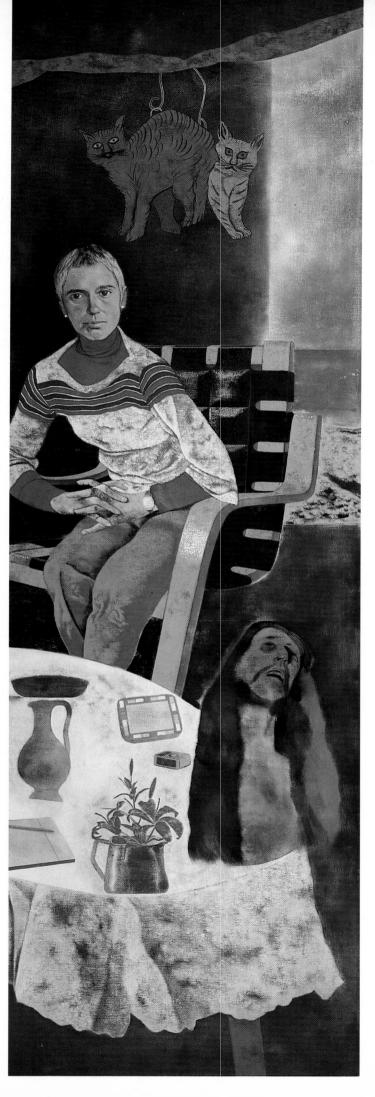

79. THE HISPANIST (NISSA TORRENTS) 1977–8. Oil on canvas, 96×30 in. (243.8 \times 76.2 cm.). H.R. Astrup, Oslo. Cat. no. 205.

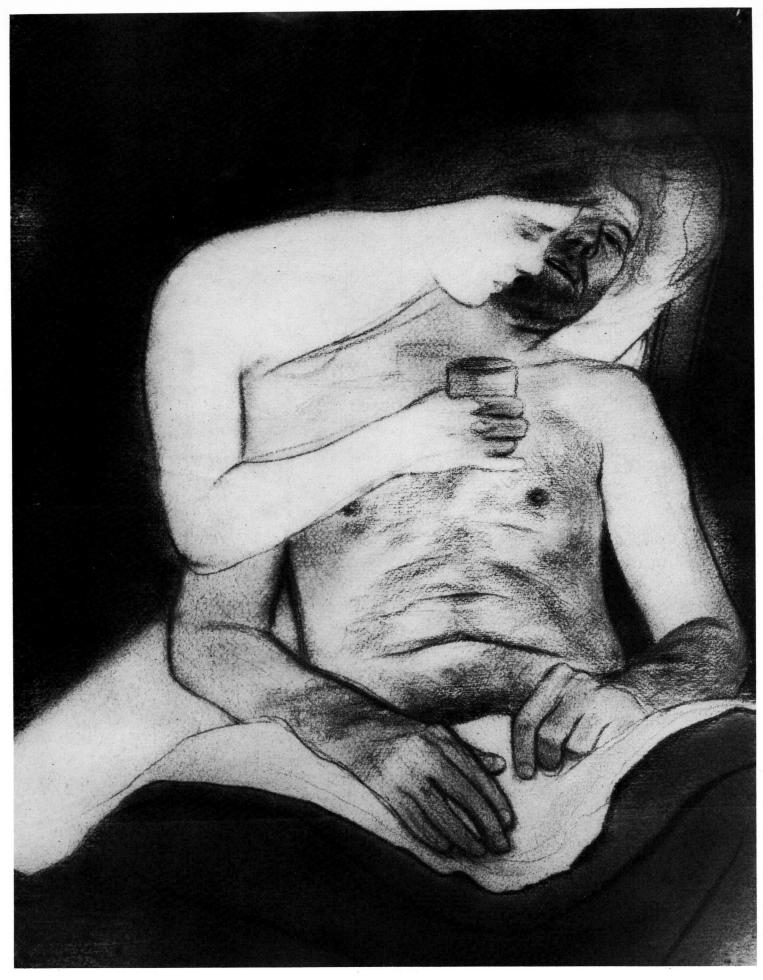

80. The green blanket, 1978. Pastel and charcoal on paper, $30\frac{1}{4} \times 22$ in. $(76.8 \times 55.9 \, \text{cm.})$. Private collection, Switzerland. Cat. no. 231.

81. The Philosopher-Queen, 1978–9. Pastel and charcoal on paper, $30\frac{1}{4} \times 22$ in. $(76.8 \times 55.9$ cm.). Collection of the artist. Cat. no. 239.

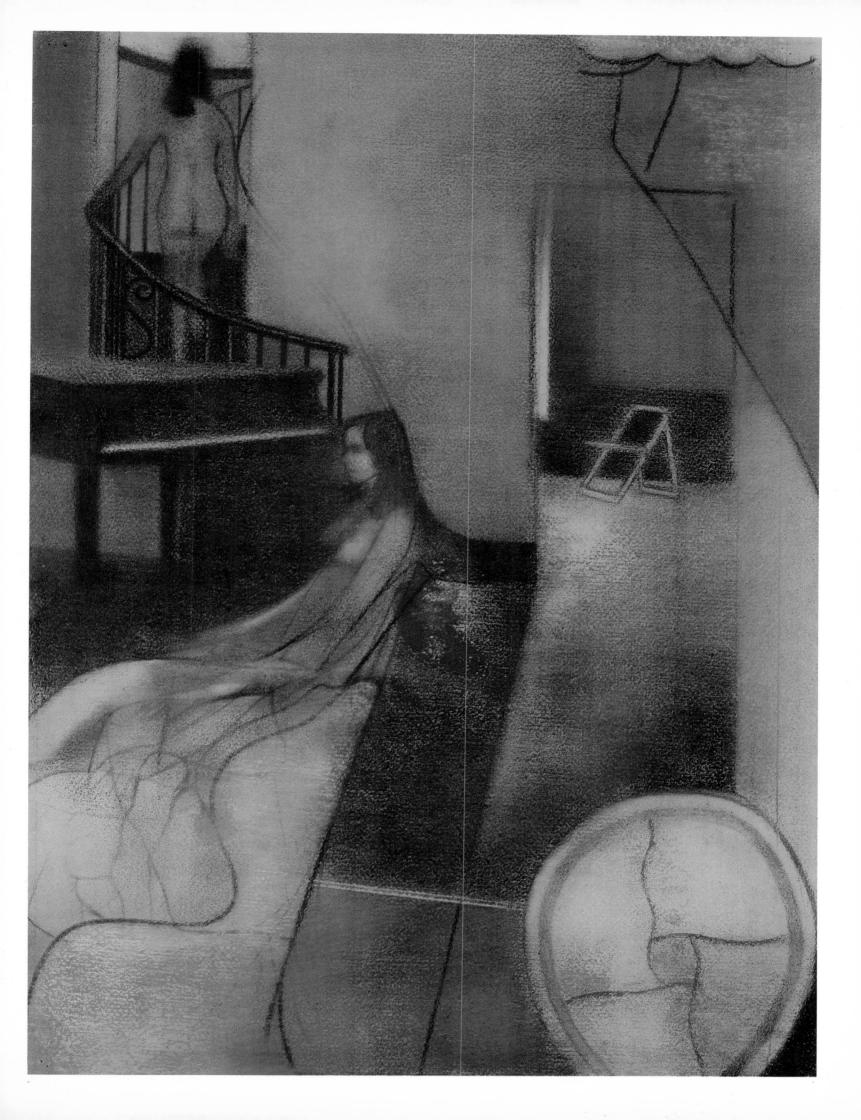

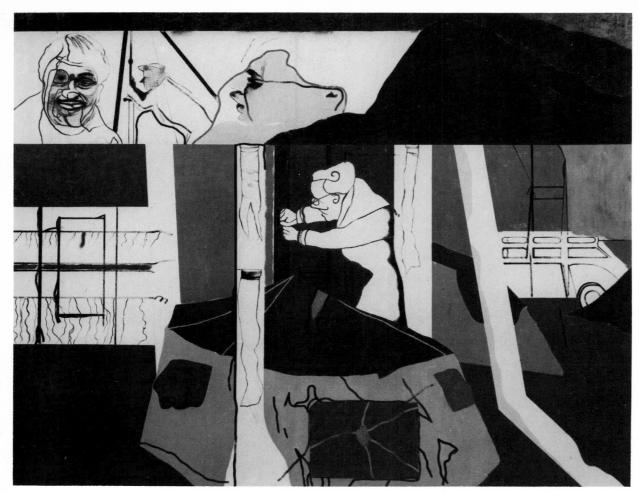

82. Primer of motives (intuitions of irregularity) (detail), 1965. Oil on canvas, 60×60 in. $(152.4 \times 152.4$ cm.). Private collection, Belgium. Cat. no. 81.

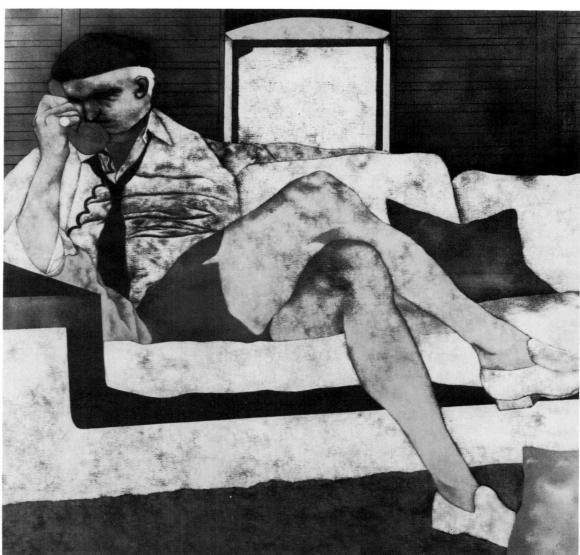

83. Marrano (the secret Jew), 1976. Oil and charcoal on canvas, 48×48 in. (121.9 \times 121.9 cm.). Private collection. Cat. no. 195.

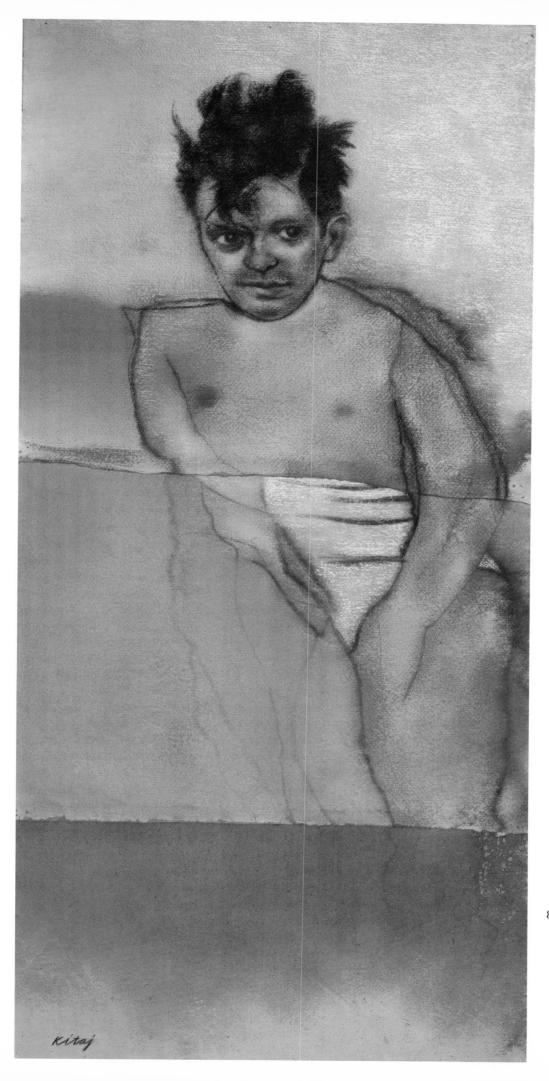

84. BATHER (TOUSLED HAIR), 1978. Pastel on paper, $47\frac{3}{4} \times 22\frac{3}{8}$ in. (121.3 \times 56.8 cm.). Nelson Blitz, Jr., New York. Cat. no. 223.

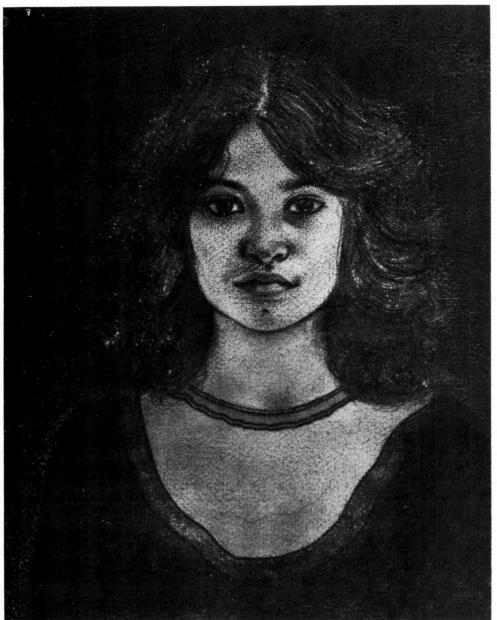

85. dominie (san feliu), 1978. Pastel and charcoal on paper, $21\frac{3}{8}\times15\frac{3}{8}$ in. (54.3 \times 39.1 cm.). Collection of the artist. Cat. no. 219.

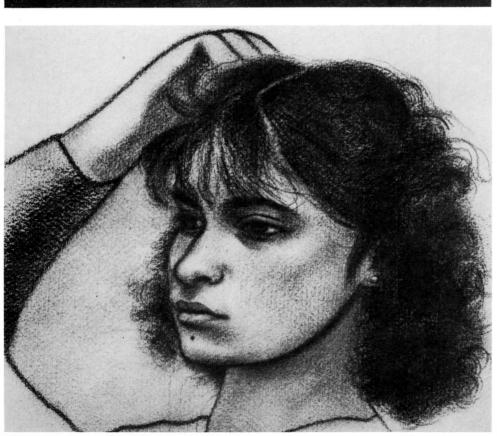

86. Sacha and Gabriel, 1981. Charcoal on paper, $30\frac{3}{8} \times 22\frac{1}{4}$ in. $(77.2 \times 56.5$ cm.). Collection of the artist. Cat. no. 300.

87. dominie (dartmouth), 1978. Pastel and charcoal on paper, 22 \times 15 in. (55.9 \times 38.1 cm.). Collection of the artist. Cat. no. 217.

88. Quentin, 1979. Pastel and charcoal on paper, $25\frac{3}{4}\times15\frac{3}{4}\,\mathrm{in.}$ (65.4 \times 40 cm.). Collection of the artist. Cat. no. 254.

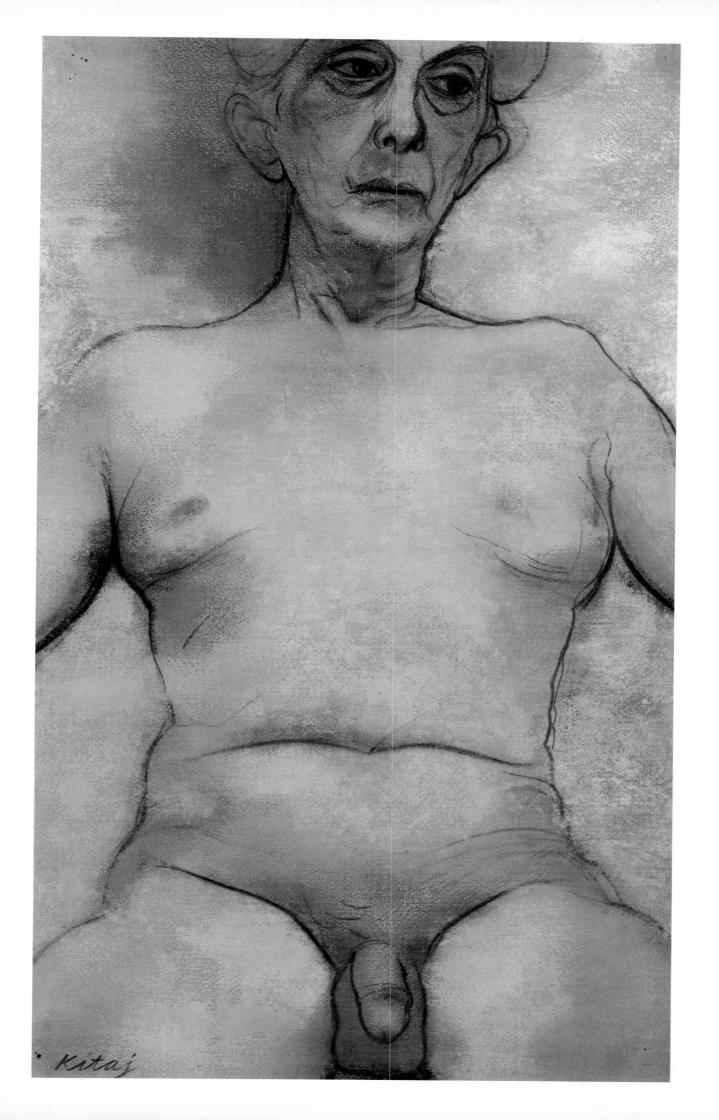

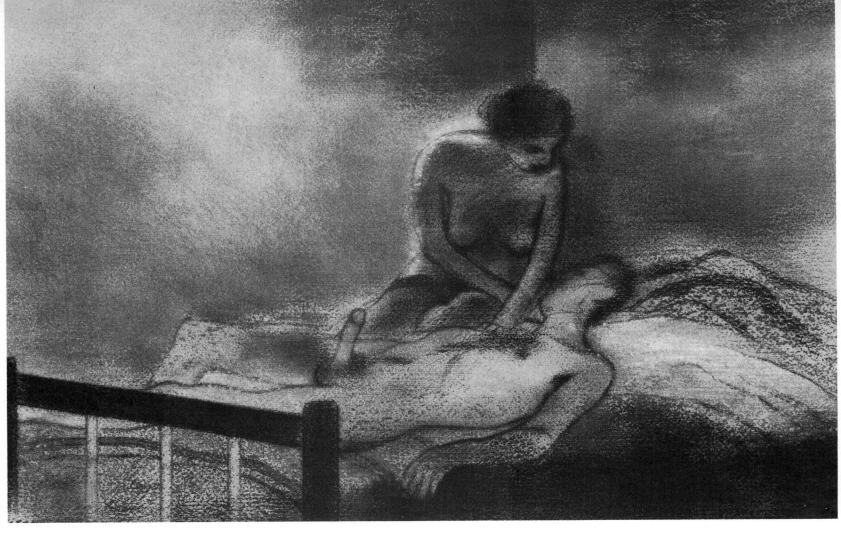

89. COMMUNIST AND SOCIALIST, 1975. Pastel on paper, $15\frac{1}{8} \times 22\frac{1}{4}$ in. $(38.5 \times 56.5 \text{ cm.})$. Collection of the artist. Cat. no. 173.

90. STUDY FOR MISS

BROOKE, 1974. Pastel on paper, $23\frac{7}{8} \times 15\frac{1}{8}$ in.

(60.6 \times 38.5 cm.).

Museum Boymans-van Beuningen, Rotterdam.
Cat. no. 166

91. STUDY (MICHAEL HAMBURGER), 1969. Oil on canvas, 14 \times 11 in. (35.6 \times 28 cm.). Private collection, England. Cat. no. 115.

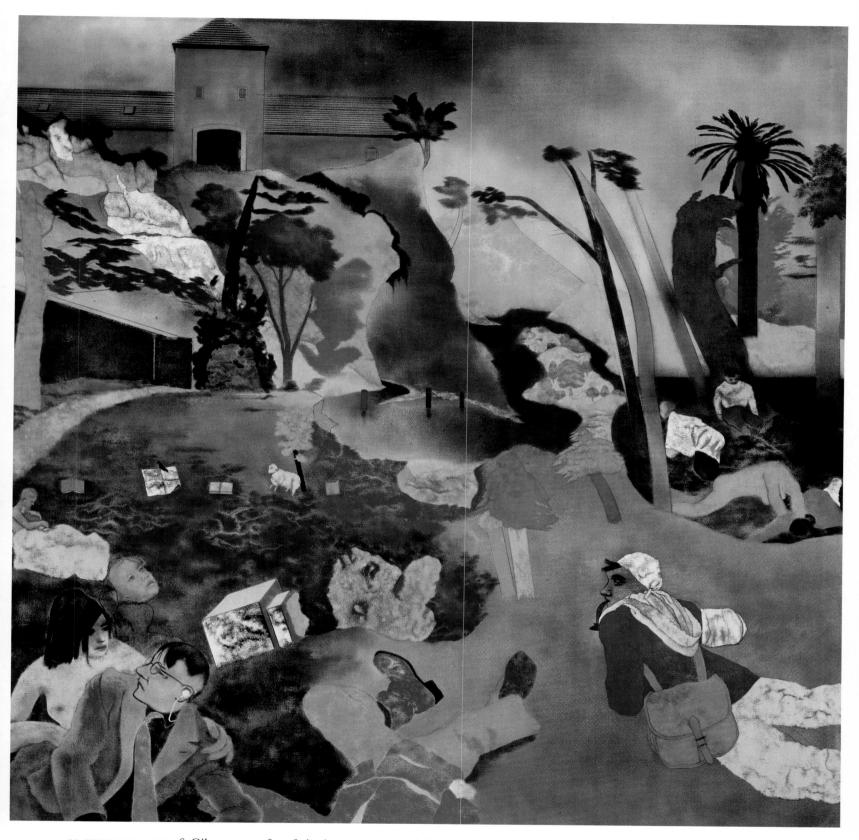

92. IF NOT, NOT, 1975–6. Oil on canvas, 60×60 in. $(152.4 \times 152.4$ cm.). Scottish National Gallery of Modern Art, Edinburgh. Cat. no. 186.

94. The Rise of Fascism, 1979–80. Pastel and oil on paper, $33\frac{3}{8} \times 62$ in. $(84.8 \times 157.5$ cm.). The Tate Gallery, London. Cat. no. 260.

95. Lem (san feliu), 1978. Pastel and charcoal on paper, $30\frac{1}{4} \times 22$ in. $(76.8 \times 55.9 \text{ cm.})$. Collection of the artist. Cat. no. 220.

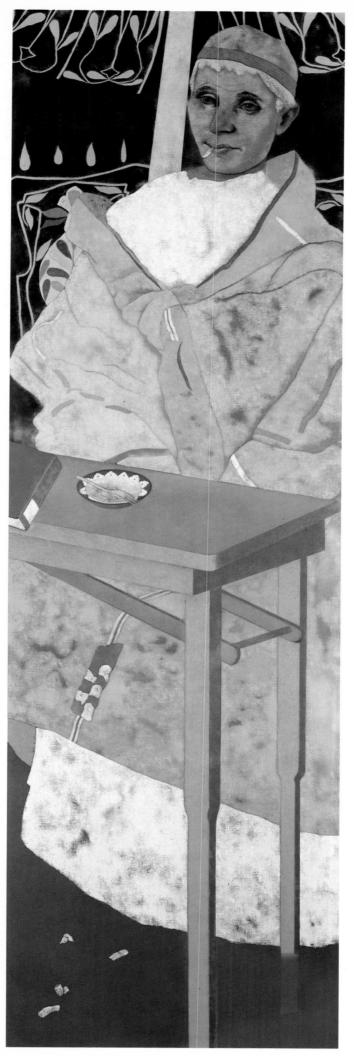

96. The arabist (formerly moresque), 1975–6. Oil on canvas, 96×30 in. (243.8 \times 76.2 cm.). Museum Boymansvan Beuningen, Rotterdam. Cat. no. 187.

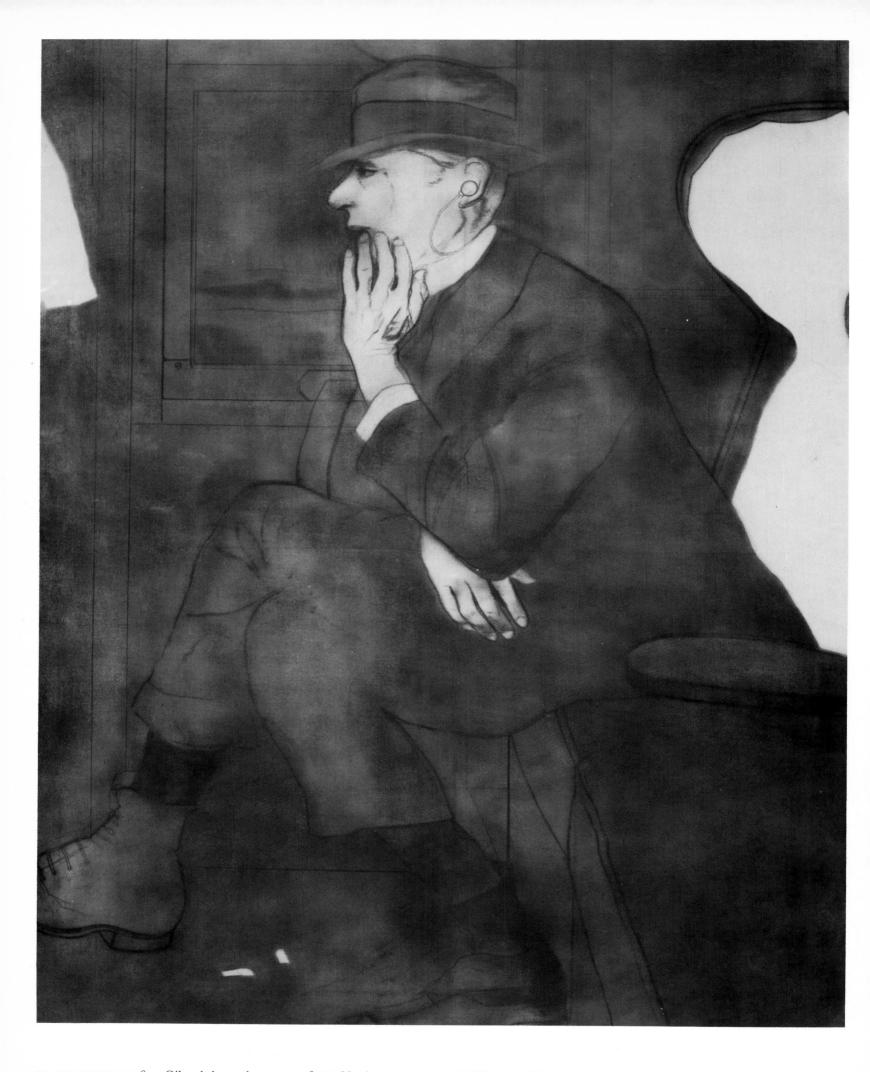

97. The Jew etc. 1976–9. Oil and charcoal on canvas, 60×48 in. (152.4 \times 121.9 cm.). Collection of the artist. Cat. no. 199.

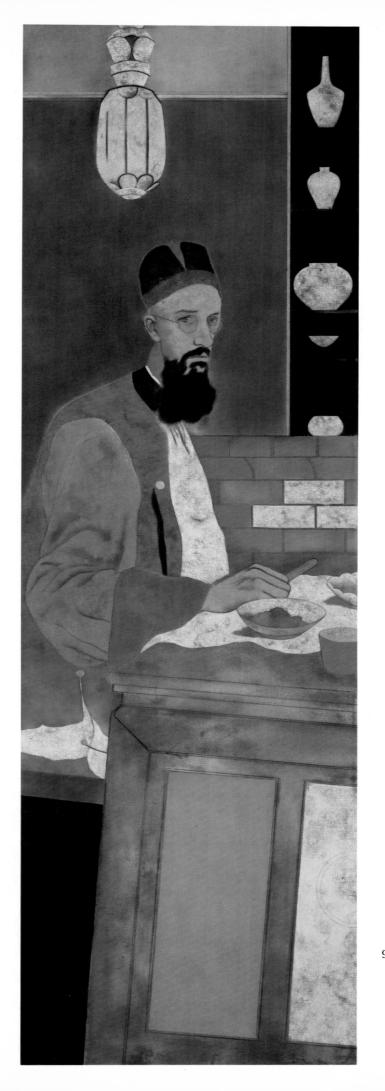

98. The orientalist, 1975–6. Oil on canvas, 96×30 in. (243.8 \times 76.2 cm.). The Tate Gallery, London. Cat. no. 188.

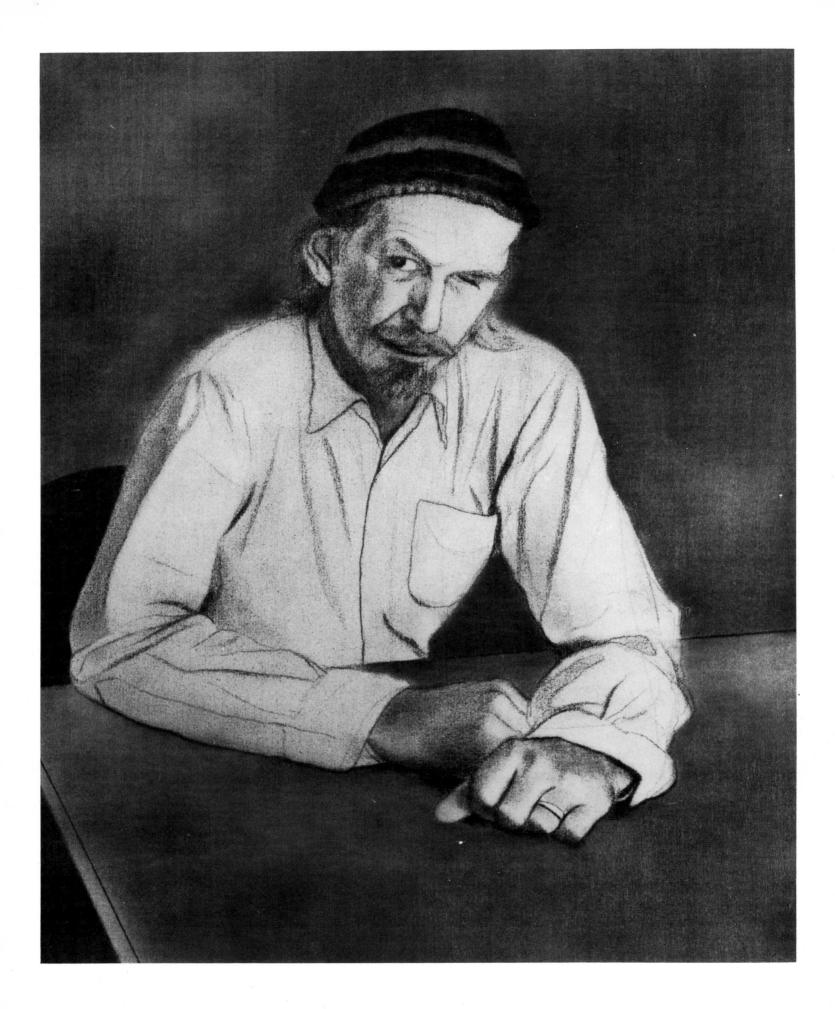

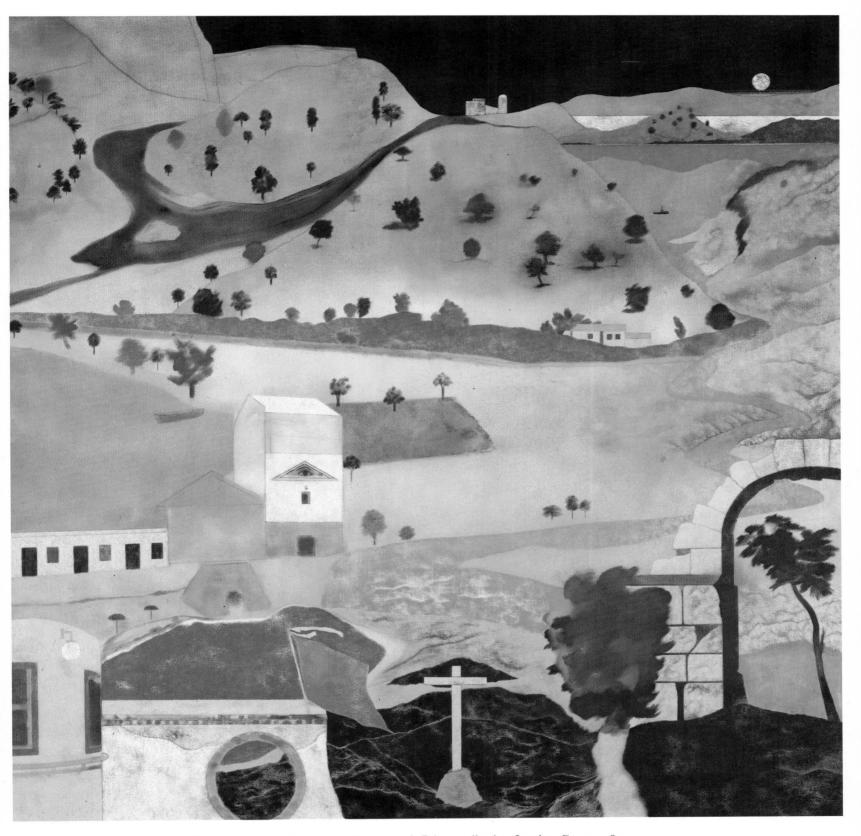

100. Land of lakes, 1975–7. Oil on canvas, 60×60 in. $(152.4 \times 152.4$ cm.). Private collection, London. Cat. no. 189.

99. A VISIT TO LONDON (ROBERT CREELEY AND ROBERT DUNCAN) (detail), 1977–9. Oil and charcoal on canvas, 72 × 24 in. (182.9 × 61 cm.). Collection Thyssen-Bornemisza, Lugano. Cat. no. 206.

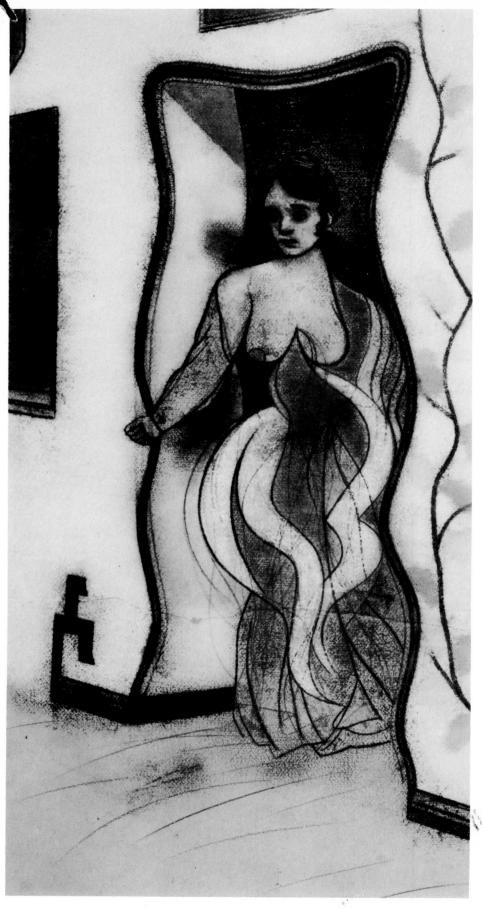

101. Manchu decadence, 1979. Pastel and charcoal on paper, $45^{\frac{1}{4}} \times 22$ in. (115 \times 55.9 cm.). Private collection, Rumson, New Jersey. Cat. no. 245.

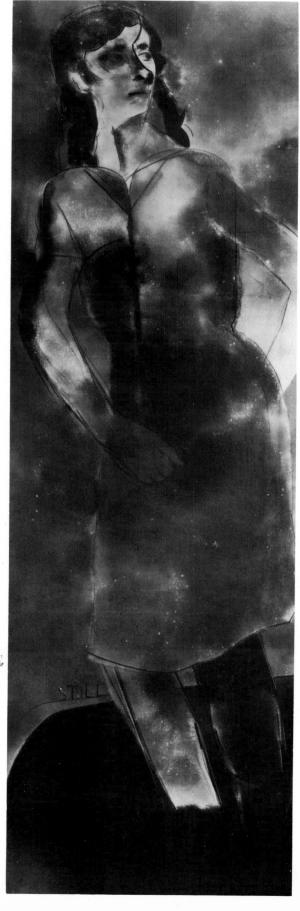

102. STILL (THE OTHER WOMAN), 1973. Oil on canvas, 96×30 in. (243.8 \times 76.2 cm.). Mr and Mrs Ian Stoutzker, London. Cat. no. 157.

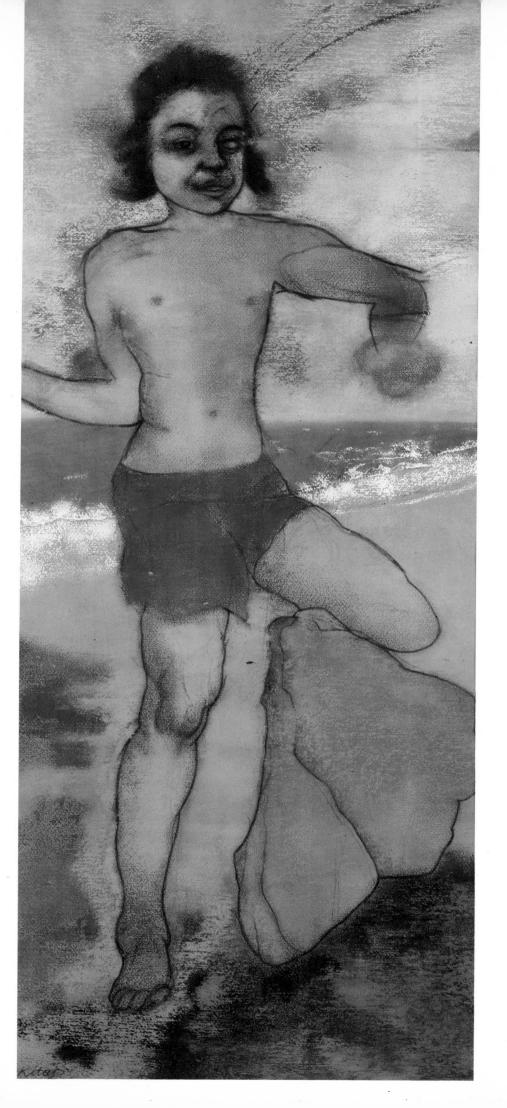

103. BATHER (PSYCHOTIC BOY), 1980. Pastel and charcoal on paper, $52\frac{3}{4} \times 22\frac{1}{2}$ in. (134 × 57.2 cm.). H.R. Astrup, Oslo. Cat. no. 281.

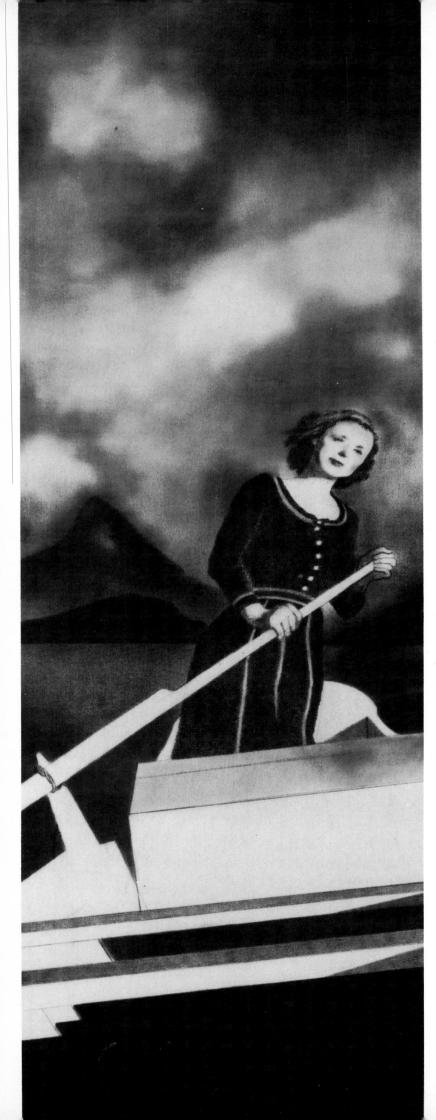

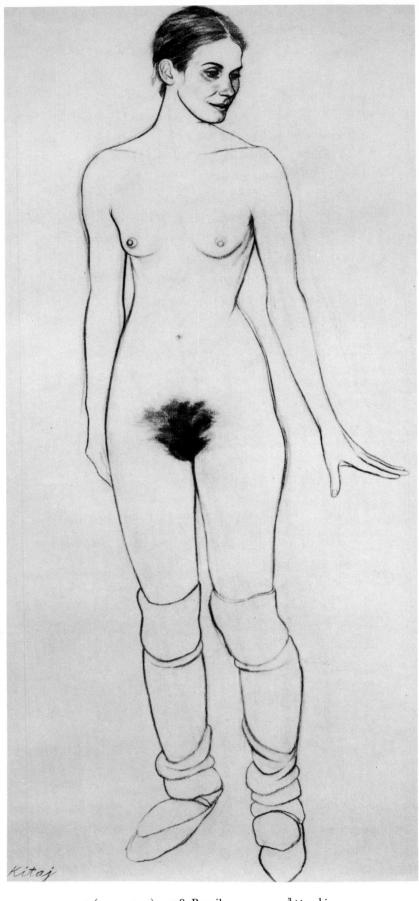

105. The dancer (margaret), 1978. Pencil on paper, $39\frac{3}{8} \times 25\frac{1}{2}$ in. (100 × 64.8 cm.). Edwin A. Bergman, Chicago. Cat. no. 212.

104. Houseboat days (for John Ashbery), 1976. Oil on canvas, 72×24 in. (182.9 \times 61 cm.). Private collection, London. Cat. no. 191.

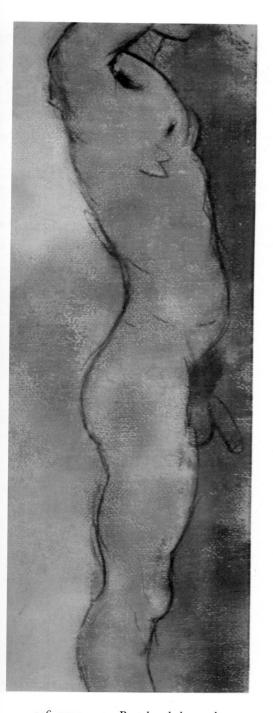

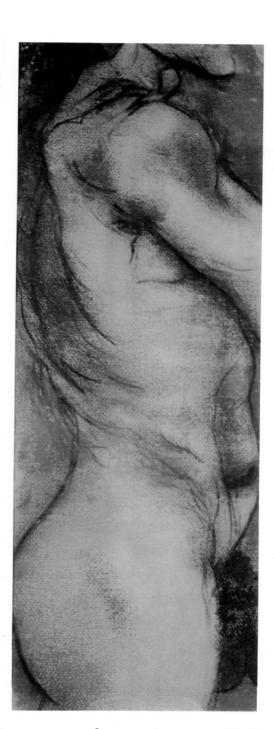

106. SIDES, 1979. Pastel and charcoal on paper, each panel of three, $30\frac{3}{4} \times 11$ in. $(78.1 \times 28 \, \text{cm.})$. The British Museum, London. Cat. no. 248.

107. Alcade, detail from communist and socialist (second version), 1979. Pastel and charcoal on paper, $30\frac{1}{4} \times 22$ in. (76.8 \times 55.9 cm.). Collection of the artist. Cat. no. 247.

108. On a regicide peace, 1970. Oil and silkscreen on canvas, $38 \times 21\frac{1}{4}$ in. (96.5 × 54 cm.). Louisiana Museum, Humlebaek, Denmark. Cat. no. 139.

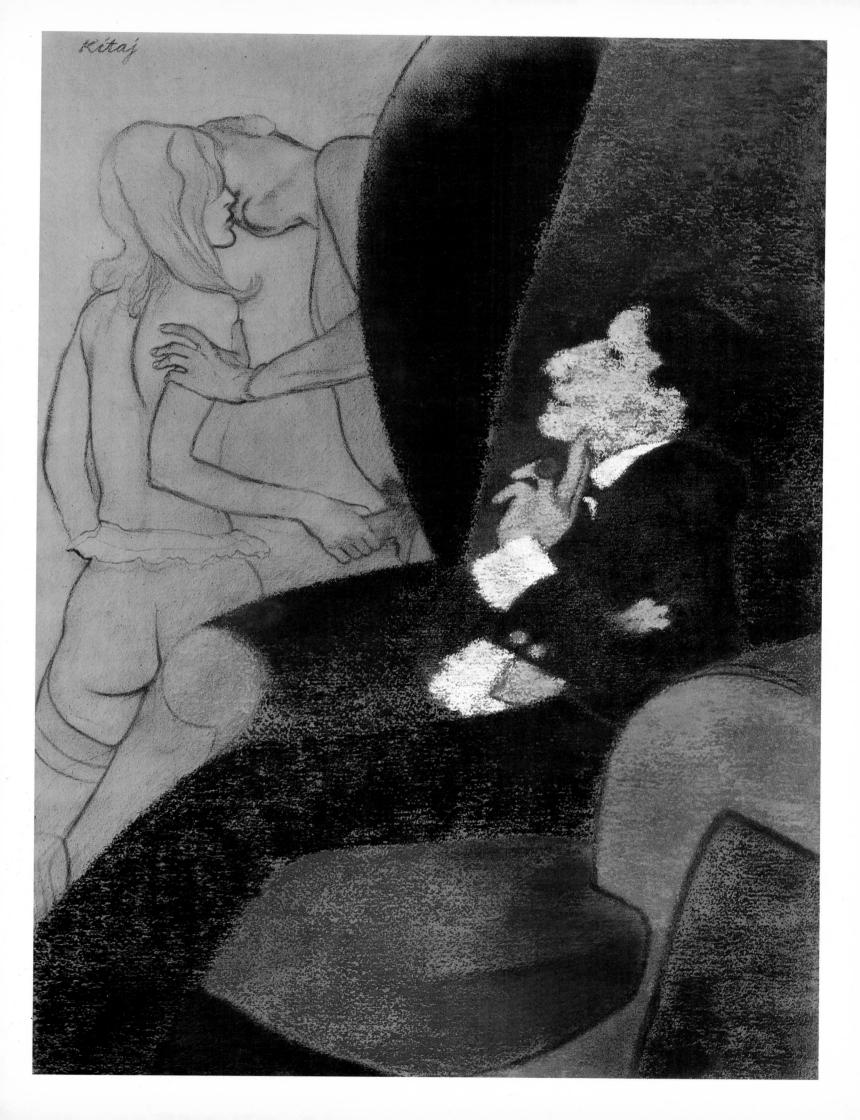

- UNDER SNOW,
 1979. Pastel and
 charcoal on paper,
 304 × 44 in.
 (76.8 × 111.8 cm.).
 Odyssia Gallery,
 New York. Cat.
 no. 244.
- PAINTERS (FRANK AUERBACH AND SANDRA FISHER), 1979. Pastel and charcoal on paper, 22 × 30¼ in. (55.9 × 76.8 cm.). The Michael and Dorothy Blankfort Collection at Los Angeles County Museum. Cat. no. 246.
- 112. MARYNKA SMOKING, 1980. Pastel and charcoal on paper, $35\frac{3}{4} \times 22\frac{1}{4}$ in. (90.8 × 56.5 cm.). Collection of the artist. Cat. no. 269.

113. THE LISTENER (JOE SINGER IN HIDING), 1980. Pastel and charcoal on paper, $40\frac{5}{8} \times 42\frac{5}{8}$ in. (103.2 × 108.2 cm.). Nelson Blitz Jr., New York. Cat. no. 280.

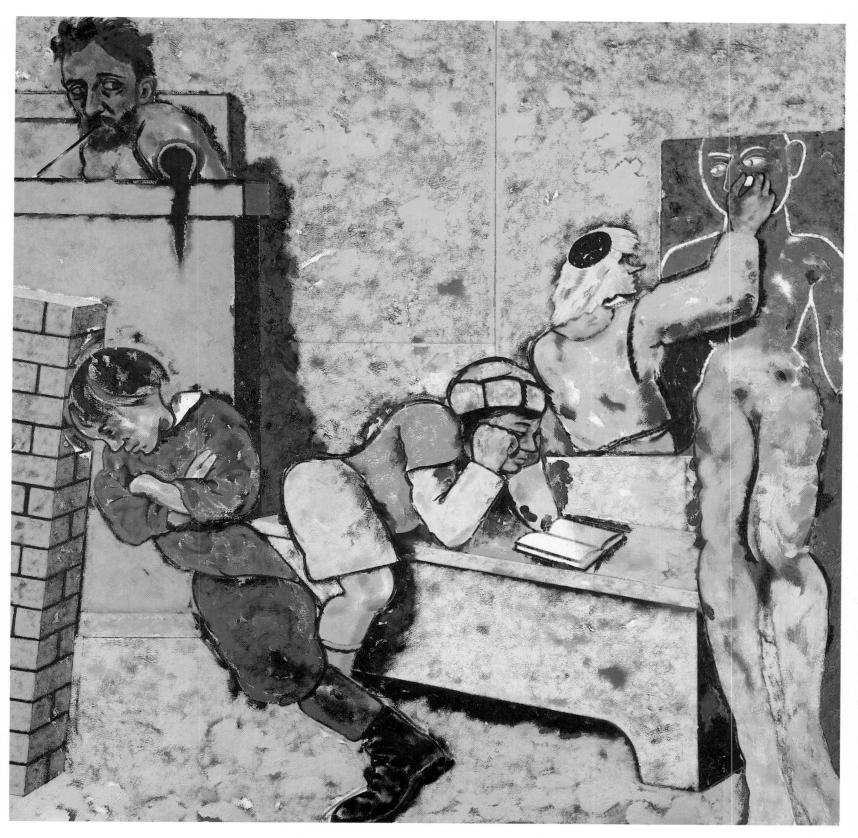

114. The Jewish School (drawing a golem), 1980. Oil on canvas, 60 × 60 in. (152.4 × 152.4 cm.). Private collection, Monte Carlo. Cat. no. 290.

115. RICHARD, 1979. Pastel and charcoal on paper, $30\frac{1}{4} \times 22$ in. (76.8 \times 55.9 cm.). Private collection, New York. Cat. no. 243.

117. Bad faith (Riga) (Joe singer taking leave of his fiancee), 1980. Pastel, charcoal and oil on paper, $37\times22\frac{1}{4}$ in. (94 \times 56.5 cm.). I.R. Wookey, Toronto. Cat. no. 285.

116. The Yellow hat, 1980. Pastel and charcoal on paper, $30\frac{1}{2} \times 22\frac{3}{4}$ in. $(77.5 \times 57.8$ cm.). Private collection, London. Cat. no. 284.

118. DEGAS, 1980. Pastel and charcoal on paper, $28\frac{3}{4} \times 20$ in. $(73 \times 50.8$ cm.). Collection of the artist. Cat. no. 266.

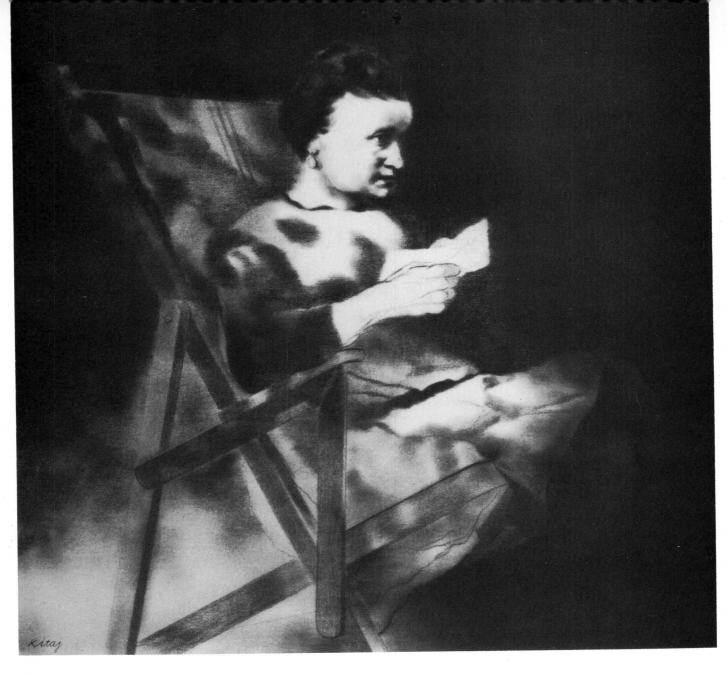

119. The mother, 1977. Oil and charcoal on canvas, 42×42 in. (106.7 × 106.7 cm.). Collection of the artist. Cat. no. 203.

120. The SNEEZE, 1975. Charcoal and pastel on paper, 34×27 in. (86.4 \times 68.6 cm.). The Museum of Modern Art, (Gift of Nancy & Jim Dine), New York. Cat. no. 179.

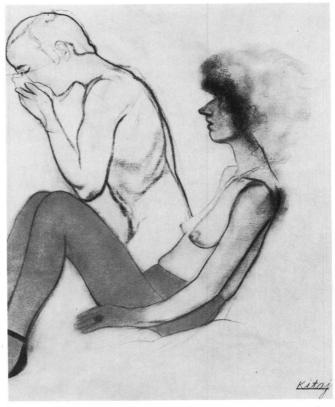

121 (opposite). Mary-ann, 1980. Pastel and charcoal on paper, $30\frac{1}{2}\times22$ in. $(77.5\times55.9$ cm.). Private collection, London. Cat. no. 270.

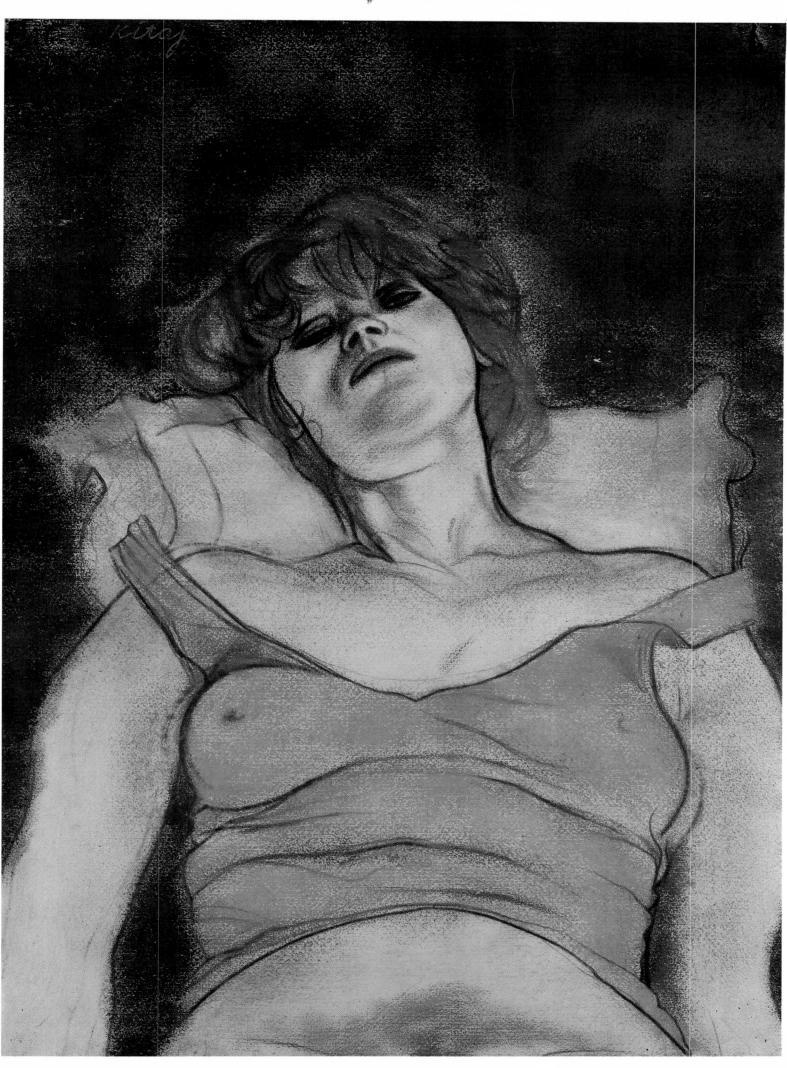

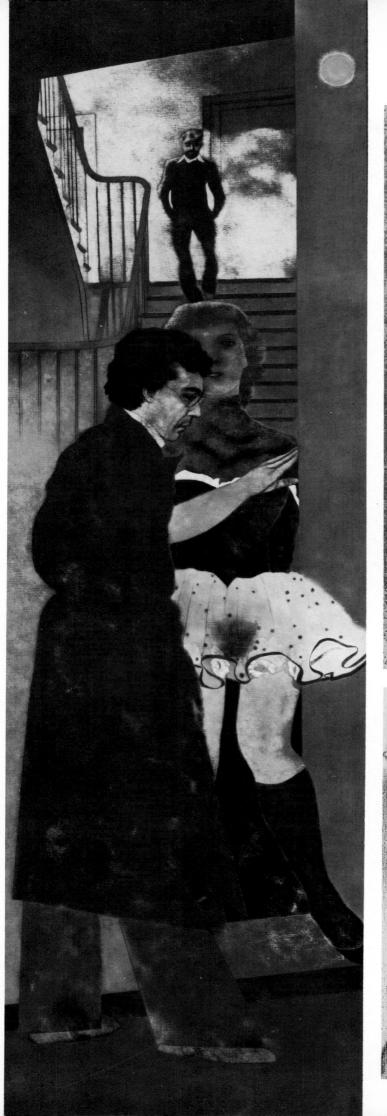

125. The Garden, 1981. Oil on canvas, 48×48 in. (121.9 \times 121.9 cm.). The Cleveland Museum of Art, Ohio. Cat. no. 296.

122 (far left). SMYRNA GREEK (NIKOS), 1976–7. Oil on canvas, 96×30 in. (243.8 \times 76.2 cm.). Collection Thyssen-Bornemisza, Lugano. Cat. no. 198.

123 (top left). In Catalonia, 1975. Pastel on paper, $25\frac{1}{2} \times 15\frac{1}{4}$ in. (64.8 \times 38.7 cm.). Private collection, London. Cat. no. 175.

126. Paul Blackburn, 1980. Charcoal on paper, $15\frac{1}{4} \times 15\frac{3}{4}$ in. (38.7 × 40 cm.). Akron Institute, Ohio. Cat. no. 268.

127 (below left). The poet and notre dame (robert duncan), 1982. Pastel and charcoal on paper, $22\frac{1}{2} \times 15\frac{1}{2}$ in. $(57.2 \times 39.4$ cm.). Private collection, Switzerland. Cat. no. 320.

128. CHIMERA, 1980–1. Oil on canvas, $22 \times 9_4^3$ in. (55.9 \times 24.8 cm.). Galerie Beyeler, Basle. Cat. no. 294.

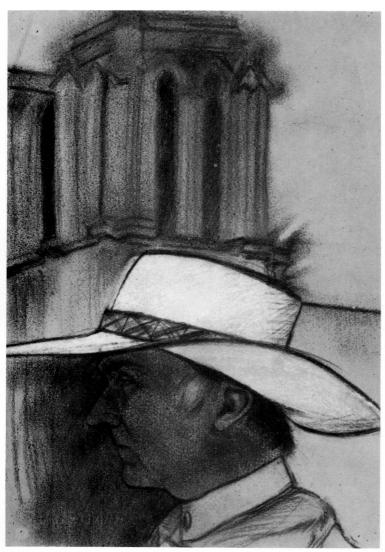

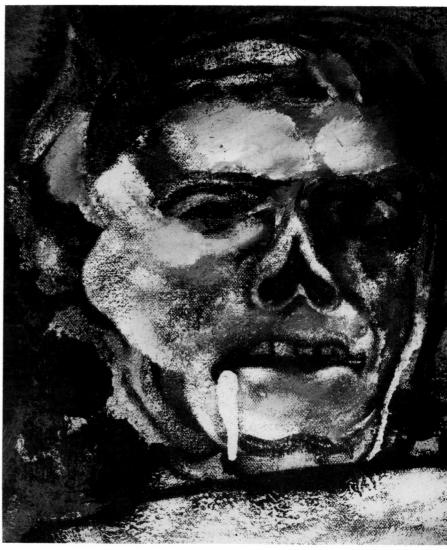

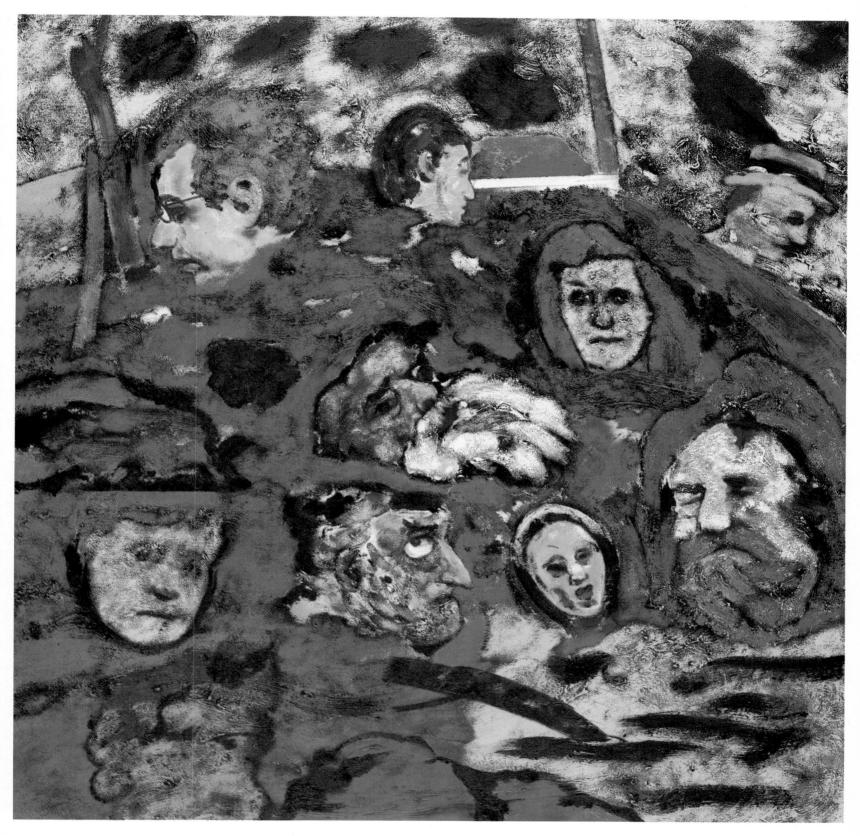

129. ROCK GARDEN (THE NATION), 1981. Oil on canvas, 48×48 in. (121.9 \times 121.9 cm.). Private collection, Chicago. Cat. no. 299.

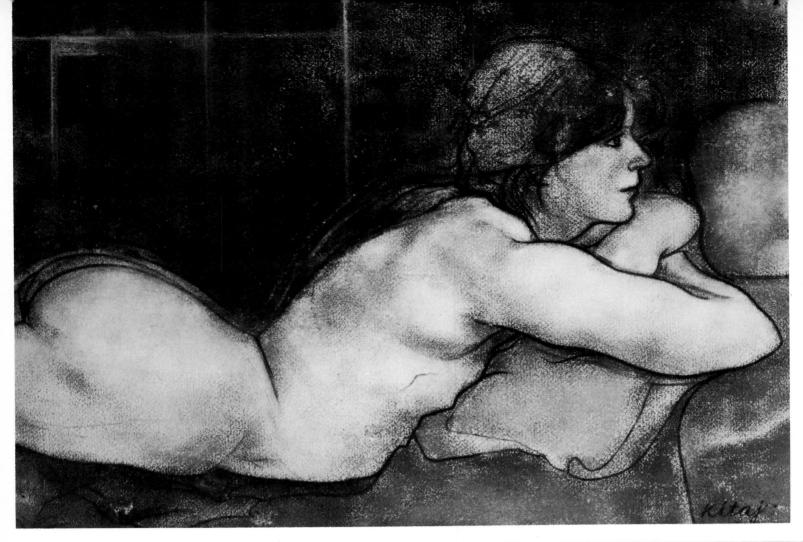

130. MARY-ANN ON HER STOMACH (FACE RIGHT), 1980. Pastel and charcoal on paper, 22 × 30 in. (55.9 × 76.2 cm.). H.N. Astrup, Oslo. Cat. no. 271.

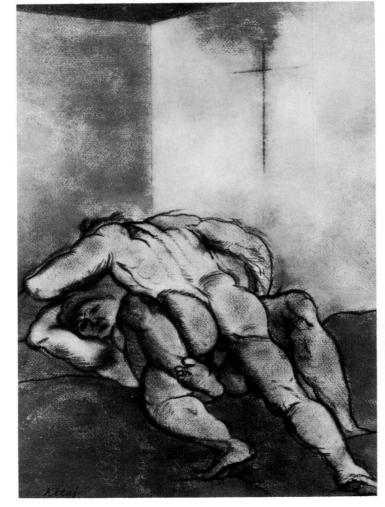

131. FORM AND CONTENT (AFTER GIULIO ROMANO), 1979. Pastel and charcoal on paper, $28\frac{3}{4} \times 20\frac{1}{2}$ in. $(73 \times 52.1$ cm.). Collection of the artist. Cat. no. 255.

132. SELF-PORTRAIT IN SARAGOSSA, 1980. Charcoal and pastel on paper, $58 \times 33^{\frac{1}{2}}$ in. (147.3 × 85.1 cm.). The Israel Museum, Jerusalem. Cat. no. 288.

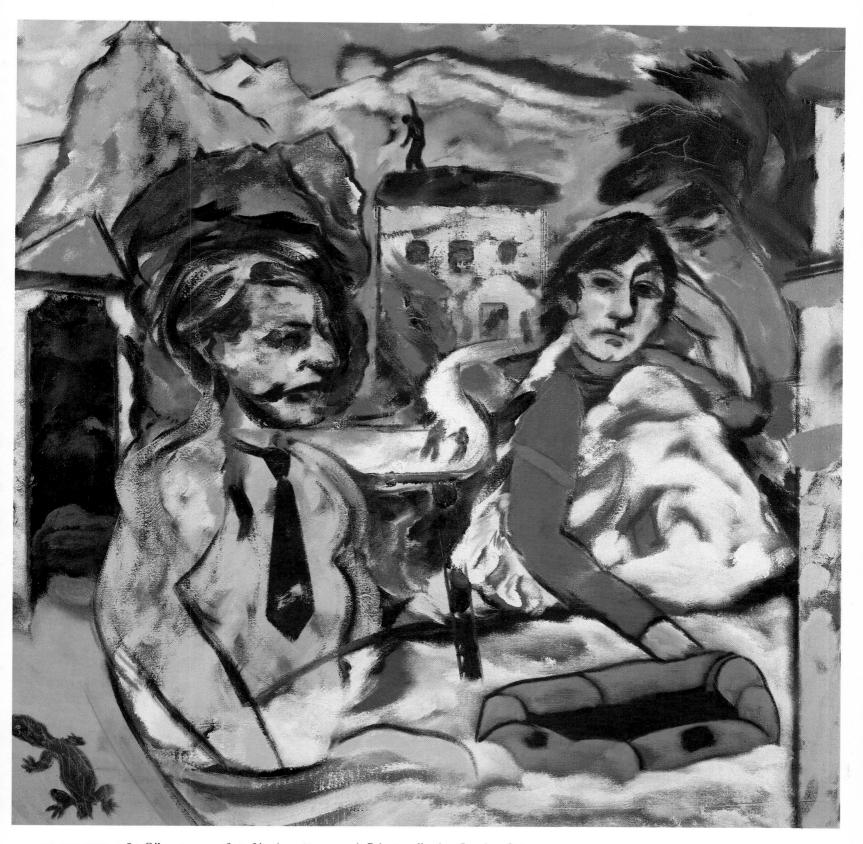

133. The cure, 1982. Oil on canvas, 36×36 in. $(91.5 \times 91.5$ cm.). Private collection, London. Cat. no. 332.

134. WOLLHEIM AND ANGELA, 1980. Charcoal on paper, $22\frac{1}{8} \times 30\frac{1}{4}$ in. $(56.2 \times 76.8 \text{ cm.})$. Collection of the artist. Cat. no. 267.

136. THE STREET (A
LIFE), 1975. Pastel on
paper, 30\(^3\) \times 22 in.
(77.2 \times 55.9 cm.).
H.N. Astrup, Oslo.
Cat. no. 181.

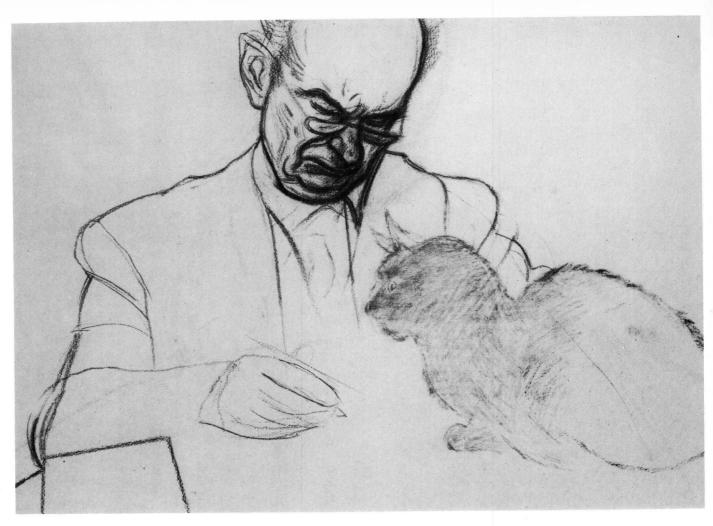

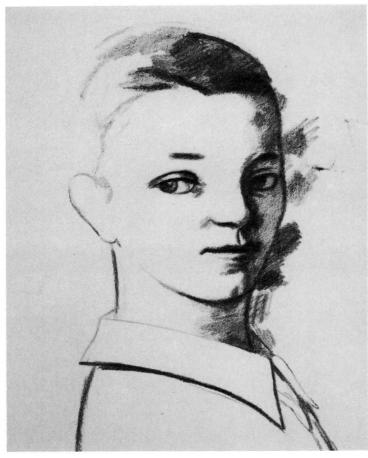

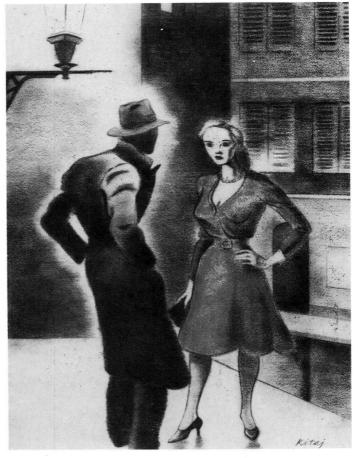

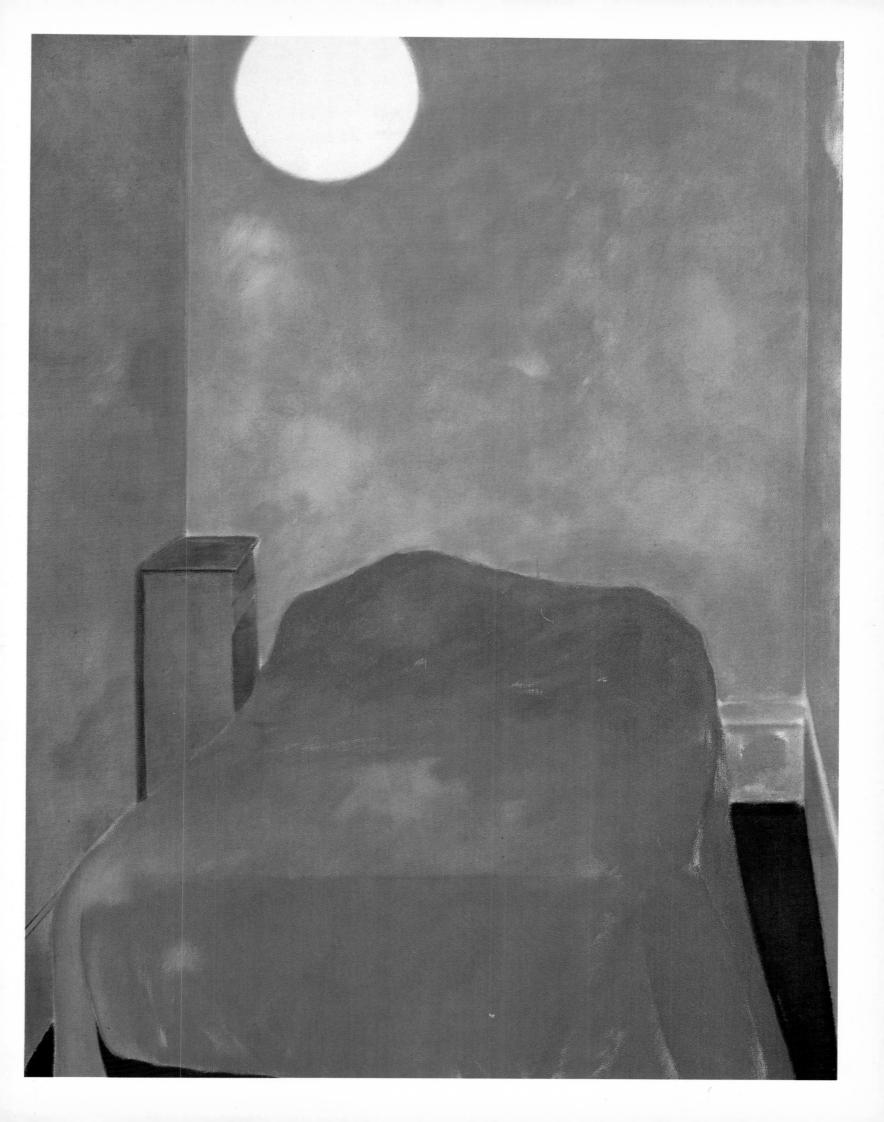

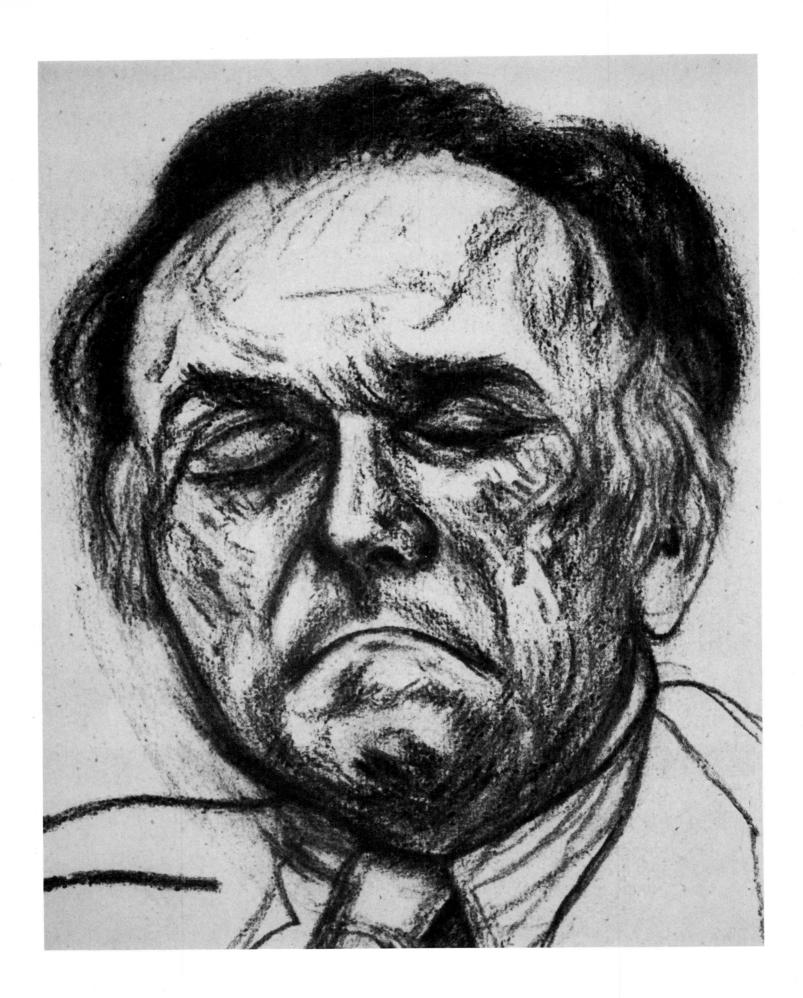

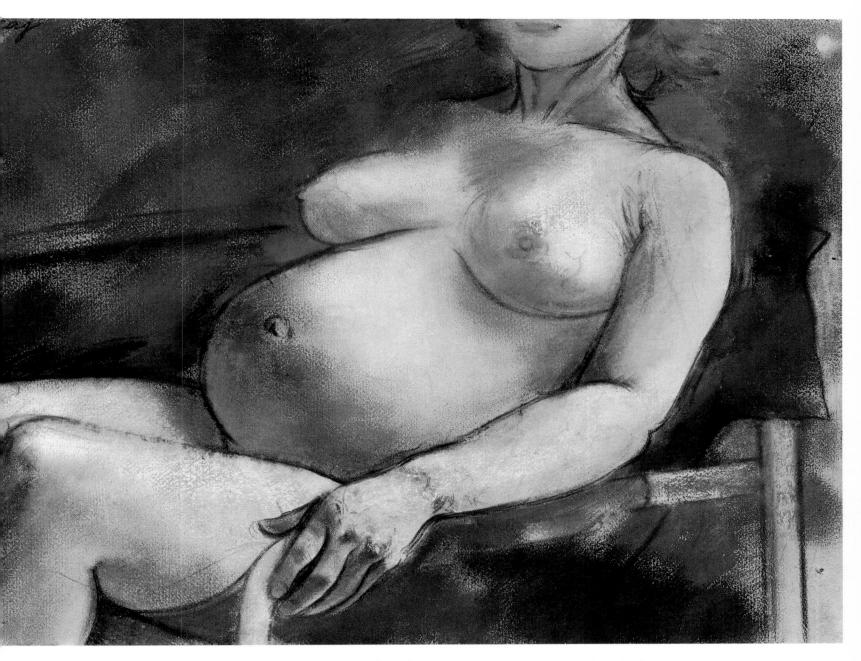

139. Marynka pregnant II, 1981. Pastel and charcoal on paper, $22\frac{1}{4} \times 30\frac{3}{8}$ in. $(56.5 \times 77.2$ cm.). Collection of the artist. Cat. no. 301.

138. THE POET, EYES CLOSED (ROBERT DUNCAN), 1982. Charcoal on paper, 22½ × 31 in. (57.2 × 78.7 cm.). Collection of the artist. Cat. no. 319.

140. ELLEN AND SHOFAR, 1983–4. Pastel and charcoal on paper, $43\frac{1}{2} \times 30$ in. (110.5 \times 76.2 cm.). Mr and Mrs Edward L. Gardner, Larchmont, New York. Cat. no. 356.

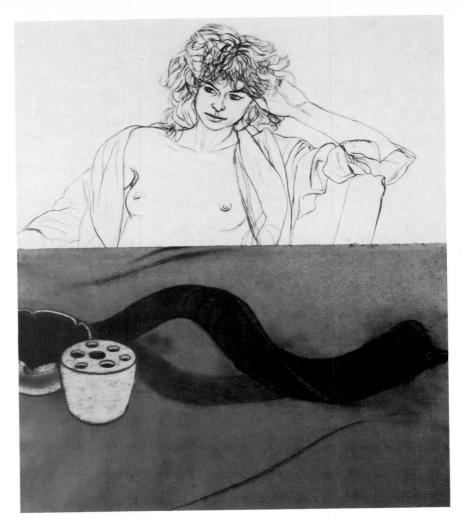

141. DOCTOR KOHN, 1978. Pastel and charcoal on paper, 22×15 in. $(55.9 \times 38.1$ cm.). Collection of the artist. Cat. no. 221.

142 (below right). Garth, 1981. Oil on canvas, 24×14 in. (61 \times 35.6 cm.). Private collection, Belgium. Cat. no. 303.

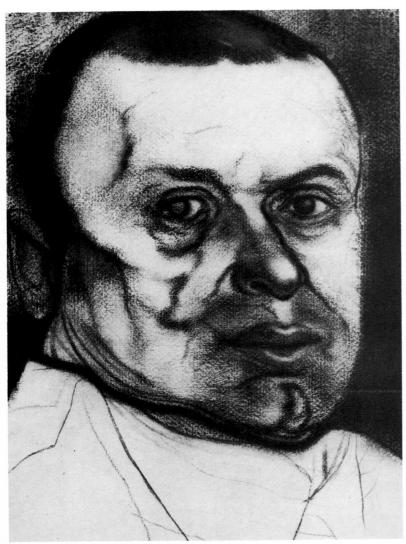

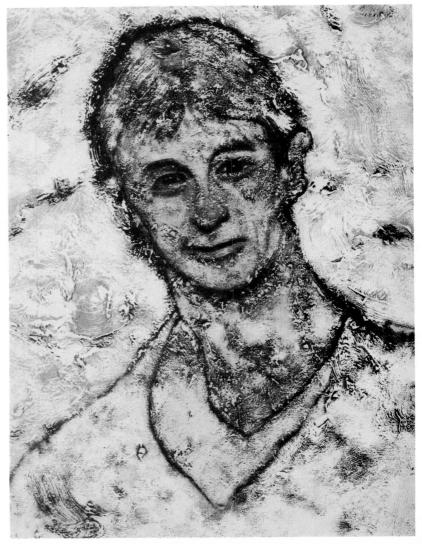

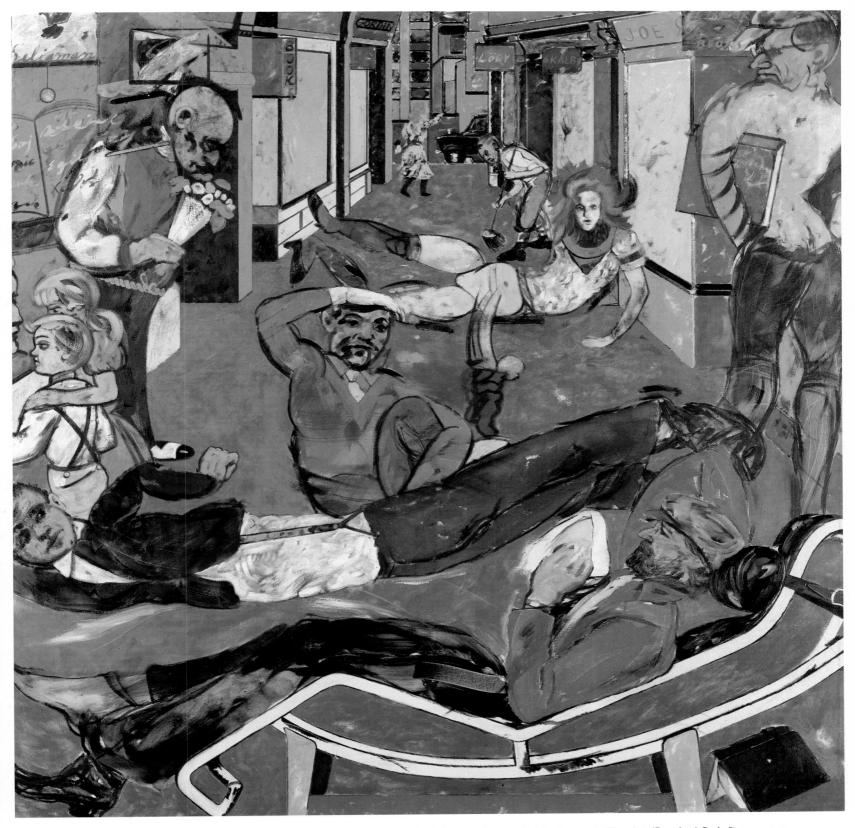

 $\textbf{143. CECIL COURT, LONDON WC2 (THE REFUGEES)}, \ \textbf{1983-4. Oil on canvas}, \ \textbf{72} \times \textbf{72 in. (182.9} \times \textbf{182.9 cm.)}. \ \textbf{Marlborough Fine Art (London) Ltd. Cat. no. 357}.$

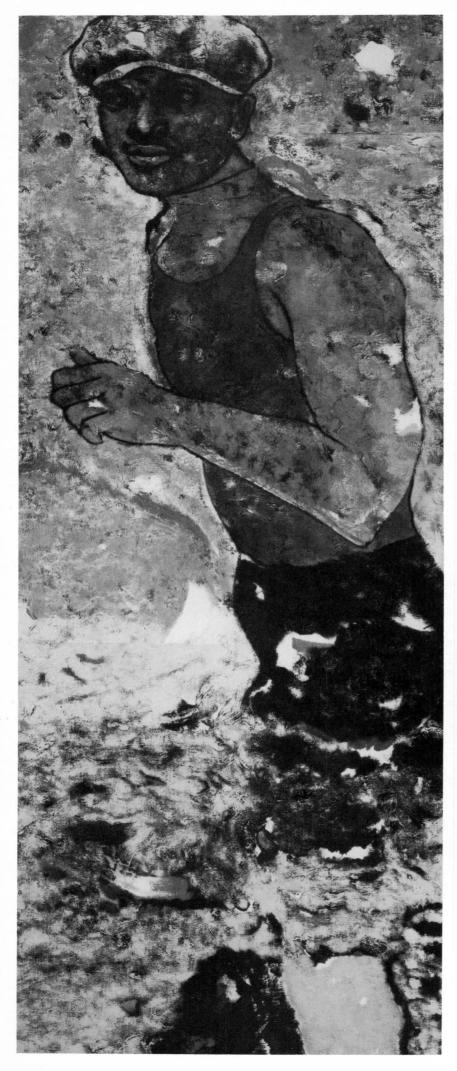

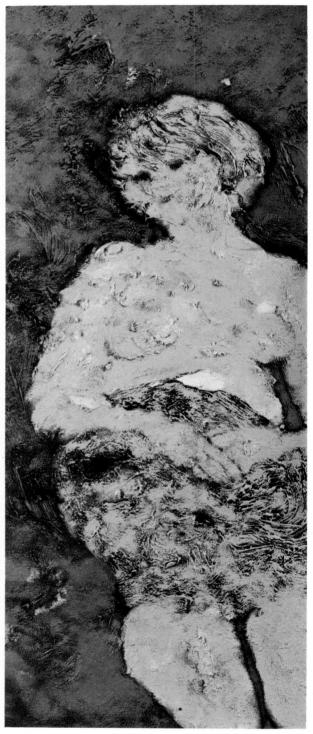

145. GREY GIRL, 1981. Oil on canvas, 30×12 in. $(76.2 \times 30.5$ cm.). Collection of the artist. Cat. no. 297.

144. The sailor (david ward), 1979–80. Oil on canvas, 60×24 in. (152.4 \times 61 cm.). Collection of H.R. Astrup, Oslo. Cat. no. 261.

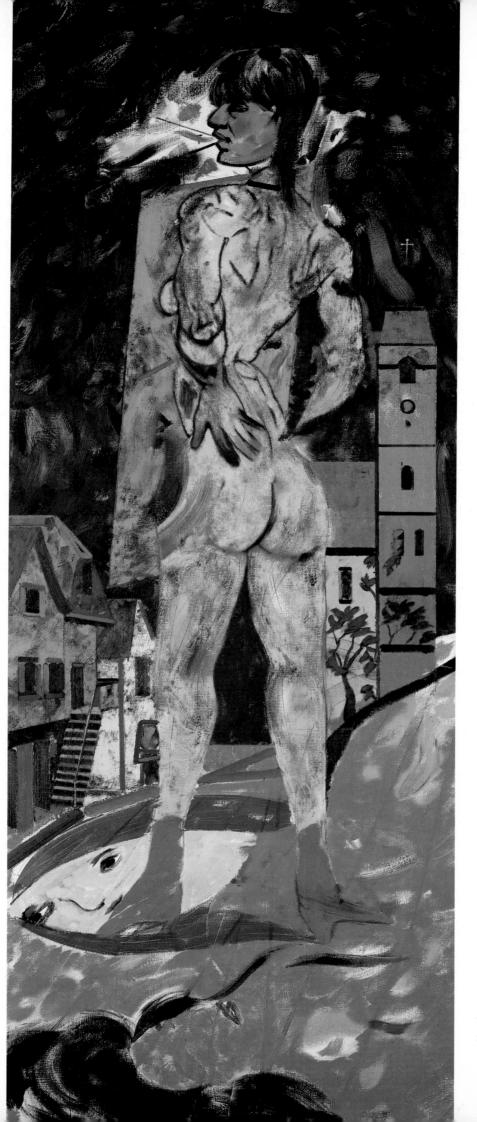

146. SELF-PORTRAIT AS A WOMAN, 1984. Oil on canvas, 97 × 30\frac{3}{8} in. (246.4 × 77.2 cm.). H.R. Astrup, Oslo. Cat. no. 361.

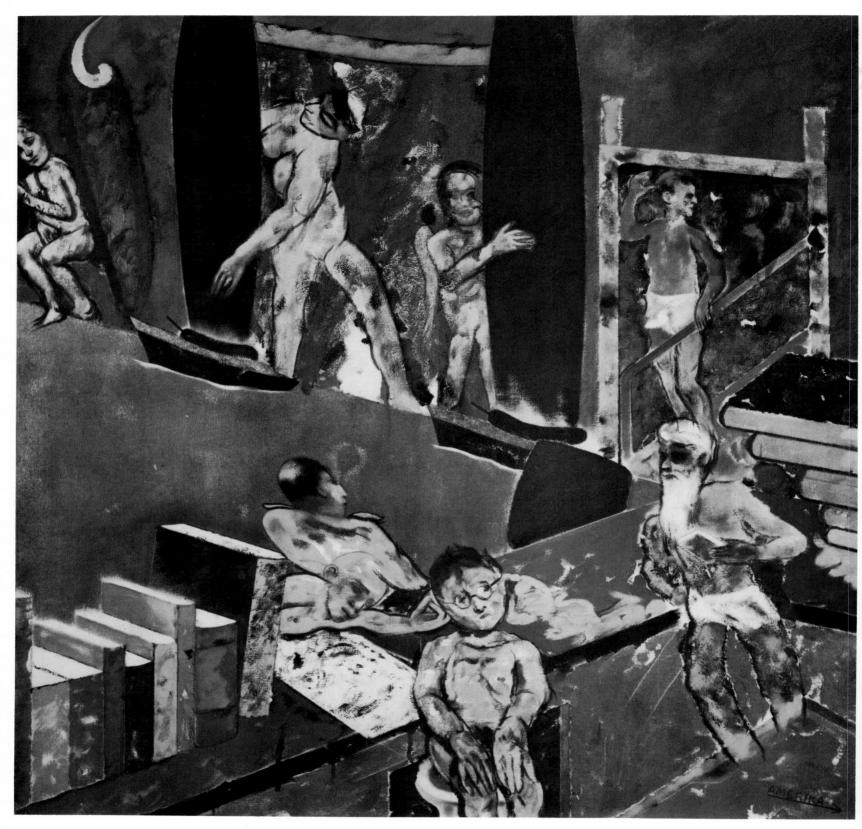

147. London, england (bathers), 1982. Oil on canvas, 48×48 in. (121.9 \times 121.9 cm.). Marlborough Fine Art (London) Ltd. Cat. no. 323.

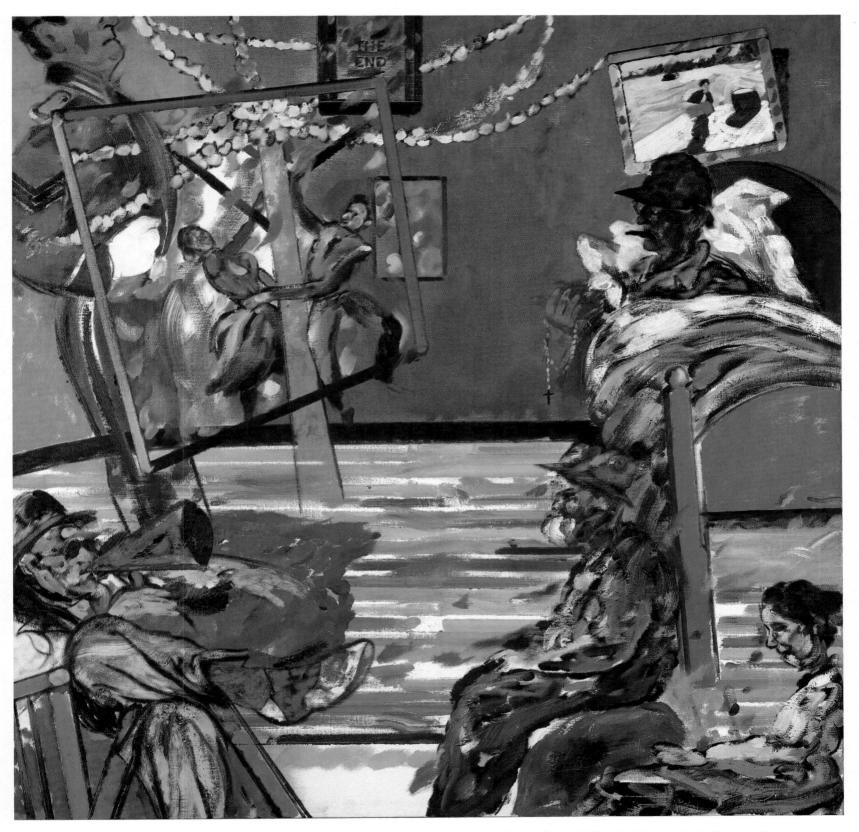

148. AMERIKA (JOHN FORD ON HIS DEATH BED), 1983–4. Oil on canvas, 60×60 in. (152.4 \times 152.4 cm.). Marlborough Fine Art (London) Ltd. Cat. no. 362.

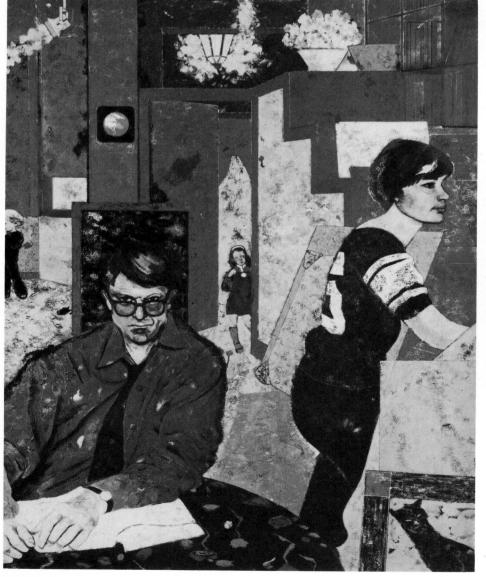

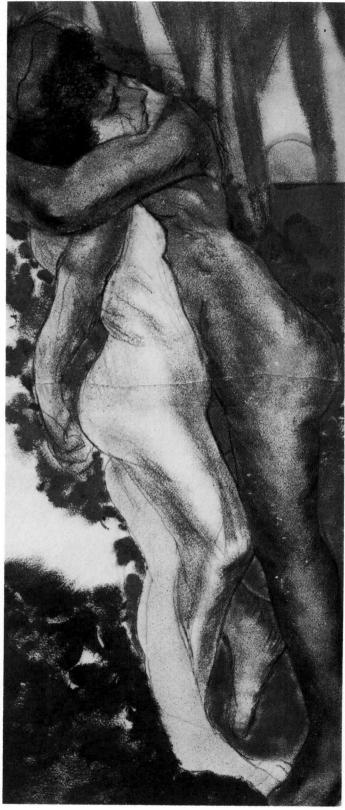

151. The Red embrace, 1980–1. Charcoal, pastel and oil on paper, $57\times22\frac{3}{4}$ in. (144.7 \times 57.8 cm.). Private collection, Paris. Cat. no. 292.

149 (above left). Helene kitaj, aged 102, 1983. Charcoal on paper, $5\frac{3}{4}\times 6\frac{3}{4}$ in. (14.6 \times 19.7 cm.). Collection of the artist.

150. The architects, 1980–4. Oil on canvas, 48 \times 48 in. (122 \times 122 cm.). Colin St John Wilson, London.

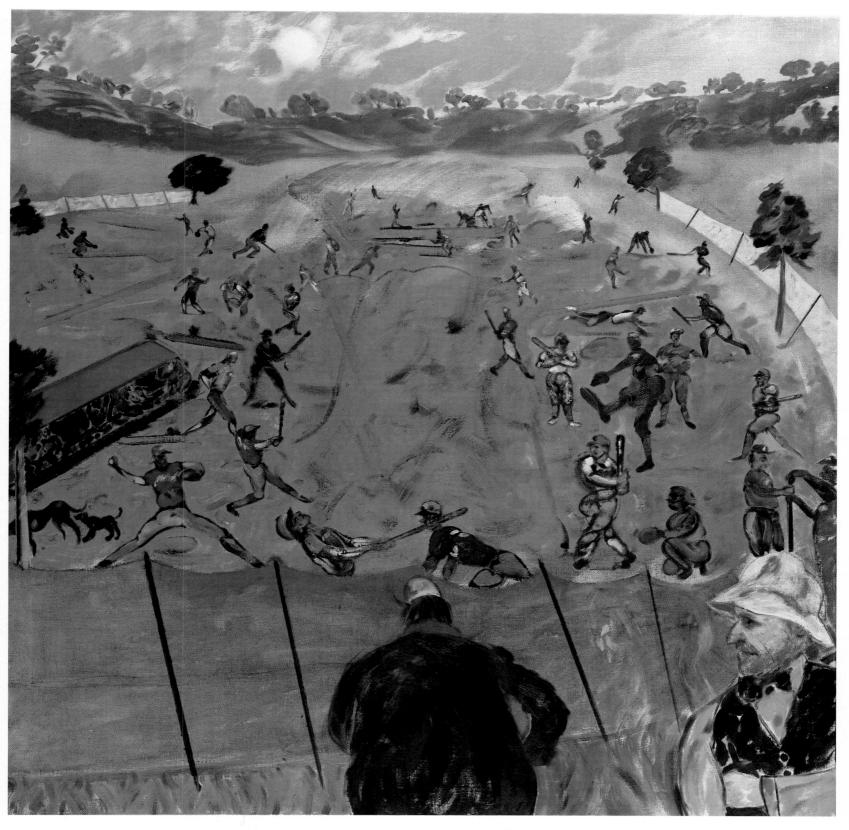

152. AMERIKA (BASEBALL), 1983–4. Oil on canvas, 60×60 in. (152.4 \times 152.4 cm.). Marlborough Fine Art (London) Ltd. Cat. no. 363.

153. STARTING A WAR (detail), 1980–1. Oil on canvas, 84 × 36 in. (213.4 × 91.5 cm.). Private collection, Akron, Ohio. Cat. no. 291.

154. THE RED BRASSIERE, 1983. Charcoal and pastel on paper, $30\frac{5}{8} \times 22\frac{3}{8}$ in. (77.8 × 56.8 cm.). Private collection, Belgium. Cat. no. 353.

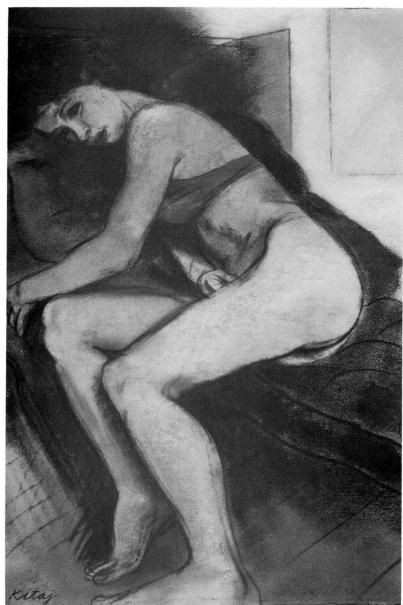

155. Desk-murder (formerly the third department (a teste study)), 1970–84. Oil on canvas, 30 × 48 in. (76.2 × 121.9 cm.). Collection of the artist. Cat. no. 142.

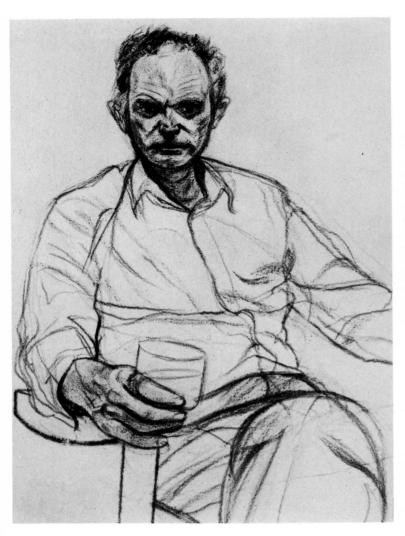

156. Yona in paris, 1982. Charcoal on paper, $22\frac{1}{2} \times 15\frac{3}{8}$ in. $(57.2 \times 39$ cm.). Collection of the artist. Cat. no. 328.

158. Study for the Jewish school (the last day), 1981. Pastel and charcoal on paper, $30\frac{3}{8} \times 22\frac{1}{4}$ in. $(77.2 \times 56.5$ cm.). Private collection, London. Cat. no. 307.

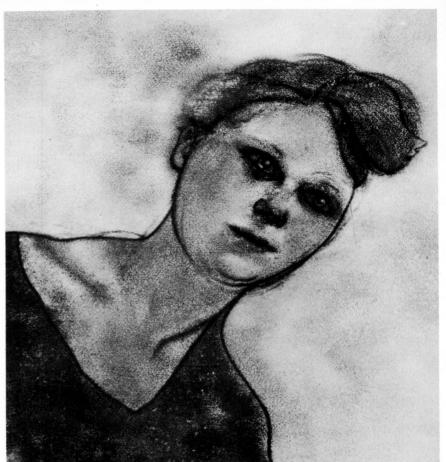

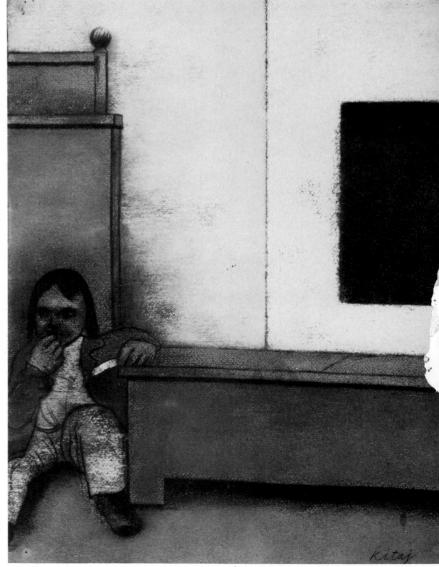

PREFACES

Gentlemen never explain.

JOWETT

Thomas Hardy wrote to an unfriendly critic that 'there is no enlightened opinion sufficiently audible to tempt an artist.' I guess it was a sarcastic rejoinder, but as much as I like Hardy, I don't believe it. All artists in my time are tempted by the quarrelsome opinions enlightening our age, but being a herd of loners, few will own up. Some say that a good work of art is an end in itself (Cynthia Ozick calls that 'idolatrous' in her religious-covenanted view). Others want to believe that art is an ally in their own version of the moral life (I've even heard said that art is the moral life). Opposite opinions like those do tempt me, but not every day, and only in uneven dosage. A third world of underdeveloped opinion, just as wobbly as the other aesthetics, may be called biographical heresy. Some of the lines of that heresy can be traced in what follows and in the uncertain prefaces to some of my uncertain paintings. If you have a weak stomach for such things, don't read on because I don't wish to offend. When I was a young painter, I wrote that some books have pictures and some pictures have books. As often as not, books (and pictures in books) happen to uncover many of the terms of my painting addiction, as landscape does for some painters. All histories and religions have both written and oral traditions which explicate each other because one or the other alone may not convey ultimate meanings. So may the painting-religion have these two traditions, its visual tradition fuelled by the other two, and its little sensations arising from ideas as they can from staring at mountains.

I'd like now to make an arguable general claim and a more easily defensible personal one: my experience of painting and painters tells me that the written and oral word opens a hell of a lot of doors into the painter's world of ideas ... and, speaking for myself, the spectres in books have attracted me all my life toward a dimly perceived crossway where even a false scholar (and not very retentive reader) like myself seems to arrive, by some natural (inherited – Jewish?) order of things, at painting by way of the word, which may come on some days before art and chance for a few of us, as it was said to in the beginning. A ratiocinative case is harder to make for straight drawing, upon one's sensations after life, but who's straight?

Harold Bloom has written, in a fearful essay about the survival of the Jews (as a Jewry) of their 'text-centeredness', their 'text-obsessiveness'. I believe that one of the most touching gifts this refractory people of mine has left to our painting art, to its cosmopolitan modernism, is justly described by Bloom's terms. Even Rothko, in his visual purity, has been called 'Yaweh's Stenographer', which is funny and great. It's a complex, untold story, brimfull of unspoken interest and taboo. I'm not learned enough to tell it but I do know that my own life in art has been illuminated by just such talismanic centeredness ... to do with my own painting.

O.K., text-centeredness and biographical heresy; uncommon modern painting senses which don't replace good old ones like Make it New, truth to materials, and art for art's sake. I'd like to center the rest of this heretical text on Robert Lowell's line:

Yet why not say what happened?

All paintings tell what happened to the artist (not only depictive, narrative or naturalistic

painting). In that sense they are all autobiographical and some of this may be confessional, which I take to be more of an intentional act like its counterparts in religion, therapy, poetry and friendship. The formalist churchmen and the biographical heretics both tell what happened (to them). As surely as intelligences are dispatched (or whispered), you know, just from seeing what you see in the painting, in its dispositions and touches and allegiances, a lot about who did it. Not everything, by a long shot, because of the separation of powers between painting and painter, which places the one over here and the other over there, thus blunting real frankness. That's one of the moments where words flourish as secret agents for painting, like these prefaces, or anything or anyone else who (so often) tries to tell what happened to the picture that tells about the life. Many, many painters claim to paint in a new language. Well and good, but even old languages have to suffer translation for most of us who want that, which brings me to these prefaces and to the last few things which I can only glance at here. They are among the first things that excite me now about my own art prospect.

Hemingway told Fitzgerald we're all bitched from the start and that we have to use that hurt; ... I think the modern term is identity, and its art can be the examined life, which is not very heretical after all. There are even a very few strong voices around, such as that of I. B. Singer, who say that good art springs from one's tribe. He once wrote: 'Only dilettantes try to be universal; a real artist knows that he's connected with a certain people.' Singer knows he has a people; I seem to have almost three. The one which tantalizes me the most these days is the one the Koran calls the book

people, and a few years ago I set about learning something of them (and me).

My idea of art is to make picture-studies, to act upon what can be learnt about the world (according to one's sensations) in these 'studies'. My idea of art is that even though you stay in your own room a lot, you still find out about the world; you find, like Picasso said, disguises of things learnt which become new and discrete (paintings) in a changeful history of subjectivity. My idea of art is that it conceals and reveals one's life and that what it confesses, is as Kafka called it 'a rumour of true things'.

I began all this by disagreeing with Hardy. Now I want to end by agreeing with the eternal art flame which burns away behind those angry words of his. My pictures and their evidences (as in these next prefaces) are not everyone's cup of tea; I know that. But our sainted Emerson spoke for me as I could never do when he said in his Divinity School Address: 'That is always best which gives me to myself. The sublime is excited in me by the great stoical doctrine, obey thyself.'

> for my son Max, a few hours old,

> R. B. KITAJ, 1984

JUNTA 1961-62 (Plate 31)

I meant to illustrate, to invent the (imaginary) members of a benign revolutionary government, so it's an early form of the idea I took up ten years later (Orientalist, Arabist, Marrano, etc.), that painters should be able to make up characters, like novelists always do in so many ways. A very few of those ways are: only slightly after the life (of someone known); composites taken from one's more general experience of people; figure-inventions (like Ratapoil and Macaire) meant to strike as lasting or glancing a blow as an artist can ever expect to commit against perceived wrong; disguised self-portraits, and so on.

Junta was painted partly in Catalonia and grew out of my friendship with Josep Vicente which began in 1953. He used to talk fondly of the grizzled old anarchists he would introduce me to and of how well they fought in what he still calls 'our war' and of their only very brief historical success, organizing some coastal villages before oblivion came down on them and Europe. The fifth, last panel in my painting was modelled after Durruti, the anarchist leader who fell, and the others are composite inventions. The bomb disguised by flowers was a favourite anarchist number and the doppelgänger above the bomb was meant to symbolize ideological compromise in such United Fronts; figures in tandem, often doomed to split apart or to murder each other in the name of some purity or other. Such fronts or their shadows are with us today, everywhere, even in England, so if my old picture seems like a backward glance, it was a student work, and everything else is past as well; even last week's dramas. Paintings may stop time in its tracks though, in homage, in reverie, in elegy, in remembrance, in fear and trembling . . . all more or less honorable things. My characters should have names maybe, to make them more real and memorable (the way I, for one, like to remember Greta Prozor, Eva Mudocci, Yvonne Landsberg, etc.), so I may give them names some day, which task will keep the old painting alive and unfinished in my mind at least.

PERILS OF REVISIONISM 1963 (Plate 45)

The Chinese and the Russians had just begun their great split-off and they were accusing each other of Revisionism and its Perils. Schism, I think, is a good subject for painting; splitting, dissociation, free association are said to manifest self-awareness in psychoanalysis, and not a bad business at all. The question of a picture's integrity or not is very unresolved in my own interest and practice. Pictures can be split, as against the concern for a picture's unity and coherence prevailing in art theory during the first part of my life (which theory I also rather like) – thus, one of my primitive attempts here at dissociation. Like Splitting, Revisionism has good and not so good aspects in history and in art. Not too good are its reactionary, dogmatic, fanatical, fundamentalist impulses. What seems sweet to me is to revise art and politics for the sake of keeping good things alive, changed and renewed – like social democracy and depictive drawing for instance, and our various freedoms. To be sure, one must turn away from consensus of opinion; one must break ranks (especially the ranks of the faithful), but Revisionism still imperils as ever (Khomeinism, Jabotinskism, etc.).

I made this picture long before I saw Michelangelo's Last Judgement wall in the Sistine Chapel, I guess my favorite (big) painting of all time. When I came to do the imperilled Chinese figure clutching his face in horror, I only had a tattered reproduction of Michelangelo's great Sinner from Life magazine (kept since I was a kid). He suddenly realizes he's condemned to Hell forever, which somehow exercises me more and more as I grow older and realize that old age isn't so bad when you consider the alternative.

THE RED TENT 1964 (Plate 29)

'Mean something! You and I, mean something! Ah, that's a good one!'

SAMUEL BECKETT

Kennedy had just been killed and I meant *The Red Tent* to paraphrase the surprising longevity of an American democracy which works pretty well, which I rather like, and which belongs to a quite rare species: government by consent. I've been told by experts that democracy, about two centuries old and experienced by only a tiny minority of people, may have been an historical accident whose days look numbered. As often as that thought scares me, another, similar intelligence keeps sneaking up on me, about our art – that this art, with which you and I try to mean something, and about which so few of us agree, for all its modern attractiveness, seems (to me anyway) a frail exercise, like democracy itself, practised almost hopelessly at the far margins of a vast world bent on the destruction of democracy by Men Without Art.

The Red Tent was a beacon used by polar explorers in the wastes. Men could return to it in some hope. Around the time I painted the picture, I was becoming a very suspicious reader of the left certainties which swirled about my youth and I designed a nice Red Tent to come home to, not from the God That Failed so many others but just out of the cold for a moment. Coming in to warm

from the cold I take to be one of the meanings of art, and the political men in my picture (some hollow, some not) hover about the Red Tent for warmth after a regicide, a perpetual play of governance by consent in what Hannah Arendt called 'the public space'.

Twenty years later, I wish this little mystery-picture had been more profoundly painted because

I like its terms even more deeply now than I understood then.

WALTER LIPPMANN 1966 (Plate 40)

Every day since I was in high school I read political criticism of many stripes. In the beginning was the word, and a columnist I often read said that the picture was not far behind.

Although this painting is a little too oblique for my taste, it's one of my few favorites among my pictures because I'm so pleased with the configurational debt it expresses to this type of journalism I read each day, that I fancy some of the pleasure I've had from columnists, like the pleasure another painter may get from trees or ancient ornament, has translated into the painted correspondences I've collected here. Now, people like Lippmann, Aron, Izzy Stone, Conor Cruise O'Brien and George Will write clear prose for their millions of readers, but perhaps I can be forgiven the difficulty of the stream-of-consciousness into which the parts of my picture flow if only because the eventful world those editorialists try to explain doesn't really come to order very often either. So, in my own practice, some art is fairly straight and some need not be, just like news, and, like stale news and ancient art, some of the original meanings in this picture are lost.

W.L., at stage right, is the voyeur and explainer of complex events he was in my youth. I took the liberty of embroidering those serious events in terms of romance, intrigue, spies and alpine idyll, like movies did in those days, often made by refugees, themselves escaping from serious events. When movies were first shown, the form was so new and unusual that most people found it difficult to understand what was happening, so they were helped by a narrator who stood beside the piano.

JUAN DE LA CRUZ 1967 (Plate 61)

Interesting about Vietnam . . . (and art) Heresies and orthodoxies are always changing places, just as the line between heresy and orthodoxy in St Juan's time was very fine indeed. Many people saw the Vietnam war as something clear-cut, evil against good. Now, only a few years later, many of those same intellectuals are not so sure. Communist Vietnam, ally of Communist Russia, at war in Communist Cambodia, ally of Communist China . . . Cambodia itself the scene of a Communist Genocide against its own people. How nutty can the world get? That one's a corker. So was the Inquisition and Juan's harassed 49 years in and out of its claws – born to an underclass, like my Sgt Cross, torn between devotion to his calling and tradition on the one hand and St Teresa's Reform on the other, like the American Black must have been in Vietnam. The subtitle of this picture is Dark Night of the Soul, after Juan's famous prose work. I was somewhat, but not overly curious about mysticism in those days. I loved the small body of poems written by St John of the Cross (mainly in prison) even though the Christian and Jewish mystics have always communicated something to me beyond any real understanding, which may be quite appropriate because mystical experience is said to be ineffable, a denial of any familiar experience, anyway. Mystics are said to discover a new world, very different from our familiar one. This is very much one of the things I like to think a painting might be – a discovered world, an unknown, made of assonances, surprise associations and this and that ... this picture and other, better ones.

The Mystic enjoins a new kind of love, remote from hot sensual love, after a sort of death which purges (Vietnam?). My poor and maybe tasteless couple to the right of Juan celebrate a blasphemous mystical union. Bridegroom and Bride are St John's own symbolic forms for this union. St Teresa, whose protégé was St John of the Cross, is made to walk the plank by Inquisitors

... Juan's poems express Christian Mystery; the Vietnam wars are most awful expressions of political mystery, the mystery of Realpolitik; so the painting is a Mystery-picture. The very mysterious origins of St Teresa and her Juan intrigue me at a personal level – St Teresa was of proven Jewish origin; St Juan's possible Jewish descent is unproven. Teresa's grandfather was accused by the Inquisition of having relapsed into Judaism, and so on It's a long story, like art. I was just beginning, when I made this picture, to become fascinated with secret Judaizers and such mysteries.

THE AUTUMN OF CENTRAL PARIS (AFTER WALTER BENJAMIN) 1972-74 (Plate 57)

Dear Benjamin is now a truly chewed-over cultural spectre, not least in art writing. I started to chew on him myself in the late sixties after having fallen upon him, before the deluge, in a publication of the Leo Baeck Institute. His wonderful and difficult morage, pressing together quickening tableaux from texts and from a disjunct world, were called citations by a disciple of his who also conceded that the picture-puzzle distinguished everything he wrote. His personality began to speak to the painter in me - the adventure of his addiction to fragment-life, the allusive and incomplete nature of his work (Gestapo at his heels) had slowly formed up into one of those heterodox legacies upon which I like to stake my own dubious art claims - against better judgements of how one is permitted to burden the crazy drama of painting. When I first showed this picture, a reviewer even began his attack by choking on the title, which he said I'd stolen from a sociological treatise having nothing to do with Benjamin. The critic was dead right. Benjamin thrills me in no small measure because he does not cohere, and beautifully. He was one of those lonely few who lived out Flaubert's instruction: 'Not to resemble one's neighbor; that is everything.' A lot of people, a whole lot of artists would wish for that, I think, but it eludes us more than we imagine it does. His angry neighbors drove him to kill himself in that very Autumn of 1940 which saw the Fall of France and in which I've set this picture, some of my working notes for which follow below. I feel I ought to apologise for this type of painting because it's such a rouged and puerile reflection upon such vivid personeity, but maybe I won't (apologise); maybe a painter who snips off a length of picture from the flawed scroll which is ever depicting the train of his interest, as Benjamin did, may put a daemon spirit like Benjamin in the picture.

CITATIONS (sketchbook entries for Benjamin painting)

B's montage practice, which he called 'agitational usage'. See fractured *suggestion* in *trompe-l'oeil* example . . . (things covering up, overlapping other things, fooling the eye in painted depiction . . .).

THE DIORAMA ('for the last time, in these DIORAMAS, the worker appeared, away from his class, as a STAGE-EXTRA in an IDYLL'). Painting as *Diorama/Tableau* (ask Cleveland Museum if they still have those dioramas they showed in my childhood; also sculptures of workmen (by Max Kalish?) I must have seen those dioramas as B was about to die in 1940.)

Café-life as an autumnal reverie of bourgeois society; nature morte; Café as open-air interior (past which the life of the city moves along).

Collage implication in B's treatment of the barricade; B cites barricade metaphors like: 'broken irregular outlines, profiles of strange constructions' – from Les Misérables.

PILE-UP (BARRICADE) of figures as in the movie poster.

THE SMOKERS; THE PASSERBY; MEN ABOUT TOWN; RUMOUR and IDLENESS; THE COCOTTE in her DISGUISES; OCCASIONAL CONSPIRATORS; THE SWIFT GLANCE; CROWD AS REFUGE; CHANCE (as a guide through city-life); PROSTITUTION (the life of the erotic person in the crowd); FETISHISM (as the 'vital nerve of fashion'); PROLETARIAT driven out of CENTRAL PARIS (title) leading to emergence of a RED BELT (margins of picture).

ANGEL OF HISTORY – IDLE STROLLER face turned 'toward the past', blown backwards into the future by the storm of progress while the pile of ruins before him grows skyward (PILE-UP of images).

MAN WITH HEARING-AID ... the POLICE-SPY/SECRET AGENT.

THE MAN WALKING AWAY ... B's suicide? (the *flâneur's* last journey: death ... 'to the depths of the unknown to find something new' – from *Flowers of Evil*).

Baudelaire said there is no exalted pleasure which cannot be related to prostitution. Now, that's the strong stuff of some very great poetry, but my own exalted pleasures are far less exclusive, while my most exalting sense of a modern art is, I think, an art of Renewal in which one's own changeful poetics, mind-sets, nerve systems, fired by the ups and downs and dreadful secrets of one's modern lives, seize up and become pictures. Of all modernist Sleep-walkers, Benjamin set a renewing pace (for a possible big-city art) quite familiar to me as he prowls those networks of streets he says prostitution opens up 'across the threshold of class'. Strangers are drawn (alone in crowds) into these districts of minor crime where one is allowed but does not belong (like some Diaspora), where danger, in its very excitement, has been known to feed the art of the quiet studio. Among those loveless alleys (where Baudelaire says he found both love and God), which are, like pictures, the same and different across the world, I have always been enchanted by an art-god plying there, as Benjamin, Picasso and Degas were. I don't mean to exalt this little pastel illustration of mine. It's just a memory-aid styled after the jacket of a pulp thriller. Each painter has his own minor deity who looks after the special art interests of his client. In this pastel, mine is talking to the woman in The Street. I think it's not the first time I'd drawn him but he is my own creature, who appears through the ether, like Daumier's Ratapoil, to agitate and excite the stuff of life into pictures recollected in tranquillity. He can act unspeakably but always in the name of my art.

Two main strands come together in the picture. One is a certain allegiance to Eliot's Waste Land and its (largely unexplained) family of loose assemblage. Eliot used, in his turn, Conrad's Heart of Darkness, and the dying figures among the trees to the right of my canvas make similar use of Conrad's bodies strewn along the riverbank.

Eliot said of his poem, 'To me it was only the relief of a personal and wholly insignificant grouse against life; it is just a piece of rhythmical grumbling.' So is my picture . . . but the grouse here has to do with what Winston Churchill called 'the greatest and most horrible crime ever committed in the whole history of the world' . . . the murder of the European Jews. That is the second main theme, presided over by the Auschwitz gatehouse. This theme coincides with that view of the Waste Land as an antechamber to hell. There are (disputed) passages in the poem where drowning, 'Death by Water', is associated with either the death of someone close to the poet or the death of a Jew . . . like most of the poem, these passages are fraught with innuendo.

The man in the bed with a child is a self-portrait detail in the waste-like middle ground which also shows scattered fragments (such as the broken Matisse bust) being sucked up as if in a sea. This sense of strewn and abandoned things and people was suggested by a Bassano painting, of which I had a detail, showing a ground after a battle. Love survives broken life 'amid the craters' as someone said of the poem.

The general look of the picture was inspired by my first look at Giorgione's *Tempesta* on a visit to Venice, of which the little pool at the heart of my canvas is a reminder. However, water, which often symbolizes renewed life, is here stagnant in the shadow of a horror . . . also not unlike Eliot's treatment of water. My journal for this painting reports a train journey someone took from

Budapest to Auschwitz to get a sense of what the doomed could see through the slats of their cattle cars ('beautiful, simply beautiful countryside') ... I don't know who said it. Since then, I've read that Buchenwald was constructed on the very hill where Goethe often walked with Eckermann.

LAND OF LAKES 1975-77 (Plate 100)

'Grub first, Art after.' BRECHT

I'm not an optimist, but the other night we were watching a television program about Lord Beveridge and his famous Plan to eradicate poverty in England, and the telly and I fairly glowed with warmth for the old man and his hopeful scheme for things to come. 'Good Government', I said to my wife. A minute later I thought: Bloody Hell, England owned one fifth of the world's body, against the will of those bodies, at the same time old Beveridge and his pals, like the Webbs, were designing 'beautiful eyes' for their island.

My pretty painting, Land of Lakes (with its beautiful eye), is an optimistic scenic view. It takes its first inspiration from a detail of Lorenzetti's Effects of Good Government fresco at Siena, said to be the first landscape of its kind to have survived, and its next influence from the 'Historic Compromise' I used to read about when this picture was being made, between the Christians and the Left (cross and red flag). There are no people in my landscape. They are holding their breath somewhere while a Polity is being determined for them in our own time. This impersonal meditation takes its name from the water which is the symbol of renewed life and which courses in the southern countryside from the north of the same land. If Good Government has been known to disguise Bad Government, then what can Picasso have meant when he said that art is a lie?

THE JEW, ETC. 1976-unfinished (Plate 97)

'I have long since resolved to be a Jew ... I regard that as more important than my art.' SCHÖNBERG

I've seen people wince at this title; sophisticated art people, who think it's better not to use the word Jew. Kafka, my greatest Jewish artist, never utters the word once in his work, so I thought I would. This name-sickness, which many Jews will recognize and understand in different ways, is so touching to me, that I've also given my Jew a secret name: Joe Singer. Now it's not secret anymore.

In this picture, I intend Joe, my emblematic Jew, to be the unfinished subject of an aesthetic of entrapment and escape, an endless, tainted Galut-Passage, wherein he acts out his own unfinish. All painters are familiar with the forces of destiny embedded in happy accident and other revelations and failures which inform one's painting days. In that way, I'd like to expose Joe, in his representation here, to a painted fate not unlike the unpredictable case of one's own dispersion in the everyday world. For instance, before long I may name Joe's fellow passengers, those you can't see unless I paint them in, even though there's not much room left. In fact, I've begun to people this train-compartment in my journal. One of Joe Singer's jobs relates to a tradition of our exile, which influences this picture, whereby living messengers are trained up, who take the place of books, in order to preserve a freshness of teaching, not endangered by date or dogma. Joe is the messenger-invention of my own peculiar dispersion (Galut), about which I learn more every day. His depiction on his expiatory pilgrimage, presides over what belongs to my sense of that changeful exilic condition and its uncertain art habits and futures, as in these beautiful lines about the Jews by the Catholic Péguy: 'Being elsewhere, the great vice of this race, the great secret virtue, the great vocation of this people.'

THE ORIENTALIST 1975-76 (Plate 98)

I did not come to England as a refugee, nor did I emigrate here as so many did to America, but I stayed on, and it became a habit. Some people live out their lives in places they don't come from, assigning themselves to a strange race of men and an alien sense of land and city. Who is to say why they do what they do with their lives, or for that matter, why painters do what they do with their painting lives? This picture belongs to such questions. Getting dressed up in another culture is no more a mug's game, I guess, than dressing our pictures in the borrowings, trickery and deceit we all affect, which Degas likened to the perpetration of a crime. Speaking of tricksters, my Orientalist relates to Trevor-Roper's amazing book about Edmund Backhouse, the Hermit of Peking. The setting was inspired by Whistler's Peacock Room in Freer's Detroit house. The real subject here is un-at-homeness.

THE RISE OF FASCISM 1979-80 (Plate 94)

I used to mean these bathers to allude to the classic Fascist period only, but now I don't. The bather on the left is the beautiful victim, the figure of Fascism is in the middle and the seated bather is everyone else. The black cat is bad luck and the bomber coming over the water is hope.

THE SENSUALIST 1973-84 (Plate 1a)

'Cézanne! He was my one and only master!' PICASSO

I think Cézanne is my favorite painter too. This picture belongs some to one of my hobbies: trying to figure him, trying to figure his little and big sensations all over again. Pete Rose said: 'Nobody's got a book on me.' Cézanne could have said it. Maybe that's why he draws so many of us to him.

This (canvas) began life 11 years ago, the other way round, as a woman. You can still see her pink head upside down at the bottom. I don't remember who she was but I think she represents the real woman in the Sensualist's life in the repainted picture. This studio picture was not painted from life. First, I painted over the woman a kind of copy of the famous Cézanne male Bather of 1885 (itself painted after a photo). Then, the Titian Marsyas came to the Royal Academy and blew everyone's mind. I'd put a postcard of it upside down on my wall and meanwhile Kossoff, who'd been drawing from the Marsyas, gave us one of those drawings as a wedding present. The drawing was lying on the floor, again upside down, looking like a man walking, so I painted from that over my bather, which became the final version. All too artful, so I wrote ART over the mean street doorway, for Art's sake. In the end oneself is the making of it; not after life but about the life, I think Pound said. Titian came to exploit what has been called the victory of the subjective principle, then only recently prepared. The depiction of human proportions would always now turn on the mystery of subjective styles - never more so before or since Cézanne's bathers, bemused as they often are by a torsion like that in the dangling Marsyas, though not in the frontal magic of the great N.Y. Male Bather whose (implied) quadrifacial stance I grafted onto my tall canvas at first. I left his right hand on his hip as you can see, as an action between the crises of the torsion. In the end, the muscularity comprises frontal breast, three-quarter hips and profile legs, the transition or joining of which Titian seems to have beautifully fudged, for the sake of, I suppose, an animality.

DESK-MURDER 1970-84 (Plate 155)

The subject of this picture turns out to be hate. It was only upon reading the obituaries of Herr Walter Rauff that I knew my painting was finished. I hadn't touched it for many years, in its metaphysical desuetude, but the last stroke would be to give it this final title. Fourteen years before, I'd called it *Teste Study*, after Valéry's mindful Monsieur (based on Degas), who had so entranced my youth. Then, for a while, it was *The Third Department* ... (political police; getting warmer). I think the new title is just right because the terms of the picture fit so well.

Herr Rauff, Schreibtischtaeter (Desk-Murderer), was dead, but I could now float this office picture out, with just a wee bit more confidence, into the same world in which his pals are still alive, including those who gave the Hitler-salute at his grave in Chile. Some people will laugh at my ignorance of the proper powers of the painting art (as if one could express an historical unhappiness), but I'll tell you, it makes me feel a little keener to get a painting to 'work' in my own way, and so there may be a very small art lesson in it. Let me go on:

Incredibly, there used to be a naval officer in my painting until I took him out years ago. Rauff, I just learned, had been a failed naval officer who turned to the SS after he was kicked out of the navy. At some point in the life of this picture, I stuck on a fragment of canvas and drew on it what looks like a contraption of some sort, emitting fume. Rauff was the guy who designed the mobile gas vans used by *Einsatzgruppen* in Eastern Europe before the German killing-centers became operational. At last I knew what my odd device was. I had even obliged fate by draping my composition in mourning black and sketching in an unlaid ghost. The murder office is empty and my banal picture of evil, like Rauff, is finished, its purpose, as Helen Gardner said of *The Waste Land*, altered in fulfilment.

CECIL COURT, LONDON WC2 (THE REFUGEES) 1983-84 (Plate 143)

'I consider myself no longer a German. I prefer to call myself a Jew.'
SIGMUND FREUD

I have very little experience of water-lilies or ballet-dancers or jazz or long walks or wine or loneliness. Among some other things, I think I have a lot of experience of refugees from the Germans, and that's how this painting came about. My dad and grandmother Kitaj and quite a few people dear to me just barely escaped. One of the first friends to see this painting (a 75 year old refugee) said the people in it looked meshugge. They were largely cast from the beautiful craziness of Yiddish Theater, which I only knew at second hand from my maternal grandparents, but fell upon in Kafka, who gives over a hundred loving pages of his diaries to a grand passion for these shabby troupes, despised by aesthetes and Hebraists who were revolted by them. Painters are in the business of 'baking' (a plot device from Y.T.) pictures whose perpetration may be sparked by unlikely agents of conversion, which in Kafka's case really caused his art to turn when he met these players. Excited, according to my own habits, I began (in Paris, California, N.Y., Jerusalem and London), to collect scarce books and pictures about this shadow world, the trail of which has not quite grown cold in my own past life. I would stage some of the syntactical strategies and mysteries and lunacies of Yiddish Theater in a London Refuge, Cecil Court, the book alley I'd prowled all my life in England, which fed so much into my dubious pictures from its shops and their refugee booksellers, especially the late Mr Seligmann (holding flowers at left) who sold me many art books and prints. Another day I'll tell who the other people in the painting are supposed to be, whether aesthetes find such midrashic gloss and emendation revolting or not. For now, I must confess that I wish I could continue to paint the shopsigns in the spirit of a distinction made by my favorite antisemite, Pound, who said that symbols quickly exhaust their references, while signs renew theirs.

AMERIKA (BASEBALL) 1983-85 (Plate 152)

'The day Custer lost at the Little Big Horn, the Chicago White Sox beat the Cincinnati Red Legs, 3-2.' CHARLES O. FINLEY

About a year after I began this painting, a famous neo-Cubist friend took us to see a seventeenth-century Chinese handscroll by Wang Hui at the British Museum, which my friend said had changed his life. This very long (70 feet) Royal Inspection Tour down the Yangtse had confirmed for my friend his belief that one must (he must) set about representing the element of time in painted depiction, as Picasso had done to the end of his many days.

I thought the scroll was terrific but it didn't change my life. As you can guess, there were an awful lot of tiny people going about their business along that river, and what it tended to confirm for me was the unusual fun I was having at home, painting a whole lot of little baseball players on a vast metaphoric field, because painting is very rarely what I would call fun, in my own experience of doing it. The depiction of time, different kinds of time, had already deeply scored my baseball

picture.

For most of my life I've lived thousands of miles away from real baseball and I've got to recollect such things past from an English setting which has warped time through these thirty years of mostly exile from the Summer Game; in fact, since my poor lost tribe of Cleveland Indians last won a pennant and began their three decades of decline by blowing four straight to Leo Durocher's Giants in the '54 Series. I sometimes fear my own decline began in that fall of 1954. Proust's sessions of sweet silent thought have deluded me into painted remembrance and I've not taken Satchel Paige's advice: 'Don't look back; something may be gaining on you.' Any baseball folk over the age of 50 who look hard will find that great man (Paige, not Proust) in my painting, as I remember him when Bill Veeck brought him up to Cleveland from the Negro League in old age.

This painting's title begins with Amerika, as will some others from time to time. Unlike Kafka, I've been there, know it well and get quite homesick for it, but Kafka's crazed, beautiful, unfinished book inspired me, years ago, to look at my exilic self in changeful ways. I would attempt to paint that selfhood, to reconstruct its homeland, as painters have always worked on machines, in the studio after sketches; only, my sketches would be sensory, invisible. One little sensation, for instance, arriving after I'd begun to dispose the players one sees from afar, was an unaccountable urge to open up the centre, either to show a clearing in the King's blue field or to endanger the players, to suck them toward a barren middle ground – I don't know which or why; not yet I don't...

I decided to paraphrase both Velázquez and Kafka, and so the great fieldscape of the Boar Hunt at London combined with a Cuckoo Nature-Theatre of Ohio and upstate New York; the Velázquez setting reminded me of the low hills of home which often framed the playing fields where we toiled at pick-up ball long after dusk blinded us. I was going to say how the little figures on that broad plain stand for the hundred ways that baseball lives mirror our own, teach me lessons – even art ones, but I think I'll leave that to the novelists for now and give these last words to Max Brod: 'In enigmatic language Kafka used to hint smilingly, that within this "almost limitless" theatre his young hero was going to find again a profession, a stand-by, his freedom, even his old home and his parents, as if by some celestial witchery.'

SELECTED BIBLIOGRAPHY

Exhibition catalogues

Berkeley. University of California. R.B. Kitaj. 1967. Text by the artist. Berlin. Galerie Mikro. R.B. Kitaj: Complete Graphics 1963-1969. 1969. Introduction by Werner Haftmann.

Cincinnati. Cincinnati Art Museum. Dine, Kitaj. 1973. Essay by

Richard J. Boyle.

Hannover. Kestner-Gesellschaft. R.B. Kitaj. 1970. Retrospective exhibition. Introduction by Wieland Schmied. Republished in slightly modified form by Boymans-van Beuningen Museum, Rotterdam,

London. Hayward Gallery. The Human Clay: An Exhibition Selected by R.B. Kitaj. 1976. Introduction by the artist.

London. Marlborough New London Gallery. R.B. Kitaj: Pictures with Commentary, Pictures without Commentary. 1963. Notes by the artist.

London. Marlborough New London Gallery. R.B. Kitaj: Pictures from an exhibition held at the Kestner-Gesellschaft, Hannover, and the Boymans-van Beuningen Museum, Rotterdam, 1970. 1970.

London. Marlborough Fine Art. R.B. Kitaj: Pictures. 1977. Introduction by Robert Creeley

London. Marlborough Fine Art. R.B. Kitaj: Pastels and Drawings. 1980. Introduction by Stephen Spender.

London. National Gallery. The Artist's Eye: An Exhibition Selected by R.B.

Kitaj. 1980. Introduction by the artist. Los Angeles. Los Angeles County Museum of Art. R.B. Kitaj: Paintings

and Prints. 1965. Introduction by Maurice Tuchman New York. Marlborough-Gerson Gallery. R.B. Kitaj: Paintings. 1965. Notes by the artist.

New York. Marlborough Gallery. R.B. Kitaj: Pictures. 1974. Introduction by Frederic Tuten.

New York. Marlborough Gallery. Fifty Drawings and Pastels, Six Oil

Paintings. 1979. Introduction by Timothy Hyman.

Washington, D.C. Hirshhorn Museum and Sculpture Garden, Smithsonian Institution. R.B. Kitaj. 1981. Retrospective exhibition. Texts by John Ashbery, Joe Shannon and Jane Livingston; reprint of Timothy Hyman's interview with the artist, 'A Return to London'; and full bibliography and list of exhibitions to 1981. Republished in German by the Städtische Kunsthalle Düsseldorf, and in English, London (Thames and Hudson), 1983, in slightly modified form.

Articles, essays, interviews

ASHBERY, JOHN, 'Poetry in Motion', New York, 16 April 1979, pp. 94-6. ASHBERY, JOHN, 'R.B. Kitaj: Hunger and Love', Art in America, January

1982, pp. 130-5.
ASHTON, DORE, 'R.B. Kitaj and the Scene', Arts and Architecture, April

1965, pp. 8-9, 34-5

BARO, GENE, 'The British Scene: Hockney and Kitaj', Arts Magazine,

May-June 1964, pp. 94-101.
BERTHOUD, ROGER, 'A Love for Pictures and an Enthusiasm for Life; Roger Berthoud interviews R.B. Kitaj', The Times (London), 7 May 1977, p. 8.

CREELEY, ROBERT, 'Ecce Homo', Art International, March 1979, pp. 27-

DALEY, JANET, 'R.B. Kitaj', Arts Review, 29 April 1977, pp. 289–91. DE CONINCK, HERMAN, 'Portfolio – Kitaj', NWT, May 1984, pp. 40–7. FAURE WALKER, JAMES, 'R.B. Kitaj Interviewed by James Faure

Walker', Artscribe, February 1977, pp. 4-5

FINCH, CHRISTOPHER, Image as Language - Aspects of British Art 1950-1968,

Harmondsworth, 1969. Chapter on Kitaj. FRANCIS, RICHARD, ""The Red Banquet" by R.B. Kitaj', Annual Reports and Bulletin, Walker Art Gallery, Liverpool, 1971-4, pp. 84-90.

GLUECK, GRACE, 'Painter's Painter', New York Times, 14 February 1965, sec. 2, p. 19.

HAWORTH-BOOTH, MARK, 'Kitaj/Brandt/Screenplay', Creative Camera, June 1982, pp. 546-9. HUGHES, ROBERT, 'The History Painter: Expatriate R.B. Kitaj Brings

Home the Bacon', Time, 23 April 1979, pp. 70-1

HUGHES, ROBERT, 'Art - Edgy Footnotes to an Era', Time, 26 October 1981, pp. 76-7.

HYMAN, TIMOTHY, 'R.B. Kitaj: Avatar of Ezra', London Magazine, August-September 1977, pp. 53-61.

HYMAN, TIMOTHY, 'A Return to London: R.B. Kitaj Replies to Some Questions Put to Him by Timothy Hyman', London Magazine, February 1980, pp. 15-27.

HYMAN, TIMOTHY, 'Kitaj: A Prodigal Returning', Artscribe, October

1980, pp. 37-41.

KITAJ, R.B., 'On Associating Texts with Paintings', Cambridge Opinion, January 1964, pp. 52-3.

KITAJ, R.B., essay in Arte inglese Oggi 1966-1976, exhibition catalogue,

Palazzo Reale, Milan, 1976, vol. I, p. 128. KITAJ, R.B. and HOCKNEY, DAVID, 'R.B. Kitaj and David Hockney Discuss the Case for a Return to the Figurative', New Review,

February 1977, pp. 75-7.
KITAJ, R.B., 'Dine ... Some Historical Notes Apropos', in *Jim Dine*: Works on Paper 1975-76, exhibition catalogue, Waddington and Tooth Galleries II, London, 1977.

KITAJ, R.B., 'The Autumn of Central Paris (After Walter Benjamin), 1971', Art International, March 1979, pp. 19-20.

KRAMER, HILTON, 'R.B. Kitaj', New York Times, 6 April 1979, sec. C,

KUDIELKA, ROBERT, 'R.B. Kitaj und die Schuld des Auges', Kunstwerk, August-September 1967, pp. 3-12.

LIVINGSTONE, MARCO, 'Iconology as Theme in the Early Work of R.B.

Kitaj', Burlington Magazine, July 1980, pp. 488-97. LUCIE-SMITH, EDWARD, 'R.B. Kitaj', Art and Artists, January 1982, pp. 34-5.

MACBETH, GEORGE, 'R.B. Kitaj and George Macbeth in Dialogue', Art Monthly, April 1977, pp. 8-10.

McCORQUODALE, CHARLES, 'Edinburgh - Two Exhibitions', Art International, November 1975, pp. 26-9.
McNAY, MICHAEL, 'R.B. Kitaj in an interview with Michael McNay',

Manchester Guardian, 8 May 1970, p. 8.

PEPPIATT, MICHAEL, 'R.B. Kitaj: Pictures like Novels', Connaissance des arts, September 1981, pp. 28-35.

PEPPIATT, MICHAEL, 'R.B. Kitaj', Kunst og Kultur, no. 3, 1983, pp. 166-PIZZEONI, ATILLIO, 'La presenza di Kitaj nella situazione inglese',

Artecontro, no. 15, 1976, pp. 14-15. PLANTE, DAVID, 'Paris, 1983', Sulfur (Los Angeles, California), issue 9,

1984, pp. 96-110. PODRO, MICHAEL, 'Some Notes on Ron Kitaj', Art International, March

1979, pp. 18-30.

REICHARDT, JASIA, 'R.B. Kitaj: A Return to the Figurative? A New Direction, Indeed Unforeseen', Metro, issue 6, 1962, pp. 94-

REICHARDT, JASIA, 'Kitaj's Drawings from Life', Connoisseur, October 1963, pp. 112-16.

ROBERTSON, BRYAN, 'R.B. Kitaj: A Fantastic Conspiracy', Sunday Times Magazine, 10 February 1963, pp. 23-5.
RUSSELL, JOHN, 'The Polemical Painter', Sunday Times, 10 February

1963, p. 33. RUSSELL, JOHN, 'A British Show Built of "Human Clay", New York

Times, 5 September 1976, sec. 2, p. 23. SCHULZE, FRANZ, 'The Kitaj Retrospective - Too late or too early?' Art

News, January 1982, pp. 122-5. SCOTT, JAMES, R.B. Kitaj. Film, Arts Council of Great Britain, London, 1967, with narration by R.B. Kitaj and Christopher Finch.

STEVENS, MARK, 'Art - Pictures that have a plot', Newsweek, 28

September 1981, pp. 96-7.
TARSHIS, JEROME, 'The "Fugitive Passions" of R.B. Kitaj', Art News,

October 1976, pp. 40-3.

TATE GALLERY, London. Entries on individual works in Review 1953-1963 (Isaac Babel Riding with Budyonny); The Tate Gallery 1968-70

(Mahler Becomes Politics, Beisbol); Biennial Report and Illustrated Catalogue of Acquisitions 1972-74 (The Man of the Woods and the Cat of the Mountains); Acquisitions 1978-80 (The Rise of Fascism); and Acquisitions 1980-82 (The Murder of Rosa Luxemburg)

Time Magazine, 19 February 1965, p. 72 (no author listed), 'Painting: Literary Collage'

TUCHMAN, MAURICE, 'European Painting in the Seventies', Art and Artists, November 1975, pp. 44-9.
TUTEN, FREDERIC, 'Neither Fool, nor Naive, nor Poseur-saint: Frag-

ments on R.B. Kitaj', Artforum, January 1982, pp. 61-9.

WELTI, ALFRED, 'Vorwärts zu den Alten Meistern', Art - Das Kunstmagazin, February 1982, pp. 136-7.

WILLETT, JOHN, 'Where to Stick it', Art International, November 1970, pp. 28-36.

WYNDHAM, FRANCIS, 'The Dream Studio of R.B. Kitaj', Sunday Times Magazine, 25 May 1980, pp. 59-62, 67.

LIST OF WORKS

- 1. The first terrorist, 1957. Plate 19 Oil on canvas, $6\frac{1}{2} \times 4\frac{1}{2}$ in. (16.5 × 11.4 cm.). Collection of the artist
- 2. Tarot variations, 1958. Plate 4 Oil on canvas, 44×34 in. (111.8 \times 86.4 cm.). The High Museum (J.J. Haverty Collection), Atlanta, Georgia.
- 3. ERASMUS VARIATIONS, 1958. Plate 1 Oil on canvas, $41 \times 33\frac{1}{8}$ in. (104.2 \times 84.2 cm.). Peter Cochrane, London.
- 4. MISS IVY CAVENDISH (OXFORD), 1958. Plate 2 Charcoal pencil on paper, $21 \times 16\frac{3}{8}$ in. $(53.3 \times 41.6$ cm.). Collection of the artist.
- 5. IVY CAVENDISH, c.1958. Fig. 3 Oil on canvas 16×12 in. $(40.6 \times 30.5$ cm.). Collection of the artist.
- 6. Monseigneur ungar, 1958. Oil on canvas, $10\frac{1}{4} \times 8$ in. (26.1 \times 20.3 cm.). Private collection, London.
- 7. KNITTING, ℓ . 1958–9. Oil on canvas, $24\frac{1}{8}\times20\frac{1}{4}$ in. $(61.3\times51.5$ cm.). Private collection.
- 8. words, 1959. Plate 7 Oil on canvas, 30 \times 24 in. (76.2 \times 61 cm.). The Lefevre Gallery, London.
- 9. GIRL WITH MAUVE HAIR, ℓ . 1959. Oil on board, $8\frac{1}{8} \times 9\frac{1}{4}$ in. (20.6 \times 23.5 cm.). Private collection, Washington, D.C.
- 10. The Red Banquet, 1960. Plate 9 Oil on canvas, 48×48 in. (121.9 \times 121.9 cm.). Walker Art Gallery, Liverpool.
- 11. A RECONSTITUTION. 1960. Oil on canvas, 50 × 40 in. (127 × 101.6 cm.). Peter Cochrane, London
- 12. The Bells of Hell, 1960. Plate 26 (detail) Oil on canvas, 36×60 in. $(91.5 \times 152.5$ cm.). Waddington Galleries, London.
- 13. The Murder of Rosa Luxemburg, 1960. Plate 30 Oil and collage on canvas, 60×60 in. (152.5 \times 152.5 cm.). The Tate Gallery, London.
- 14. Pariah, 1960. Plate 21 (detail) Oil on canvas, 40×50 in. (101.6 \times 127 cm.). Silkeborg Kunstmuseum (Asger Jorn Donation), Denmark.
- 15. OH, LEMUEL, 1960. Plate 16 Oil on canvas, $40 \times 60\frac{1}{4}$ in. (101.6 \times 153 cm.). Marlborough Fine Art (London) Ltd.
- 16. THE TWIN BIRTHDATES OF MARTIN LUTHER, 1960. Plate 5 Oil on canvas, 60 × 40 in. (152.4 × 101.6 cm.). Private collection.
- 17. Warburg's visit to New Mexico, 1960–2. (In collaboration with Eduardo Paolozzi). Oil and collage on canvas, 40×50 in. (101.6 \times 127 cm.). Private collection.
- 18. AN UNTITLED ROMANCE, 1961. Oil on canvas, 29×9 in. $(73.7 \times 22.9 \text{ cm.})$. Private collection, London.

- 19. Certain forms of association neglected before, 1961. Plate 17 Oil on canvas, 40×50 in. (101.6 \times 127 cm.). Private collection.
- 20. Yamhill, 1961. Plate 11 Oil on canvas, 40×50 in. (101.6 \times 127 cm.). James H. Grady, Atlanta, Georgia.
- 21. AUSTRO-HUNGARIAN FOOTSOLDIER, 1961.
 Oil and collage on canvas, 60 × 36 in. (152.4 × 91.5 cm.). Museum Ludwig, Cologne.
- 22. NOTES TOWARDS A DEFINITION OF NOBODY, 1961. Plate 41 (detail) Oil on canvas, 48 × 88 in. (121.9 × 223.5 cm.). The Toledo Museum of Art (Gift of Dr & Mrs Joseph A Gosman), Ohio.
- 23. Specimen musings of a democrat, 1961. Plate 23 Oil and collage on canvas, 40 \times 50 in. (101.6 \times 127 cm.). Colin St John Wilson, London.
- 24. WASHINGTON ALLSTON IN ROME. 1961. Atlanta, Georgia. Oil on canvas, $7\frac{1}{4} \times 6$ in. (18.5 × 15.2 cm.). Colin St John Wilson, London. 41. A HISTORY OF 1962. Equation 1962.
- 25. PRIEST, ETC., 1961. Plate 35 Oil on canvas, 40×50 in. (101.6 \times 127 cm.). Colin St John Wilson, London.
- 26. A STUDENT OF VIENNA, 1961–2. Plate 28 (detail) Oil and collage on canvas, 36×36 in. (91.5 \times 91.5 cm.). James H. Grady, Atlanta, Georgia.
- 27. Warburg as Maenad, 1961–2. Oil and collage on canvas, 76×36 in. (193 \times 91.5 cm.). Kunstmuseum, Düsseldorf.
- 28. Daedalus, c. 1961–2. Oil on canvas, 40×50 in. (101.6 \times 127 cm.). Museum of Art, Rhode Island.
- 29. NIETZSCHE'S MOUSTACHE, 1962. Plate 25 Oil on canvas, 48×48 in. (121.9 \times 121.9 cm.). Private collection, London.
- 30. Junta, 1962. Plate 31 Oil and collage on canvas, 36×84 in. (91.4 \times 213.4 cm.). Colin St John Wilson, London.
- 31. Homage to H. Melville, 1962. Plate 10 (detail) Oil on canvas, 54×36 in. (137.2 \times 91.5 cm.). The Royal College of Art, London.
- 32. Kennst du das land?, 1962. Plate 22 Oil and collage on canvas, 48×48 in. (121.9 \times 121.9 cm.). Collection of the artist.
- 33. Good news for incunabulists, 1962. Plate 33 Oil on canvas, 60×60 in. (152.4 \times 152.4 cm.). Private collection, Germany.
- 34. REFLECTIONS ON VIOLENCE, 1962. Plate 15 Oil and collage on canvas, 60×60 in. (152.4 \times 152.4 cm.). Hamburger Kunsthalle, Hamburg.
- 35. ISAAC BABEL RIDING WITH BUDYONNY, 1962. Plate 34 (detail) Oil on canvas, 72×72 in. (182.9 \times 182.9 cm.). The Tate Gallery, London.

- 36. WELCOME EVERY DREAD DELIGHT, 1962.
 Oil and collage on canvas, 60×48 in.
- (152.4 × 121.9 cm.). McCrory Corporation, New York.
- 37. WORK IN PROGRESS, 1962. (In collaboration with Eduardo Paolozzi).

 Mixed media on wood, 34 × 32½ in. (86.4 × 82.5 cm.). Private collection.
- 38. Cracks and reforms and bursts in the violet air, 1962. Oil and collage on canvas, 48×48 in. (121.9 \times 121.9 cm.). Private collection, London.
- 39. Interior/dan Chatterton's town house, 1962. Plate 14 Oil and collage on canvas, 60×48 in. (152.4 \times 121.9 cm.). Private collection, London.
- 40. THIS TRAIN OF THOUGHT WHICH YOU BLAME IS THE SOLE CONSOLATION THAT MY LIFE CONTAINS, 1962. Oil on canvas, 30×30 in. $(76.2 \times 76.2 \text{ cm.})$. James H. Grady, Atlanta, Georgia.
- 41. A HISTORY OF POLISH LITERATURE, 1962. Found and assisted object, $19\frac{1}{2} \times 33\frac{1}{2}$ in. $(49.5 \times 85.1$ cm.). Collection of the artist.
- 42. RATS AND ROSES, 1962. Oil and collage on canvas, 60×48 in. (152.4 \times 121.9 cm.). Private collection, Switzerland.
- 43. HOW TO DO IT AND HOW NOT TO DO IT, 1962. Found and assisted object, $9\frac{3}{4} \times 14\frac{1}{4}$ in. (24.8 \times 36.2 cm.). Collection of the artist.
- 44. CROSSES, 1962. Oil and pencil on canvas, 36×36 in. (91.4 \times 91.4 cm.). Private collection, London.
- 45. TEDEUM, 1963. Plate 71 Oil on canvas, 48 × 72 in. (121.9 × 182.9 cm.). National Museum of Wales, Cardiff.
- 46. Good god where is the king? or where is count hadik?, 1963. Collage, 30×20 in. $(76.2 \times 50.8$ cm.). Collection of the artist.
- 47. VALUE, PRICE AND PROFIT, 1963. Plate 20 (detail) Oil on canvas, 60×60 in. $(152.4 \times 152.4$ cm.). Private collection, London.
- 48. Art the enorm, 1963. Collage, 20 \times 30 in. (50.8 \times 76.2 cm.). Collection of the artist.
- 49. THE PERILS OF REVISIONISM, 1963. Plate 45
 Oil on canvas, 60 × 60 in.
 (152.4 × 152.4 cm.). Private collection, New York.
- 50. RANDOLPH BOURNE IN IRVING PLACE, 1963. Plate 27 Oil and collage on canvas, 60×60 in. (152.4 \times 152.4 cm.). Private collection, Switzerland.
- 51. The baby tramp, 1963/4. Plate 23 Oil and collage on canvas, 72×24 in. (182.9 \times 61 cm.). Gemeentemuseum, The Hague.
- 52. APOTHEOSIS OF GROUNDLESSNESS, 1964. Plate 18 Oil on canvas, 60×84 in. (152.4 \times 213.4 cm.). Cincinnati Art Museum, Ohio.

- 53. The ohio gang, 1964. Plate 32 Oil on canvas, 72×72 in. (182.9 \times 182.9 cm.). The Museum of Modern Art (Philip Johnson Fund, 1965), New York.
- 54. HALCYON DAYS, 1964. Oil and collage on canvas, 72 × 72 in. (182.9 × 182.9 cm.). Museum Boymans-van Beuningen, Rotterdam.
- 55. BOYS AND GIRLS!, 1964 Collage on wood, 21×16 in. $(53.4 \times 40.6$ cm.). Collection of the artist
- 56. Burgess meredith as george, 1964. Oil on canvas, 14 \times 10 in. (35.5 \times 25.4 cm.). Marlborough Fine Art (London) Ltd.
- 57. WHERE THE RAILROAD LEAVES THE SEA, 1964. Plate 36 Oil on canvas, 48×60 in. (121.9 \times 152.4 cm.). Collection of the artist.
- 58. AN EARLY EUROPE, 1964. Oil on canvas, 60 × 84 in. (152.4 × 213.4 cm.). Mary Moore.
- 59. COVER FOR THE TIMES LITERARY SUPPLEMENT SPECIAL ISSUE 'THE CRITICAL MOMENT', ENGLISH AND AMERICAN CRITICISM, 1964. Pencil and collage on paper, $12\frac{1}{4} \times 10$ in. (31.1 \times 25.4 cm.). The Museum of Modern Art, New York.
- 60. THE REPUBLIC OF THE SOUTHERN CROSS, 1964.
 Collage on wood, 48 × 24 in.
 (121.9 × 61 cm.). Colin St John Wilson, London.
- 61. The master of sentences/ preface: Med (portrait of norman douglas), 1964. Oil and collage on canvas, 48×48 in. (121.9 × 121.9 cm.). Private collection.
- 62. THE NICE OLD MAN AND THE PRETTY GIRL (WITH HUSKIES), 1964. Oil on canvas, 48×48 in. (121.9 \times 121.9 cm.). Private collection.
- 63. A disciple of Bernstein and Kautsky, 1964. Oil on canvas, 60×48 in. (152.4 \times 121.9 cm.). Private collection, London.
- 64. The vampire/his kith and kin, 1964. Collage on wood, 13×10 in. $(33 \times 25.4$ cm.). Colin St John Wilson, London.
- 65. HIS CULT OF THE FRAGMENT, 1964. Oil on canvas, 10×8 in. $(25.4 \times 20.3 \text{ cm.})$. Private collection.
- 66. Maria Prophetissa, 1964. Plate 37 Oil on canvas, 10 \times 8 in. (25.4 \times 20.3 cm.). Private collection.
- 67. An impossibilist, 1964. Oil on canvas, 10 \times 8 in. (25.4 \times 20.3 cm.). Private collection.
- 68. In the social memory, 1964. Oil on canvas, 10 \times 8 in. (25.4 \times 20.3 cm.). Private collection.
- 69. ALL I CAN SAY ETC., 1964. Oil on canvas, 10×8 in. $(25.4 \times 20.3 \text{ cm.})$. Private collection.
- 70. AN URBAN OLD MAN WHO NEVER LOOKED AT THE SEA EXCEPT PERHAPS ONCE, 1964. Oil on canvas, 50×40 in. $(127 \times 101.6 \, \text{cm.})$. Private collection.

71. Cover for times literary supplement 'shakespeare's quarter centenary celebrations', 1964. Oil and collage on canvas, $13\frac{3}{8} \times 10$ in. $(34 \times 25.4$ cm.). Collection of the artist.

72. The ohio and indiana of anderson and dreiser, 1964. Oil on canvas, 36×36 in. (91.4 \times 91.4 cm.). Private collection.

73. Early Harbingers of Christ, 1964. Oil on canvas, 35×36 in. $(88.9 \times 91.4$ cm.). Private collection.

74. LONDON BY NIGHT: PART 1, 1964. Oil on canvas, 57 × 73 in. (144.8 × 185.4 cm.). Stedelijk Museum, Amsterdam.

75. DISMANTLING THE RED TENT, 1964. Plate 29 Oil on canvas, including an original etching by Alphonse Legros, 48×48 in. (121.9 \times 121.9 cm.). The Michael and Dorothy Blankfort Collection at Los Angeles County Museum.

76. AUREOLIN, 1964. Plate 39 Oil on canvas, 60 × 48 in. (152.4 × 121.9 cm.). Mr and Mrs Ian Stoutzker, London.

77. Dante's every-day wife, 1965. Oil and collage on canvas, 10 \times 14 in. (25.4 \times 35.6 cm.). Private collection.

78. The sorrows of Belgium, 1965. Oil on canvas, 60×84 in. (152.4 \times 213.4 cm.). Private collection, Paris.

79. THE RIVAL POET, 1965. Oil on canvas, $22\frac{1}{2} \times 15$ in. $(57.2 \times 38.1$ cm.). The Graves Art Gallery, Sheffield.

80. POGANY 1, 1965. Oil on canvas, 12×16 in. $(30.5 \times 40.6$ cm.). Private collection.

81. PRIMER OF MOTIVES (INTUITIONS OF IRREGULARITY), 1965. Plate 82 (detail) Oil on canvas, 60×60 in. (152.4 \times 152.4 cm.). Private collection, Belgium.

82. Self-Portrait, 1965. Oil on canvas, 14 \times 10 in. (35.6 \times 25.4 cm.). Private collection.

83. POGANY 2, 1965. Oil on canvas, 12×16 in. $(30.5 \times 40.6$ cm.). Peter Blake, London.

84. TROUT FOR FACTITIOUS BAIT, 1965. Plate 52 Oil on canvas, $60 \times 83^{\frac{1}{2}}$ in. (152.4 \times 212.1 cm.). The Whitworth Art Gallery, University of Manchester.

85. They went, 1965. Oil on canvas, $14\frac{1}{2} \times 11\frac{1}{2}$ in. (36.9 \times 29.2 cm.). Private collection, London.

86. Alone, 1965. Oil on canvas, 36×10 in. $(91.4 \times 25.4$ cm.). Private collection.

87. THINGS TO COME, 1965–70. Oil and screenprint on canvas, 25×35 in. $(63.5 \times 88.9 \text{ cm.})$. Private collection.

88. WALTER LIPPMANN, 1966. Plate 40 Oil on canvas, 72 × 84 in. (182.9 × 213.4 cm.). Albright-Knox Art Gallery (Gift of Seymour H. Knox, 1967), Buffalo, New York.

89. ERIE SHORE, 1966. Plate 43(detail) Oil on canvas, 72×60 in.

(182.9 × 152.4 cm.). Nationalgalerie, Berlin, Staatliche Museen, Stiftung Preussische Kulturbesitz.

90. DEAD END KID, 1966. Oil on canvas, 14 \times 10 in. (35.6 \times 25.4 cm.). Private collection, London.

91. The harold J. Laski field day, 1966–7. Oil on canvas, 60×60 in. (152.4 \times 152.4 cm.). Colin St John Wilson, Cambridge.

92. THANKSGIVING, 1966–7. Plate 70 (detail)
Oil on canvas, 60 × 72 in.
(152.4 × 182.9 cm.). Colin St John Wilson, Cambridge.

93. Juan de la cruz, 1967. Plate 61 Oil on canvas, 72×60 in. (182.9 \times 152.4 cm.). Private collection, Brussels.

94. THE WILLIAMS SHIFT (FOR LOU BOUDREAU), 1967. Plate 42 Oil on canvas, 12 × 24 in. (30.5 × 61 cm.). Private collection.

95. SISLER AND SCHOENDIENST, 1967. Oil on canvas, 10 × 14 in. (25.4 × 35.6 cm.). Colin St John Wilson, London.

96. Tampa, 1967. Oil on canvas, $8 \times$ 10 in. (20.3 \times 25.4 cm.). Private collection.

97. Stanky and Berra at St Petersburg, 1967. Oil on canvas, 14 \times 10 in. (35.6 \times 25.4 cm.). David Hockney, Los Angeles.

98. EDDIE STANKY, 1967. Oil on canvas, 16×12 in. $(40.6 \times 30.5$ cm.). McCrory Corporation, New York.

99. MORTON FELDMAN, 1967. Oil on canvas, 12 × 12 in. (30.5 × 30.5 cm.). Private collection.

100. Tinker to evers, 1967. Oil on canvas, 18×13^3_4 in. $(45.7\times34.9$ cm.). Private collection.

101. Batboy, 1967. Oil on canvas, $12 \times 15\frac{3}{4}$ in. $(30.5 \times 40$ cm.). Private collection.

102. FOR EDWARD DAHLBERG, 1967. Oil on canvas, 10 \times 8 in. (25.4 \times 20.3 cm.). Private collection, London.

103. SCREENPLAY, 1967. Oil on canvas, $31\frac{1}{2} \times 33$ in. $(80 \times 83.8$ cm.). Arts Council of Great Britain.

104. CASTING, 1967–9. Plate 38 (detail) Oil on canvas, $98\frac{1}{2} \times 36$ in. (250.2 × 91.4 cm.). Museum Ludwig, Cologne.

105. Shanghai gestures, 1968. Oil on canvas, 24×48 in. $(61 \times 121.9$ cm.). The Metropolitan Museum of Art, New York.

106. LITTLE SLUM PICTURE, 1968. Plate 48
Oil on canvas, 30 × 24 in.
(76.2 × 61 cm.). Stanley Seeger,
Sutton Place Heritage Trust,
Cuildford

107. UNITY MITFORD, 1968. Plate 44 Oil on canvas, 10 \times 8 in. (25.4 \times 20.3 cm.). Collection of the artist.

108. Indigo, 1968. Oil on canvas, 20 \times 20 in. (50.8 \times 50.8 cm.). Private collection.

109. ROBERT DUNCAN, 1968. Oil on canvas, 12 × 12 in. (30.5 × 30.5 cm.). Collection of the artist.

110. David at Berkeley, 1968. Oil on canvas, 10 \times 8 in. (25.4 \times 20.3 cm.). Collection of the artist.

111. STUDY (FRANCIS BACON), 1968. Oil on canvas, $11\frac{1}{2} \times 9\frac{1}{2}$ in. (29.2 \times 24.2 cm.). Private collection, New York.

112. PETER, 1968. Oil on canvas, 10 × 8 in. (25.4 × 20.3 cm.). David Hockney, Los Angeles.

113. SYNCHROMY WITH F.B. – GENERAL OF HOT DESIRE, 1968–9. Plate 47 (detail) Oil on canvas (diptych), each panel 60×36 in. (152.4 \times 91.5 cm.). Mr and Mrs Ian Stoutzker, London.

114. Jack London square, oakland, 1969. Plate 55 Oil on canvas, 24×30 in. $(61 \times 76.2 \text{ cm.})$. Private collection, Belgium.

115. STUDY (MICHAEL HAMBURGER), 1969. Plate 91 Oil on canvas, 14 × 11 in. (35.6 × 28 cm.). Private collection, England.

116. LITTLE ROMANCE I, 1969. Plate 54 Oil on canvas, 12 \times 10 in. (30.5 \times 25.4 cm.). Private collection.

117. PAUL CLAUDEL AND EDWIGE FEUILLERE, 1969. Oil on canvas, 15 \times 12 in. (38.1 \times 30.5 cm.). Private collection, England.

118. PRIMO, 1969. Oil on canvas, $18\frac{3}{4} \times 16$ in. $(47.6 \times 40.6$ cm.). Roberto Shorto, London.

119. STUDY (KENNETH KOCH), 1969. Oil on canvas, 10×8 in. (25.4 \times 20.3 cm.). Private collection.

120. LA PASSIONARIA, 1969. Plate 51 Oil on canvas, $16\frac{3}{4} \times 12\frac{1}{2}$ in. (42.5 \times 31.8 cm.). Colin St John Wilson, London.

121. STUDY (JEAN), 1969. Pencil on paper, $22\frac{1}{2} \times 13\frac{1}{2}$ in. $(57.2 \times 34.3 \text{ cm.})$. Collection of the artist.

122. OUTLYING LONDON DISTRICTS (IN CAMBERWELL), 1969. Plate 69 (detail) Oil on canvas, 96×36 in. (243.8 \times 91.5 cm.). Private collection, Belgium.

123. GOODBYE TO EUROPE, 1969. Fig. 5 Oil on canvas, 40×31 in. $(101.6 \times 78.8$ cm.). Private collection.

124. Chelsea Reach (first version) (for J.A. McN.W.), 1969. Fabrics and wood, 96×180 in. (243.8 \times 458 cm.). Private collection.

125. LITTLE SUICIDE PICTURE, 1969. Plate 50 Oil on canvas, 20×20 in. (50.8×50.8 cm.). The Baltimore Museum of Art (Thomas Benesch Memorial Collection), Maryland.

126. Drawing (from: Lives of the engineers), 1969. Pastel, 23×16 in. $(58.5 \times 40.6$ cm.). Private collection, London.

127. Aden-Arabie, 1969. Oil on canvas, 20 \times 20 in. (50.8 \times 50.8 cm.). Private collection.

128. HIS LOVE AFFAIRS (WAITER), 1969. Oil and crayon on canvas, 19×13 in. $(48.2 \times 33$ cm.). Private collection.

129. LOUIS JOUVET AS ANNE, 1969. Oil on canvas, 12×10 in. $(30.5 \times 25.4$ cm.). Private collection, London.

130. W.H. AUDEN, 1969. Oil on canvas board, 14×10 in. $(35.6 \times 25.4$ cm.). Collection of the artist.

131. MICHAEL MCCLURE, 1969. Oil on canvas, 8×10 in. (20.3 \times 25.4 cm.). Collection of the artist.

132. KENNETH REXROTH AND JOHN WIENERS, 1969. Oil on canvas board, $8\frac{3}{4} \times 18$ in. (22.2 \times 45.7 cm.). Collection of the artist.

133. CHARLES OLSON, 1969. Oil on canvas board, 11 $\frac{3}{4} \times 9_8^7$ in. (29.8 × 25.1 cm.). Collection of the artist.

134. EZRA POUND, 1969. Oil on canvas, 14×17 in. $(35.6 \times 43.2 \text{ cm.})$. Collection of the artist.

135. BLACK, 1969. Oil on canvas board, $9\frac{7}{8} \times 8$ in. (25.2 × 20.3 cm.). Joel Bernstein, Chicago.

136. Outlying london districts (englishwoman (Js) denmark hill), 1969–70. Oil on canvas, 84×36 in. (213.4 \times 91.5 cm.). Private collection.

137. Dashiell Hammett c.1934, 1970. Oil on canvas, 49 \times 10 in. (124.5 \times 25.4 cm.). Private collection, London.

138. dashiell hammett, 1970. Oil on canvas, 49 × 10 in. (124.5 × 25.4 cm.). Private collection, London.

139. ON A REGICIDE PEACE, 1970. Plate 108 Oil and silkscreen on canvas, $38 \times 21\frac{1}{4}$ in. $(96.5 \times 54$ cm.). Louisiana Museum, Humlebaek, Denmark.

140. PIANO, 1970. Oil on canvas, 31×10 in. $(78.8 \times 25.4$ cm.). Private collection, London.

141. GIRL ON A SCOOTER, 1970. Plate 13 (detail) Oil on canvas, $36\frac{1}{2} \times 13\frac{1}{2}$ in. (92.7 \times 34.3 cm.). Private collection, London.

142. DESK-MURDER (formerly THE THIRD DEPARTMENT (A TESTE STUDY)), 1970–84. Plate 155 Oil on canvas, 30×48 in. $(76.2 \times 121.9$ cm.). Collection of the artist.

143. As a man grows older, 1971. Oil on canvas, 48×24 in. (121.9 \times 61 cm.). Private collection.

144. PEER GYNT, LUNATIC ASYLUM, CAIRO, 1971.
Pencil and collage on paper, $34\frac{7}{8} \times 45\frac{5}{8}$ in. (88.5 × 116 cm.). Sonja Henies og Niels Onstads Stiftelser, Norway.

145. CLERK'S DREAM, 1972. Oil on canvas, 78 × 25 in. (198 × 63.5 cm.). Marlborough Gallery Inc., New York.

146. PROFILE, 1972. Pastel and charcoal on paper, $_{15\frac{1}{2}} \times _{22\frac{1}{4}}$ in. (39.4 × 56.5 cm.). Private collection, Johannesburg.

147. PENCIL DRAWING FOR DAYBOOK BY ROBERT CREELEY, 1972. Pencil on paper, $24\frac{1}{2} \times 16\frac{1}{8}$ in. $(62.2 \times 41$ cm.). Private collection, London.

148. HUGH LANE, 1972. Plate 56 Oil on canvas, 96 × 30 in. $(243.8 \times 76.2 \,\mathrm{cm.})$. Private collection, Switzerland.

149. THE AUTUMN OF CENTRAL PARIS (AFTER WALTER BENJAMIN), 1972-3. Plate 57 Oil on canvas, 60×60 in. (152.4 × 152.4 cm.). Mrs Susan Lloyd, New York.

150. ARCADES (AFTER WALTER BENJAMIN), 1972-4. Plate 46 Oil on canvas, 60 × 60 in. $(152.4 \times 152.4 \text{ cm.})$. I.R. Wookey, Toronto.

151. JOSE VICENTE (unfinished study for the singers), 1972–4. Plate 60 Oil and charcoal on canvas, 48×24 in. (121.9 × 61 cm.). Collection of the artist.

152. BATMAN, 1973. Plate 67 Oil on canvas, 96 × 30 in. $(243.8 \times 76.2 \text{ cm.})$. Private collection, Cologne.

153. SUPERMAN, 1973. Plates 66 and 68 Oil on canvas, 96×30 in. (243.8 \times 76.2 cm.). Private collection, Cologne.

154. PACIFIC COAST HIGHWAY (ACROSS THE PACIFIC), 1973. Plate 63 Oil on canvas, left-hand panel, 96×60 in. $(243.8 \times 152.4$ cm.), right-hand panel, 60×60 in. (152.4 × 152.4 cm.). Colin St John Wilson, London.

155. KENNETH ANGER AND MICHAEL POWELL, 1973. Plate 62 Oil on canvas, 96 × 60 in. (243.8 × 152.4 cm.). Ludwig Collection, Aix-la-Chapelle.

156. BILL AT SUNSET, 1973. Plate 65 Oil on canvas, 96×30 in. (243.8 × 76.2 cm.). Private collection, London.

157. STILL (THE OTHER WOMAN), 1973. Plate 102 Oil on canvas, 96×30 in. $(243.8 \times 76.2 \text{ cm.})$. Mr and Mrs Ian Stoutzker, London.

158. THE MAN OF THE WOODS AND THE CAT OF THE MOUNTAINS, 1973. Plate 53 Oil on canvas, 60 × 60 in. $(152.4 \times 152.4 \text{ cm.})$. The Tate Gallery, London.

159. TO LIVE IN PEACE (THE SINGERS), 1973–4. Plate 73 Oil on canvas, 84 × 30 in. (213.4 × 76.2 cm.). Muriel and David Binder, New York.

160. THE SENSUALIST, 1973-84. Plate Oil on canvas, $97 \times 30^{\frac{3}{8}}$ in. (246.4 × 77.2 cm.). Nasjonalgalleriet, Oslo.

161. STAGE-LIFE OF THE DEAD, 1974. Lithographic pencil on paper, 34 × 24 in. (86.4 × 61 cm.). Jan Van Lerberghe, Brussels.

162. MALTA (FOR CHRIS AND ROSE), 1974. Plate 49 Oil on canvas, 60×96 in. (152.4 \times 243.8 cm.). Private collection, Belgium.

163. SCULPTURE, 1974. Pastel on paper, 30×20 in. $(76.2 \times 50.8$ cm.). Private collection, London.

164. FEMME DU PEUPLE I, 1974. Pastel on paper, $30\frac{1}{2} \times 22$ in. (77.5 × 55.9 cm.). Dr Eugene A. Solow, Chicago.

165. THUS TO REVISIT, 1974 Pastel on paper, 22 × 304 in. $(55.9 \times 76.8 \,\mathrm{cm.})$. Private collection, London.

166. STUDY FOR MISS BROOKE, 1974. Plate 90 Pastel on paper, $23\frac{7}{8} \times 15\frac{1}{8}$ in. $(60.6 \times 38.5 \text{ cm.})$. Museum Boymansvan Beuningen, Rotterdam.

167. FRANCES AND GERALDINE, 1974. Charcoal on paper, $15 \times 17\frac{3}{8}$ in. (38.1 × 44.2 cm.). Private collection, Hamburg.

168. STUDY FOR THE WORLD'S BODY, 1974. Boymans-van Beuningen, Rotterdam. Pastel on paper, 30×20 in. $(76.2 \times 50.8 \text{ cm.})$. Private collection, London.

169. SUNSET AND SUNRISE, 1974. Pastel on paper, $30\frac{1}{4} \times 22$ in. (76.8 × 55.9 cm.). Private collection.

170. THE SHIFTING OF THE FIRE, 1974-5 Pastel on paper, $32\frac{1}{4} \times 30\frac{1}{2}$ in. $(81.9 \times 77.5 \text{ cm.})$. Private collection.

171. HIS HOUR, 1975. Plate 109 Pastel and charcoal on paper, 30½ × 22½ in. (77.5 × 57.2 cm.). Private collection, Los Angeles.

172. WIFE AND WORLD, 1975. Pastel on paper, 30×22 in. $(76.2 \times 55.9 \text{ cm.})$. Private collection, London.

173. COMMUNIST AND SOCIALIST, 1975. Plate 89 Pastel on paper, $15\frac{1}{8} \times 22\frac{1}{4}$ in. (38.5 × 56.5 cm.). Collection of the artist.

174. HEAD OF A BOY, 1975. Black chalk on paper, 20 × 16 in. $(50.8 \times 40.6 \,\mathrm{cm.})$. Private collection, London.

175. IN CATALONIA, 1975. Plate 123 Pastel on paper, $25\frac{1}{2} \times 15\frac{1}{4}$ in. (64.8 × 38.7 cm.). Private collection, London.

176. ORGASM, 1975. Pastel over lithograph on paper, $12 \times 16\frac{7}{8}$ in. $(30.5 \times 42.8 \text{ cm.})$. Galerie Claude Bernard, Paris.

77. SARAH, 1975. Black chalk on paper, 16 × 20 in. $(40.6 \times 50.8 \,\mathrm{cm.})$. Private collection.

178. FOR PETER, 1975 Pastel on paper, 20 × 30 in. $(50.8 \times 76.2 \text{ cm.})$. Private collection, London.

179. THE SNEEZE, 1975. Plate 120 Charcoal and pastel on paper, 34 × 27 in. (86.4 × 68.6 cm.). The Museum of Modern Art (Gift of Nancy & Jim Dine), New York.

180. TONIGHT THE BALLET, 1975. Pastel on paper, $19\frac{7}{8} \times 15$ in. (50.5 × 38.1 cm.). Private collection,

181. THE STREET (A LIFE), 1975. Plate 136 Pastel on paper, $30\frac{3}{8} \times 22$ in. $(77.2 \times 55.9 \text{ cm.})$. H.N. Astrup, Oslo.

182. WAITING, 1975. Pastel on paper, 308×224 in. (78.5 \times 56.5 cm.). Private collection, Belgium.

183. GERALDINE, 1975. Charcoal on paper, $22 \times 15\frac{3}{8}$ in. (55.9 × 39 cm.). Private collection, Los Angeles.

184. THIS KNOT OF LIFE, 1975. Pastel on paper, $15\frac{1}{4} \times 22\frac{1}{2}$ in. (38.7 × 57.2 cm.). Collection of the

185. FROM LONDON (JAMES JOLL AND JOHN GOLDING), 1975-6. Plate 72 Oil on canvas, 60×96 in. $(152.4 \times 243.8 \text{ cm.})$. Private collection, Monte Carlo.

186. IF NOT, NOT, 1975–6. Plate 92 Oil on canvas, 60 × 60 in. (152.4 × 152.4 cm.). Scottish National Gallery of Modern Art, Edinburgh.

187. THE ARABIST (formerly MORESQUE), 1975–6. Plate 96 Oil on canvas, 96 × 30 in. $(243.8 \times 76.2 \text{ cm.})$. Museum

188. THE ORIENTALIST, 1975-6. Plate 98 Oil on canvas, 96×30 in. $(243.8 \times 76.2 \text{ cm.})$. The Tate Gallery,

189. Land of lakes, 1975–7. Plate 100 Oil on canvas, 60×60 in. $(152.4 \times 152.4 \text{ cm.})$. Private collection, London.

190. CATALAN CHRIST (PRETENDING TO BE DEAD), 1976. Plate 64 Oil on canvas, 30×96 in. $(76.2 \times 243.8 \,\mathrm{cm.})$. Louisiana Museum of Art, Humlebaek, Denmark.

IQI. HOUSEBOAT DAYS (FOR JOHN ASHBERY), 1976. Plate 104 Oil on canvas, 72 × 24 in. (182.9 × 61 cm.). Private collection, London

192. THE RASH ACT, 1976. Original transfer drawing on paper, $29 \times 30^{\frac{3}{4}}$ in. $(73.7 \times 52.7$ cm.). Collection of the artist.

193. SLADE STUDENT (STUDY FOR FRANKFURT BROTHEL), 1976. Pastel on paper, $30\frac{1}{4} \times 22$ in. $(76.8 \times 55.9 \,\mathrm{cm.})$. Private collection, London.

194. RICHARD WOLLHEIM (STUDY FOR THREE PHILOSOPHERS), 1976. Charcoal on paper, 22 × 304 in. (55.9 × 76.8 cm.). James H. Grady, Atlanta, Georgia.

195. MARRANO (THE SECRET JEW), 1976. Plate 83 Oil and charcoal on canvas, 48 × 48 in. (121.9 × 121.9 cm.). Private collection.

196. FEMME DU PEUPLE, 1976. Original transfer drawing on paper, $29 \times 20\frac{3}{4}$ in. $(73.7 \times 52.7$ cm.). Collection of the artist.

197. DAVID, unfinished. Oil and charcoal on canvas, $72 \times 60 \text{ in.} (182.9 \times 152.4 \text{ cm.}).$ Collection of the artist.

198. SMYRNA GREEK (NIKOS), 1976-7. Plate 122 Oil on canvas, 96×30 in. $(243.8 \times 76.2 \text{ cm.})$. Collection Thyssen-Bornemisza, Lugano.

199. The Jew etc., 1976-9. Plate 97 Oil and charcoal on canvas, $60 \times 48 \text{ in.} (152.4 \times 121.9 \text{ cm.}).$ Collection of the artist.

200. AFTER GIOTTO, 1976-9. Plate 124 (detail) Oil and charcoal on canvas,

 36×36 in. $(91.4 \times 91.4$ cm.). Private collection, California.

201. MY CAT AND HER HUSBAND, 1977. Plate 74 Pastel and charcoal on paper, 15×22 in. $(38.1 \times 55.9$ cm.). Dominie Lee Kitaj, London.

202. SLAV SOUL, 1977. Oil on canvas, 72 × 24 in. (182.9 × 61 cm.). Private collection, Belgium.

203. THE MOTHER, 1977. Plate 119 Oil and charcoal on canvas, 42×42 in. (106.7 × 106.7 cm.). Collection of the artist.

204. MAN IN AN AALTO CHAIR (JAMES KIRKMAN), 1977. Charcoal on canvas, $42\frac{1}{2} \times 28$ in. (108 × 71.1 cm.). James Kirkman, London.

205. The hispanist (nissa torrents), 1977–8. Plates 77 and 79 Oil on canvas, 96 × 30 in. $(243.8 \times 76.2 \text{ cm.})$. H.R. Astrup,

206. A VISIT TO LONDON (ROBERT CREELEY AND ROBERT DUNCAN), 1977–9. Plate 99 (detail), fig. 9 Oil and charcoal on canvas, 72 × 24 in. (182.9 × 61 cm.). Collection Thyssen-Bornemisza, Lugano.

207. FRANKFURT BROTHEL, 1978. Oil on canvas, 48×60 in. (121.9 \times 152.4 cm.). Private collection.

208. HER LAW SCHOOL DAYS, 1978. Pastel and charcoal on paper, 22 × 15 in. (55.9 × 38.1 cm.). Private collection, England.

209. MAN AND CHILD, 1978. Charcoal on paper, $22\frac{1}{8} \times 14\frac{1}{4}$ in. $(56.2 \times 36.2$ cm.). Marlborough Fine Art (London) Ltd.

210. JIM DINE IN WINDSOR GREAT PARK, 1978. Charcoal on paper, $22\frac{1}{4} \times 30\frac{1}{2}$ in. $(56.5 \times 77.5 \text{ cm.})$. Collection of the artist.

211. THÉRÈSE, 1978. Charcoal on paper, 22×15 in. $(55.9 \times 38.1$ cm.). The Michael and Dorothy Blankfort Collection at Los Angeles County Museum.

212. THE DANCER (MARGARET), 1978. Plate 105 Pencil on paper, $39\frac{3}{8} \times 25\frac{1}{2}$ in. (100 × 64.8 cm.). Edwin A. Bergman, Chicago.

213. THE YELLOW APRON, 1978. Pastel and charcoal on paper, $30\frac{7}{8} \times 11\frac{3}{8}$ in. $(78.4 \times 28.9$ cm.). Private collection, England.

214. BEISBOL, 1978. Charcoal and pastel on paper, $30\frac{1}{4} \times 22$ in. (76.8 × 55.9 cm.). Private collection, New York.

215. EMBLEM, 1978. Pastel on paper, $40\frac{1}{8} \times 15\frac{1}{2}$ in. (101.9 × 39.4 cm.). Private collection, Paris.

216. CATALAN CAP, 1978. Pastel and charcoal on paper, $12\frac{7}{8} \times 22\frac{1}{4}$ in. $(32.7 \times 56.5$ cm.). Private collection, New York.

217. DOMINIE (DARTMOUTH), 1978. Plate 87 Pastel and charcoal on paper, 22×15 in. $(55.9 \times 38.1$ cm.). Collection of the artist.

218. DARTMOUTH NUDE, 1978. Pastel and charcoal on canvas over board, 14 × 24 in. (35.6 × 61 cm.). Sandra Fisher, London.

219. Dominie (san feliu), 1978. Plate 85 Pastel and charcoal on paper, $21\frac{3}{8} \times 15\frac{3}{8}$ in. $(54.3 \times 39.1$ cm.). Collection of the artist.

220. LEM (SAN FELIU), 1978. Plate 95 Pastel and charcoal on paper, $30\frac{1}{4} \times 22$ in. $(76.8 \times 55.9$ cm.). Collection of the artist.

221. Doctor Kohn, 1978. Plate 141 Pastel and charcoal on paper, 22×15 in. $(55.9 \times 38.1$ cm.). Collection of the artist.

222. BAD FAITH (CHILE), 1978. Pastel and charcoal on paper, $30\frac{1}{4} \times 22$ in. $(76.8 \times 55.9$ cm.). Arkansas Arts Center.

223. BATHER (TOUSLED HAIR), 1978. Plate 84 Pastel on paper, $47\frac{3}{4} \times 22\frac{3}{8}$ in. (121.3 \times 56.8 cm.). Nelson Blitz Jr., New York.

224. Bather (wading), 1978. Plate 78 Pastel on paper, $48\frac{3}{4} \times 22\frac{2}{8}$ in. (123.8 \times 56.8 cm.). Nelson Blitz Jr., New York.

225. BAD FAITH (GULAG), 1978. Pastel and charcoal on paper, $44\frac{5}{8} \times 22$ in. (113.4 \times 55.9 cm.). Private collection.

226. The Messiah Watcher, 1978. Fig. 10. Pastel on paper, $38\frac{5}{8} \times 15\frac{1}{8}$ in. (98.1 \times 38.4 cm.). Private collection, Connecticut.

227. The symbolist, 1978. Pastel and pencil on paper, $39\frac{3}{8} \times 25\frac{1}{2}$ in. (100 \times 64.8 cm.). Mr and Mrs Edward L. Gardner, Larchmont, New York.

228. Bather (torsion), 1978. Plate 76 (detail)
Pastel on paper, $54^{\frac{1}{4}} \times 22^{\frac{2}{8}}$ in.
(137.8 \times 56.8 cm.). Sovereign
American Arts Corporation, New York.

229. BATHER (SEATED), 1978. Pastel on paper, $17\frac{5}{8} \times 22\frac{3}{8}$ in. (44.8 \times 56.8 cm.). Private collection, Geneva.

230. SLOVAK, 1978. Pastel and charcoal on paper, $22\frac{3}{8} \times 13\frac{7}{8}$ in. $(56.8 \times 35.2 \text{ cm.})$. Private collection, Switzerland.

231. The green blanket, 1978. Plate 80 Pastel and charcoal on paper, $30\frac{1}{4} \times 22$ in. $(76.8 \times 55.9$ cm.). Private collection, Switzerland.

232. Bad Faith (warsaw), 1978. Pastel and charcoal on paper, $43\frac{1}{4} \times 22\frac{3}{8}$ in. (109.9 \times 56.8 cm.). Collection of the artist.

233. DYING LIFE MODEL, 1978. Pastel on paper, $22 \times 30\frac{1}{4}$ in. $(55.9 \times 76.8$ cm.). Private collection.

234. WASHING CORK (RAMON), 1978. Plate 59 Pastel on paper, 22 × 15 in. (55.9 × 38.1 cm.). The American Can Company, Greenwich, Connecticut.

235. New York nocturne, 1978. Pastel and charcoal on paper, $30\frac{5}{8} \times 11\frac{5}{8}$ in. $(77.8 \times 29.5$ cm.). Private collection, Canada.

236. HIS NEW FREEDOM, 1978. Plate 93 Pastel and charcoal on paper, $30\frac{1}{4} \times 22$ in. $(76.8 \times 55.9$ cm.). Collection of the artist.

237. New York Madman, 1978. Pastel and charcoal on paper, $22 \times 15\frac{1}{4}$ in. $(55.9 \times 38.7 \text{ cm.})$. Private collection, London.

238. MOTHER AND CHILD, 1978. Pastel on paper, $30\frac{1}{4} \times 22$ in. $(76.8 \times 55.9 \,\mathrm{cm.})$. Private collection.

239. THE PHILOSOPHER-QUEEN, 1978–9. Plate 81 Pastel and charcoal on paper, $30\frac{1}{4} \times 22$ in. $(76.8 \times 55.9$ cm.). Collection of the artist.

240. Dominie (ninth street), 1978–9. Pastel and charcoal on paper, $16\frac{1}{2} \times 22\frac{5}{8}$ in. (41.9 × 57.5 cm.). Collection of the artist.

241. SIGHS FROM HELL, 1979. Plate 75 Pastel and charcoal on paper, $38\frac{1}{2} \times 39\frac{1}{2}$ in. (97.8 × 100.3 cm.). Edwin A. Bergman, Chicago.

242. SIXTH AVENUE MADMAN, 1979. Pastel and charcoal on paper, $30\frac{1}{4} \times 11$ in. (76.8 \times 28 cm.). Dr. Jack E. Chachkes, New York.

243. RICHARD, 1979. Plate 115 Pastel and charcoal on paper, $30\frac{1}{4} \times 22$ in. $(76.8 \times 55.9$ cm.). Private collection, New York.

244. NINTH STREET UNDER SNOW, 1979. Plate 110 Pastel and charcoal on paper, $30\frac{1}{4} \times 44$ in. $(76.8 \times 111.8 \text{ cm.})$. Odyssia Gallery, New York.

245. Manchu decadence, 1979. Plate 101 Pastel and charcoal on paper, $45\frac{1}{4} \times 22$ in. (115 \times 55.9 cm.). Private collection, Rumson, New Jersey.

246. TWO LONDON PAINTERS (FRANK AUERBACH AND SANDRA FISHER), 1979. Plate 111
Pastel and charcoal on paper, 22 × 30¼ in. (55.9 × 76.8 cm.). The Michael and Dorothy Blankfort Collection at Los Angeles County

247. COMMUNIST AND SOCIALIST (SECOND VERSION), 1979. Plate 107 (detail)
Pastel and charcoal on paper, $30\frac{1}{4} \times 22$ in. $(76.8 \times 55.9$ cm.).
Collection of the artist.

248. SIDES, 1979. Plate 106 Pastel and charcoal on paper, each panel of three, $30\frac{3}{4} \times 11$ in. $(78.1 \times 28$ cm.). The British Museum, London.

249. ACTOR (RICHARD), 1979. Pastel and charcoal on paper, $30\frac{1}{4} \times 19\frac{3}{8}$ in. (76.8 × 49.3 cm.). Marlborough Fine Art (London) Ltd.

250. Young Man by a lake, 1979. Pastel on paper, $30\frac{3}{4} \times 22\frac{1}{4}$ in. (78.1 \times 56.5 cm.). Private collection, Switzerland.

251. ANABEL, 1979. Pastel on paper, $23\frac{3}{4} \times 22\frac{3}{8}$ in. $(60.3 \times 56.8$ cm.). Private collection, Belgium.

252. FENIL HAGUE, 1979. Charcoal and oil on canvas, $18\frac{3}{4} \times 13$ in. (47.6 \times 33 cm.). Private collection, London.

253. MARYNKA, 1979. Pastel on paper, 224×413 in. (56.5 × 106 cm.). Private collection, London.

254. QUENTIN, 1979. Plate 88 Pastel and charcoal on paper, $25\frac{3}{4} \times 15\frac{3}{4}$ in. $(65.4 \times 40$ cm.). Collection of the artist.

255. FORM AND CONTENT (AFTER GIULIO ROMANO), 1979. Plate 131 Pastel and charcoal on paper, $28\frac{3}{4} \times 20\frac{1}{2}$ in. $(73 \times 52.1$ cm.). Collection of the artist.

256. Marynka and Janet, 1979. Charcoal on paper, $30\frac{3}{8} \times 22\frac{1}{4}$ in. $(77.2 \times 56.5$ cm.). Collection of the artist.

257. Marynka on Her Stomach, 1979. Charcoal and pastel on paper, $30\frac{3}{8} \times 22\frac{1}{4}$ in. $(77.2 \times 56.5$ cm.). Collection of the artist.

258. SELF-PORTRAIT FRAGMENT, c.1979. Oil on canvas, $16\frac{1}{2} \times 6\frac{1}{2}$ in. (41.7 × 16.3 cm.). Marlborough Fine Art (London) Ltd.

259. CÉZANNE, c.1979. Charcoal on paper, $20\frac{1}{4} \times 15\frac{1}{2}$ in. $(51.4 \times 39.4$ cm.). Private collection, Johannesburg.

260. The RISE OF FASCISM, 1979–80. Plate 94 Pastel and oil on paper, $33\frac{3}{8}\times62$ in. $(84.8\times157.5$ cm.). The Tate Gallery, London.

261. THE SAILOR (DAVID WARD), 1979–80. Plate 144 Oil on canvas, 60×24 in. (152.4 \times 61 cm.). H.R. Astrup, Oslo.

262. Examining negatives, 1979–81. Oil on canvas, 60×24 in. (152.4 \times 61 cm.). Marlborough Gallery Inc., New York.

263. NICKY, c. 1979–81. Pastel and charcoal on canvas, 24×14 in. $(61 \times 35.6$ cm.). Marlborough Fine Art (London) Ltd.

264. Susanna, c.1979-81. Pastel and charcoal on canvas, 24×14 in. (61×35.6 cm.). Private collection, London.

265. GOODBYE TO CATALONIA, 1979–83. Oil on canvas, 60 × 24 in. (152.4 × 61 cm.). Marlborough Fine Art (London) Ltd.

266. DEGAS, 1980. Plate 118 Pastel and charcoal on paper, $28\frac{3}{4} \times 20$ in. $(73 \times 50.8$ cm.). Collection of the artist.

267. WOLLHEIM AND ANGELA, 1980. Plate 134 Charcoal on paper, $22\frac{1}{8} \times 30\frac{1}{4}$ in. $(56.2 \times 76.8 \text{ cm.})$. Collection of the artist.

268. PAUL BLACKBURN, 1980. Plate 126 Charcoal on paper, $15\frac{1}{4} \times 15\frac{3}{4}$ in. (38.7 × 40 cm.). Akron Institute, Ohio.

269. Marynka smoking, 1980. Plate 112 Pastel and charcoal on paper, $35\frac{3}{4} \times 22\frac{1}{4}$ in. (90.8 \times 56.5 cm.). Collection of the artist.

270. Mary-ann, 1980. Plate 121 Pastel and charcoal on paper, $30\frac{1}{2} \times 22$ in. $(77.5 \times 55.9$ cm.). Private collection, London.

271. Mary-ann on her stomach (face right), 1980. Plate 130 Pastel and charcoal on paper, 22×30 in. $(55.9 \times 76.2$ cm.). H.R. Astrup, Oslo.

272. MIRANDA'S BACK, 1980. Pastel and charcoal on paper, $30\frac{1}{2} \times 22\frac{1}{4}$ in. $(77.5 \times 56.5$ cm.). Private collection, Monte Carlo.

273. ANABEL ON HER BACK, 1980. Pastel and charcoal on paper,

 22×30 in. $(55.9 \times 76.2$ cm.). Private collection, London.

274. MIRANDA (FACE LEFT), 1980. Pastel and charcoal on paper, 30×22 in. $(76.2 \times 55.9$ cm.). Private collection, Los Angeles.

275. RED EYES, 1980. Plate 157 Pastel and charcoal on paper, 30×22 in. $(76.2 \times 55.9 \text{ cm.})$. Private collection.

276. The Waitress, 1980. Pastel and charcoal on paper, $30\frac{1}{2} \times 27\frac{1}{2}$ in. $(77.5 \times 69.8$ cm.). Private collection, London.

277. AFTER RODIN, 1980. Pastel and charcoal on paper, $30\frac{1}{2} \times 22\frac{1}{2}$ in. $(77.5 \times 57.2$ cm.). Nelson Blitz Jr., New York.

278. MIRANDA, 1980. Charcoal on paper, $25 \times 18^{7}_{8}$ in. (63.5 × 48 cm.). Private collection, England.

279. THE MASK, 1980. Pastel and charcoal on paper, $30\frac{3}{4} \times 22\frac{1}{2}$ in. $(78.1 \times 57.2$ cm.). Private collection, Baltimore, Maryland.

280. The Listener (Joe singer in Hiding), 1980. Plate 113 Pastel and charcoal on paper, $40\frac{8}{5} \times 42\frac{5}{5}$ in. (103.2 × 108.2 cm.). Nelson Blitz Jr., New York.

281. BATHER (PSYCHOTIC BOY), 1980. Plate 103 Pastel and charcoal on paper, $52\frac{3}{4} \times 22\frac{1}{2}$ in. (134 × 57.2 cm.). H.R. Astrup, Oslo.

282. China and Russia, 1980. Pastel and charcoal on paper, $30\frac{1}{4}\times28\frac{3}{4}\,\mathrm{in.}$ (76.8 \times 73 cm.). Private collection, New York.

283. The Red and the black, 1980. Pastel and charcoal on paper, 31×23 in. $(78.7 \times 58.4$ cm.). Private collection, Toronto.

284. The yellow hat, 1980. Plate 116 Pastel and charcoal on paper, $30\frac{1}{2} \times 22\frac{3}{4}$ in. $(77.5 \times 57.8$ cm.). Private collection, London.

285. BAD FAITH (RIGA) (JOE SINGER TAKING LEAVE OF HIS FIANCEE), 1980. Plate 117 Pastel, charcoal and oil on paper, $37 \times 22\frac{1}{4}$ in. $(94 \times 56.5$ cm.). I.R. Wookey, Toronto.

286. STUDY FOR THE JEWISH SCHOOL (JOE SINGER AS A BOY), 1980. Pastel and charcoal on paper, $30\frac{1}{2} \times 22\frac{1}{4}$ in. $(77.5 \times 56.5$ cm.). Collection of the artist.

287. Two famous writers, 1980. Charcoal on paper, $59\frac{1}{2} \times 22$ in. (151.1 \times 55.9 cm.). Marlborough Gallery Inc., New York.

288. Self-portrait in Saragossa, 1980. Plate 132 Charcoal and pastel on paper, $58 \times 33\frac{1}{2}$ in. (147.3 \times 85.1 cm.). The Israel Museum, Jerusalem.

289. The green dress, 1980. Pastel and charcoal on paper, $30\frac{7}{8} \times 22\frac{5}{8}$ in. $(78.5 \times 57.5$ cm.). Private collection, London.

290. The Jewish school (drawing a golem), 1980. Plate 114 Oil on canvas, 60×60 in. (152.4 \times 152.4 cm.). Private collection, Monte Carlo.

291. STARTING A WAR, 1980–1. Plate 153 (detail)

Oil on canvas, 84×36 in. (213.4 \times 91.5 cm.). Private collection, Akron, Ohio.

292. THE RED EMBRACE, 1980–1. Plate 151 Charcoal, pastel and oil on paper, $57 \times 22\frac{3}{4}$ in. (144.7 \times 57.8 cm.). Private collection, Paris. *

293. GOLEM, 1980–1. Oil on canvas, $59\frac{1}{4} \times 20\frac{3}{4}$ in. (150.5 \times 52.8 cm.). Private collection, New York.

294. CHIMERA, 1980–1. Plate 128 Oil on canvas, 22 \times $9\frac{3}{4}$ in. (55.9 \times 24.8 cm.). Galerie Beyeler, Basle.

295. MARYNKA PREGNANT, 1981. Charcoal and pastel on paper, $30\frac{1}{2} \times 22\frac{1}{2}$ in. $(77.5 \times 57.2$ cm.). Private collection, Baltimore, Maryland.

296. THE GARDEN, 1981. Plate 125 Oil on canvas, 48 × 48 in. (121.9 × 121.9 cm.). The Cleveland Museum of Art, Ohio.

297. GREY GIRL, 1981. Plate 145 Oil on canvas, 30×12 in. $(76.2 \times 30.5 \text{ cm.})$. Collection of the artist.

298. MATERNITY, 1981. Pastel and charcoal on paper, $30\frac{1}{4} \times 22\frac{1}{8}$ in. (76.8 \times 56.2 cm.). Marlborough Gallery Inc., New York.

299. ROCK GARDEN (THE NATION), 1981. Plate 129 Oil on canvas, 48×48 in. (121.9 \times 121.9 cm.). Private collection, Chicago.

300. SACHA AND GABRIEL, 1981. Plate 86 Charcoal on paper, $30\frac{3}{8} \times 22\frac{1}{4}$ in. (77.2 \times 56.5 cm.). Collection of the artist.

301. Marynka pregnant II, 1981. Plate 139 Pastel and charcoal on paper, $22\frac{1}{4} \times 30\frac{3}{8}$ in. $(56.5 \times 77.2$ cm.). Collection of the artist.

302. WINTER SUN OVER CHELSEA, 1981. Oil on canvas, 30×15 in. $(76.2 \times 38.1 \text{ cm.})$. Galerie Beyeler, Basle.

303. Garth, 1981. Plate 142 Oil on canvas, 24×14 in. $(61 \times 35.6$ cm.). Private collection, Belgium.

304. Vert compose clair, 1981. Oil on canvas, $30 \times 12\frac{1}{8}$ in. (76.2 × 30.8 cm.). Private collection, London.

305. STUDY FOR THE ROCK GARDEN, 1981. Pastel and charcoal on paper, $15\frac{3}{8} \times 10\frac{1}{8}$ in. $(39 \times 25.7$ cm.). Marlborough Fine Art (London) Ltd.

306. COURBET'S SISTER, 1981. Plate 135 Pencil on paper, $30 \times 22\frac{1}{2}$ in. $(76.2 \times 57.2$ cm.). Private collection, Switzerland.

307. STUDY FOR THE JEWISH SCHOOL (THE LAST DAY), 1981. Plate 158 Pastel and charcoal on paper, $30\frac{3}{8} \times 22\frac{1}{4}$ in. $(77.2 \times 56.5$ cm.). Private collection, London.

308. The white collar, 1981. Oil on canvas, $30\frac{1}{8} \times 12$ in. $(76.5 \times 30.5 \text{ cm.})$. Private collection.

309. FED UP, 1981. Oil on paper, $28\frac{1}{8} \times 24\frac{1}{4}$ in. (71.4 × 61.6 cm.). Private collection, England. 310. HOCKNEY'S MOTHER, 1981. Charcoal on paper, $30\frac{3}{8} \times 22\frac{1}{4}$ in. $(77.2 \times 56.5$ cm.). David Hockney, Los Angeles.

311. SELF-PORTRAIT (SAN FELIU), 1982. Charcoal and pastel on paper, $30\frac{3}{4} \times 22\frac{1}{4}$ in. $(78.1 \times 56.5$ cm.). Collection of the artist.

312. SLAV SOUL (VERA), 1982. Pastel and charcoal on paper, $30\frac{1}{2} \times 22\frac{1}{8}$ in. $(77.5 \times 56.2$ cm.). Marlborough Fine Art (London) Ltd.

313. ROBERT DUNCAN IN PROFILE (RECITING WITH HANDS BEATING TIME), 1982. Charcoal on paper, $22\frac{1}{2} \times 15\frac{1}{2}$ in. $(57.2 \times 39.4$ cm.). Private collection,

314. ROBERT DUNCAN IN PROFILE FACE LEFT, 1982. Charcoal on paper, $15\frac{1}{2} \times 22\frac{3}{4}$ in. (39.4 \times 57.9 cm.). Private collection, Berkeley, California.

England.

315. ROBERT DUNGAN WITH HAT LEANING FORWARD, 1982. Pastel and charcoal on paper, $22\frac{1}{2} \times 14$ in. $(57.2 \times 35.6$ cm.). Galerie Claude Bernard, Paris.

316. ROBERT DUNCAN FACE LEFT (LIGHT VERSION), 1982. Charcoal on paper, $15\frac{1}{2} \times 22\frac{1}{2}$ in. (39.4 × 57.2 cm.). Marlborough Fine Art (London) Ltd.

317. ROBERT DUNCAN ON A BALCONY, 1982. Pastel and charcoal on paper, $29\frac{1}{2} \times 22\frac{1}{2}$ in. $(75 \times 57.2$ cm.). Marlborough Fine Art (London) Ltd.

318. ROBERT DUNCAN IN PROFILE WITH EYES CLOSED, 1982. Charcoal on paper, $15\frac{1}{2} \times 22\frac{1}{2}$ in. (39.4 \times 57.2 cm.). Marlborough Fine Art (London) Ltd.

319. THE POET, EYES CLOSED (ROBERT DUNCAN), 1982. Plate 138 Charcoal on paper, $22\frac{1}{2} \times 31$ in. $(57.2 \times 78.7$ cm.). Collection of the artist.

320. THE POET AND NOTRE DAME (ROBERT DUNGAN), 1982. Plate 127 Pastel and charcoal on paper, $22\frac{1}{2} \times 15\frac{1}{2}$ in. $(57.2 \times 39.4$ cm.). Private collection, Switzerland.

321. THE POET WRITING (ROBERT DUNCAN), 1982. Charcoal on paper, $31 \times 22\frac{1}{2}$ in. (78.7 \times 57.2 cm.). Marlborough Fine Art (London) Ltd.

322. PARIS, FRANCE, 1982. Oil on canvas, 60×24 in. (152.4 \times 61 cm.). Marlborough Fine Art (London) Ltd.

323. London, England (Bathers), 1982. Plate 147 Oil on canvas, 48×48 in. (121.9 \times 121.9 cm.). Marlborough Fine Art (London) Ltd.

324. In the mountains, 1982. Oil on canvas, 48×48 in. (121.9 \times 121.9 cm.). National Gallery, Cape Town.

325. SAILOR, 1982. Charcoal on paper, $22\frac{3}{4} \times 15\frac{1}{2}$ in. (57.8 \times 39.4 cm.). Private collection, Switzerland.

326. ILAN, 1982. Pastel and charcoal on paper, $22\frac{1}{4} \times 15\frac{5}{8}$ in. (56.5 \times 39.7 cm.). Mary Moore.

327. SELF-PORTRAIT (AFTER MATTEO), 1982.

Charcoal on paper, $22\frac{1}{2} \times 15\frac{3}{8}$ in. $(57.2 \times 39$ cm.). Collection of the artist.

328. Yona in Paris, 1982. Plate 156 Charcoal on paper, $22\frac{1}{2} \times 15\frac{3}{8}$ in. (57.2 \times 39 cm.). Collection of the artist.

329. TIM IN PARIS, 1982. Charcoal on paper, $22\frac{1}{2} \times 15\frac{3}{8}$ in. $(57.2 \times 39$ cm.). Private collection, London.

330. MAN IN BLUE CLOAK, 1982. Pastel and charcoal on paper, $22\frac{1}{2} \times 15\frac{3}{8}$ in. $(57.2 \times 39$ cm.). MacLaurin Art Gallery, Ayr.

331. Male Nude, 1982. Charcoal on paper, $22\frac{5}{8} \times 15\frac{1}{2}$ in. (57.5 \times 39.4 cm.). Private collection, London.

332. THE CURE, 1982. Plate 133 Oil on canvas, 36×36 in. (91.5 \times 91.5 cm.). Private collection, London.

333. TED IN PARIS, 1983. Charcoal on paper, $22 \times 14\frac{1}{2}$ in. (56×36.8 cm.). Private collection, London.

334. The room (rue st denis), 1982–3. Plate 137 Oil on canvas, 48×36 in. (121.9 \times 91.5 cm.). Private collection, Cleveland, Ohio.

335. ELLEN, 1983. Charcoal on paper, $22\frac{1}{2} \times 30\frac{3}{4}$ in. (57.2 × 78.1 cm.). Private collection, New York.

336. ANDROPOV, 1983. Pastel and charcoal on paper, $30\frac{8}{5} \times 22\frac{8}{5}$ in. $(77.8 \times 57.5$ cm.). Private collection, Italy.

337. MOTHER, 1983. Charcoal and pastel on paper, $30\frac{7}{8} \times 22\frac{5}{8}$ in. (78.4 \times 57.5 cm.). Collection of the artist.

338. MOTHER, 1983. Charcoal on paper, $30\frac{3}{4} \times 22\frac{1}{2}$ in. (78.1 × 57.2 cm.). Collection of the artist.

339. MOTHER, 1983. Pastel and charcoal on paper, $30\frac{7}{8} \times 22\frac{5}{8}$ in. $(78.4 \times 57.5$ cm.). Collection of the artist.

340. MOTHER, 1983. Pastel and charcoal on paper, $30\frac{7}{8} \times 22\frac{3}{8}$ in. $(78.4 \times 56.8$ cm.). Collection of the artist.

341. SARAH, 1983. Charcoal on paper, $30\frac{1}{2} \times 22\frac{5}{8}$ in. (77.5 × 57.5 cm.). Thomas Gibson, London.

342. AMERICAN IN PARIS (WENDY), 1983. Charcoal on paper, $30\frac{5}{8} \times 22\frac{5}{8}$ in. $(77.8 \times 57.5$ cm.). Marlborough Fine Art (London) Ltd.

343. AMERICAN IN PARIS (WENDY'S BACK), 1983. Charcoal on paper, $22\frac{1}{2} \times 15\frac{3}{8}$ in. (57.2 × 39 cm.). Galerie Claude Bernard, Paris.

344. AMERICAN IN PARIS (WENDY PRONE), 1983. Charcoal on paper, $15\frac{1}{4} \times 22\frac{1}{2}$ in. (38.8 \times 57.2 cm.). Galerie Claude Bernard, Paris.

345. Self-portrait (reading), 1983. Charcoal on paper, $22\frac{1}{2} \times 15\frac{1}{2}$ in. (57.2 \times 39.4 cm.). Sandra Fisher, London.

346. SELF-PORTRAIT (GRETA PROZOR), 1983. Charcoal on paper, $22\frac{5}{8} \times 15\frac{3}{8}$ in. $(57.5 \times 39 \text{ cm.})$. Collection of the artist

347. Self-Portrait (CIRCLE), 1983. Charcoal on paper, $22\frac{5}{8} \times 15\frac{1}{4}$ in. (57.5 \times 38.8 cm.). Collection of the artist.

348. Sandra in Paris, 1983. Charcoal on paper, $19\frac{1}{2} \times 22\frac{1}{2}$ in. (49.5 × 57.2 cm.). Collection of the artist.

349. Self-portrait (hand on chin), 1983. Charcoal on paper, $13\frac{3}{4} \times 10\frac{5}{8}$ in. (35 × 27 cm.). Collection of the artist.

350. Self-Portrait (Papillon), 1983. Charcoal on paper, $13\frac{3}{4} \times 10\frac{5}{8}$ in. (35 × 27 cm.). Collection of the artist.

351. PLACE DE LA CONCORDE, 1983. Fig. 7 Charcoal on paper, $30\frac{5}{8} \times 22\frac{5}{8}$ in. $(77.8 \times 57.5 \text{ cm.})$. Private collection, Paris.

352. GEORGE ORWELL, 1983. Pastel and charcoal on paper, $30\frac{1}{2} \times 22\frac{1}{4}$ in. $(77.5 \times 56.5$ cm.). Time Magazine, New York.

353. THE RED BRASSIERE, 1983. Plate 15 Charcoal and pastel on paper, $30\frac{5}{8} \times 22\frac{3}{8}$ in. $(77.8 \times 56.8$ cm.). Private collection, Belgium.

354. ELLEN (SUNLIT), 1983. Pastel and charcoal on paper, $30\frac{1}{2} \times 22\frac{1}{8}$ in. (77.5 \times 56.2 cm.). Private collection, Switzerland.

355. GLEN GOULD (ON T.V.), 1983. Charcoal on paper, $5\frac{3}{4} \times 7\frac{3}{4}$ in. (14.6 × 19.7 cm.). Collection of the artist.

356. ELLEN AND SHOFAR, 1983–4. Plate 140 Pastel and charcoal on paper, $43^{\frac{1}{2}} \times 30$ in. (110.5 \times 76.2 cm.). Mr and Mrs Edward L. Gardner, Larchmont, New York.

357. CECIL COURT, LONDON WC2 (THE REFUGEES), 1983–4. Plate 143 Oil on canvas, 72×72 in. (182.9 \times 182.9 cm.). Marlborough Fine Art (London) Ltd.

358. ELLEN'S BACK, 1984. Pastel and charcoal on paper, $30\frac{3}{4} \times 22\frac{1}{4}$ in. (78.1 \times 56.5 cm.). Mr and Mrs Edward L. Gardner, Larchmont, New York.

359. ANNA, 1984. Charcoal and pastel on paper, $30\frac{5}{8} \times 22\frac{3}{8}$ in. $(77.8 \times 56.9$ cm.). Private collection, Belgium.

360. Sarah's back, 1984. Charcoal and pastel on paper, $30\frac{5}{8} \times 22\frac{5}{8}$ in. $(77.8 \times 57.5$ cm.). Private collection, Sydney.

361. SELF-PORTRAIT AS A WOMAN, 1984. Plate 146 Oil on canvas, $97 \times 30\frac{3}{8}$ in. (246.4 \times 77.2 cm.). H.R. Astrup, Oslo.

362. AMERIKA (JOHN FORD ON HIS DEATH BED), 1983–4. Plate 148 Oil on canvas, 60×60 in. (152.4 \times 152.4 cm.). Marlborough Fine Art (London) Ltd.

363. AMERIKA (BASEBALL), 1983–4. Plate 152 Oil on canvas, 60×60 in. (152.4 \times 152.4 cm.). Marlborough Fine Art (London) Ltd.